virtual interiorities
book two: the myth of total virtuality

edited by Vahid Vahdat, Dave Gottwald, and
Gregory Turner-Rahman

CARNEGIE MELLON UNIVERSITY: ETC PRESS
PITTSBURGH, PA

Virtual Interiorities by Carnegie Mellon University: ETC Press is licensed under a Creative Commons Attribution-NonCommercial-NoDerivatives 4.0 International License, except where otherwise noted.

COVER DESIGN Dave Gottwald and Gregory Turner-Rahman

BOOK DESIGN Dave Gottwald

COPY EDITING Rebecca J. Kanaskie

virtualinteriorities.org

Copyright © by ETC Press 2022
press.etc.cmu.edu

ISBN: 978-1-387-50501-2 (Print)
ISBN: 978-1-387-49251-0 (ePUB)

The text of this work is licensed under a Creative Commons Attribution-NonCommercial-NonDerivative 2.5 License (creativecommons.org/licenses/by-nc-nd/2.5/). All images appearing in this work are property of the respective copyright owners, and are not released into the Creative Commons. The respective owners reserve all rights.

This book was produced with Pressbooks (https://pressbooks.com) and rendered with Prince.

contents

Acknowledgements — v

Foreword — vii
Graham Harman

Introduction — xiii
Vahid Vahdat

III. (DIS)EMBEDDEDNESS

The Second Fall of Man — 21
A Filmic Narrative of Consumerist Interiorities in WALL·E
Vahid Vahdat

The Mirror Chiasm — 43
Problematizing Embeddedness in Video Games Through Mirrors
Andri Gerber

The Hunter and the Horrors — 61
Impossible Spaces in Analog and Digital Immersive Environments
Ágnes Karolina Bakk

Simulation Arts and Causality Montage — 83
Miracle as Metaphor
Deniz Tortum

IV. COMMODITIZED VIRTUALITIES

The Happiest Virtual Place on Earth — 97
Theme Park Paratextuality
Florian Freitag

Transmedia Storytelling in Disney's Theme Parks — 123
Or How Colonialism Underpins Participatory Culture
Sabrina Mittermeier

Agent P vs. the Drunks 137
Competing Interiorities in the Theme Park Space
Jennifer A. Kokai and Tom Robson

Rescripting Saudi Arabia 159
The Curation of a National Metaverse
Anna Klingmann

About the Editors 203
About the Contributors 205
About the ETC Press 207

acknowledgements

The editors wish to thank, first and foremost, all our contributors. During a global pandemic—during which many of us were living under some kind of lockdown—they replied kindly to our emails and met over Zoom calls across disparate timezones to plan and produce the compelling essays comprising these three books. Thank you to Dr. Scott Lukas for recommending the good people at Carnegie Mellon University's ETC Press, and to Editorial Director Brad King and his associates there for their ongoing support of this project. Dave Gottwald wishes to thank Brad Beacom and Emma Sondock for stimulating conversations about his work and for their ongoing friendship and support. Gregory Turner-Rahman wishes to thank Jim Bizzocchi for taking the time to discuss his work. Vahid Vahdat wishes to thank Graham Harman for accepting his invitation to write a thought-provoking foreword to this collection. Finally, great thanks from the editors to Rebecca J. Kanaskie for her sharp eye in copy editing the final manuscript.

foreword

Graham Harman

In the academic world it is an open secret that a certain percentage of edited anthologies are doomed to sink quickly beneath the waves, never to be heard from again. Often amounting to repositories for well-meaning conference papers, such books are those that fail to gain traction with the reading public, whether through a lack of internal unity of their various chapters or for purely accidental reasons. This three-volume collection now before you is something much better than that, and thus deserves a more glorious fate. Its title, *Virtual Interiorities*, should be read in a surprisingly literal manner, for its chapters discuss nothing less than the possible transformation of our conception of space (and even time) by way of a number of challenging technologies, ranging historically from amusement parks to the latest video game interfaces. In the introductions that follow for each book, the editors give a fine chapter-by-chapter overview of the individual contributions that form this collection. Here I will do something different, providing a general philosophical framework to assist the reader in grasping the possible stakes of *Virtual Interiorities*.

One common way to think of space and time is to view them as stable, empty containers within which things and events are located. At least prior to Albert Einstein and his general theory of relativity, which speaks of the distortion of space and time by mass, the empty container theory was the dominant one in modern physical science. The locus classicus of this concept is the Principia of Isaac Newton, where we find the following emblematic words: "Absolute, true, and mathematical time, of itself, and from its own nature, flows equably without relation to anything external ... Absolute space, in its own nature, without relation to anything external, remains always similar and immovable."[1] It could be said that the chief philosopher of the modern era, Immanuel Kant, retained this theory in his own system of thought.[2] True enough, Kant treats time and space as universal forms of human subjectivity rather than as objective containers found in the outside world. Nonetheless, both continua remain constant for Kant as well as for Newton: no stretching, bending, or twisting of time or space is conceivable for either of them.

Long before Kant this theory was defended on Newton's behalf by his ally Samuel Clarke in a famous debate with the philosopher G.W. Leibniz that ended with Leibniz's death in 1714.[3] Famously, Leibniz challenged the Newtonian conception of time and space by offering a relational alternative: space and time do not exist independently of the entities that occupy them but are defined by those entities in the first place. Among other rhetorical strategies, Leibniz ridicules the possibility that God might have created the universe ten minutes earlier than he did or one mile further to the west, since neither earlier/later nor east/west could have any meaning at all prior to the creation of the universe. Hence, space and time require a purely relational structure in which all temporal and spatial conceptions make sense only when entities are measured against one another. Given that relationality is highly fashionable in today's intellectual atmosphere, few will resist the chance to snap at the bait of Leibniz's argument. For reasons lying beyond the scope of this foreword, I am inclined to push

1. Isaac Newton, *Philosophiae Naturalis Principia Mathematica*, Book One, trans. Andrew Motte (Berkeley, CA: University of California Press, 1934), 6.
2. Immanuel Kant, *Critique of Pure Reason*, trans James Ellington (Indianapolis: Hackett, 1996).
3. *G.W. Leibniz & Samuel Clarke, Correspondence* (Indianapolis: Hackett, 2000).

back against relational ontologies of this sort. Yet that is beside the point, for more relevant to us here is the implication that far from being stable backgrounds for events—as even quantum theory still assumes—the Leibnizian model entails that our spatio-temporal framework is changeable. It was Albert Einstein who developed this possibility, in both the special and general theories of relativity, in which velocity (special) as well as mass and acceleration (general) play a previously unknown role in distorting one or both of the background continua we inhabit.

But, instead of these famous discoveries in physics, the three books of *Virtual Interiorities* discuss the possible role of technology in warping our usual sense of space and time. In a sense, this far predates what we think of modern technology. Ancient empires are known to have used gigantic statues and related techniques to terrify their enemies. Indeed, architecture itself might be viewed as a method of distorting natural space into something more emphatic or even psychedelic, with torch-lit inner chambers or distressing pyramids and ziggurats bringing a disoriented awe to those who visit them. The present work, however, focuses on more recent history, beginning with the pioneering amusement parks of the early twentieth century. Other chapters focus on advances in video game technology, including certain engines that allow players to explore worlds where the customary laws of physics are violated. While there may be limits to how much space and time can be modified without neurosurgical tampering, the still-young field of virtual reality is already capable of producing vertiginous effects in its users.

It was the great merit of Jakob von Uexküll to explore in empirical detail how the environment of each animal is determined by the limits of what it is able to perceive.[4] Although his most famous example is that of the tick, I am even more struck by his observation that different animals are capable of seeing the same flash of light a differing number of times per second. For instance, a snail is able to see just three or four flashes per second; more than that and it sees a steady light instead. A human is capable of seeing more than three times as many flashes per second as

4. Jakob von Uexküll, *A Foray into the Worlds of Animals and Humans: With A Theory of Meaning*, trans. Joseph O'Neil (Minneapolis: University of Minnesota Press, 2010).

snails, but fighting fish turn out to be even more gifted in this respect.[5] Of course, it is well-known that dogs hear in different registers from humans and that many animal species feel storms coming even while humans experience nothing but the blue sky above, however, the coming technologies might eventually put these animal talents within human reach. In his interesting book *Discognition*, Steven Shaviro further explores the cognitive difference between humans and such exotic creatures as slime molds,[6] but theorizing such topics in books is one thing and enabling journeys into these theorized alternate worlds is quite another. What the contributors to *Virtual Interiorities* succeed in doing is making us feel closer than ever to a technological era in which such questions as Thomas Nagel's famous query "What is it like to be a bat?" are not just philosophical thought-experiments but possible advertising slogans for products that enable customers to find out for themselves.[7] If there is anything I envy in the young, it is the fact that the power of space-time manipulation might be technologically within reach during their lifetimes, though probably not in my own. *Virtual Interiorities* improved my imagination by giving an early sketch of how such a thing might happen.

Long Beach, California
September 2022

Bibliography

Harman, Graham. "Magic Uexküll," in *Living Earth: Field Notes from the Dark Ecology Project 2014-2016*: 115-130. Amsterdam: Sonic Acts Press, 2016.

Kant, Immanuel. *Critique of Pure Reason*. Translated by James Ellington. Indianapolis: Hackett, 1996.

Leibniz, G.W. & Samuel Clarke. *Correspondence*. Indianapolis: Hackett, 2000.

Nagel, Thomas. "What is it Like to Be a Bat?" *The Philosophical Review* 83, no. 4 (1974): 435-450.

Newton, Isaac. *Philosophiae Naturalis Principia Mathematica*, Book One. Translated by

5. See Graham Harman, "Magic Uexküll," in *Living Earth: Field Notes from the Dark Ecology Project 2014-2016*: 115-130 (Amsterdam: Sonic Acts Press, 2016).
6. Steven Shaviro, *Discognition* (London: Repeater, 2016).
7. Thomas Nagel, "What is it Like to Be a Bat?," *The Philosophical Review* 83, no. 4 (1974):435-450.

Andrew Motte. Berkeley, CA: University of California Press, 1934.

Shaviro, Steven. *Discognition*. London: Repeater, 2016.

Uexküll, Jakob von. *A Foray into the Worlds of Animals and Humans: With A Theory of Meaning*. Translated by Joseph O'Neil. Minneapolis: University of Minnesota Press, 2010.

introduction

Vahid Vahdat

The guiding myth, then, inspiring the invention of [Virtual Reality,] is the accomplishment of that which dominated in a more or less vague fashion all the techniques of the mechanical reproduction of reality . . . a recreation of the world in its own image, an image unburdened by the freedom of interpretation of the artist.

—André Bazin[1]

A senior architecture professor of mine used to tell us that overlooked experts on spatial relationships are cats! "They fully understand space hierarchies, borders, and thresholds," she would say, "and use that skill to occupy the corners and edges of the space that would position them in a state of observational power—secure from potential threats." Architecture students learn early in their studies that such anecdotes are appreciated for their provocative power, rather than their factual accuracy. This story, and maybe what comes after in this introduction, is such.

1. André Bazin, "The Myth of Total Cinema," in *What is Cinema: Volume II*, ed. and trans. Hugh Gray (Berkeley: University of California Press, 1967), 23-27. Note that in this excerpt, I have replaced "cinema" with "Virtual Reality."

It has become a redundant but necessary task to rethink the idea of the virtual, especially as new potentials for epistemic raptures arise with each emerging form/technology of mediation.[2] With the rapid development of VR technologies, previous theories of virtual space can benefit from being revisited, dusted, polished, and refurbished. One well-exhausted approach to define the virtual is looking into its opposite realm in the hope of detecting a defining border where the two collide—this collision between the virtual and the nonvirtual was the premise of the first book. But situating the virtual in a dichotomous relation with the real, the physical, or the built has been a problematic approach that has rightly been contested in the literature. But, what if, as the "Physical/Virtual Continuum" section in Book One asks, one starts at the border with a deliberate disregard for all that constitutes the exclusivity of a supposedly comprehensive definition of the virtual? What if the virtual is no longer seen in a hierarchical relationship with the real that positions it as inferior and secondary? What if the relationship is flattened and the virtual is no longer dependent on mimicking an external, more "authentic" reality? Moreso, what if, in addition to the ontological autonomy of the virtual, one positions it at the center of theorization and thereby pushes the non-virtual into the periphery? In an attempt to contemplate these questions, Book Two catwalks the thin fade border at the edge of the virtual world, with some disregard to whatever lies outside, in opposition to how the "Liminal Encounters" section in Book One dwelled on the threshold between the two.

This approach thus assumes an interiority inherent to the virtual. The virtual—whether a Homerian epic, an impressionist painting, a choose-your-own-adventure novel, a pornographic anime, or a hyper-casual game app—affords its subject with an internal logic/narrative that is occupied through experience. This immersive quality has a three-dimensional and embodied quality that feels rather spatial. That perhaps explains the emphasis these three books put on the interiority of the virtual.

2. See Deniz Tortum, "Embodied Montage: Reconsidering Immediacy in Virtual Reality," (Master's thesis, Massachusetts Institute of Technology, 2016), 19; and Gaston Bachelard, *The Formation of the Scientific Mind: A Contribution to a Psychoanalysis of Objective Knowledge* (Beacon Press, 1986).

It is no wonder why artistic and filmic references to the virtual often find a territorial representation. While exiting the border of the virtual can assume a variety of forms—a red pill, perhaps, that factures *The Matrix* (1999)—too frequently does it find an architectural expression: climbing a staircase in *The Truman Show* (1998), sliding through a hole in the wall in *Being John Malkovich* (1999), jumping from a high-rise rooftop in *Vanilla Sky* (2001), or stepping into a wardrobe in *The Chronicles of Narnia* (2005).

With emerging technologies of virtuality, the modes of mediation are becoming less visible in a never-ending quest to achieve an absolute, subjective presence within the immersive experience of virtual interiorities—a phenomenon that media theorists Jay David Bolter and Richard Grusin call "immediacy."[3] Technologies of virtual reality are soon to achieve a recreation of human experience with an artificial interiority that is indistinguishable from reality,[4] a desire that Deniz Tortum, a contributor to these books, indicates to be the intention of the pioneers of the technology.[5]

The intention of the pioneers of the technology, as I discuss elsewhere,[6] is the same logic that French film critic and theorist André Bazin uses in *The Myth of Total Cinema* to justify his advocacy of "objective realism." "In their imaginations," according to Bazin, "they [the pioneers] saw the cinema as a total and complete representation of reality; they saw in a trice the reconstruction of a perfect illusion of the outside world."[7] These inventors, Bazin continues, "conjure up nothing less than a total cinema

3. Jay David Bolter and Richard A. Grusin, *Remediation: Understanding New Media* (Cambridge, MA: The MIT Press, 2000), 18.
4. Ibid.
5. See for example *Wired* magazine's interview with Palmer Luckey, the inventor of the Oculus Rift, and the TED Talk by Chris Milk, a public leader in the field of virtual reality. Deniz Tortum, *Embodied Montage*, 17-18.
6. Vahid Vahdat, "Meta-Virtuality: Strategies of Disembeddedness in Virtual Interiorities." *Journal of Interior Design* (2022). https://doi.org/10.1111/joid.12230.
7. Bazin, "The Myth of Total Cinema," 25.

that is to provide that complete illusion of life."[8] Is the suppression of modes of mediation, including the ever-thinning of the screen and continuous minimization of the VR apparatus, not a reflection of the desire to achieve "total virtuality"?

This totalizing immersivity of VR technologies in constructing the perfect illusion of the outside world should be contextualized within the consumerist nature of our societies, where, as Jean Baudrillard observed, the hyperreal order of simulation extends to our very cities.[9] Not only has it become harder to discover the edge of mediated spaces, represented in the wireframe landscape of digital simulation in *The Thirteenth Floor* (1999), it has also become increasingly more challenging to exit the "entangled orders of simulacra."[10] An inability to imagine alternatives to mediated spaces keeps the subjects suspicious of the possibility of any occupiable exteriority—not unlike the infinite darkness of the abyss surrounding *Dark City* (1998)—and ultimately consumes their will and ability to escape the mediated interiority, quite like the gravitational force that keeps the guest from leaving in *The Exterminating Angel* (1962).

The need to reimagine utopian visions has been examined in Book One[11] and will continue to be discussed here,[12] but the emancipatory potential of resisting the immersive quality of virtual interiors requires an awareness about the mediation involved in a virtual experience, which I refer to as "metavirtuality."[13] It is in this book and under the section titled "(Dis)embeddedness" that strategies of un-immersion, which bring the mediating role of virtual technology to the forefront, are introduced. The virtual expansion of physical space in immersive theatre productions, as Bakk explains, is possible because the audience is immersed in fictional

8. Ibid.
9. Jean Baudrillard, *Simulacra and Simulation*, trans. Sheila Glaser (Ann Arbor, MI: University of Michigan Press, 1994), 13.
10. Ibid.
11. See, for example, Konstantinos Dimopoulos, "Imagining Cities Through Play."
12. See, for example, Anna Klingmann, "Rescripting Saudi Arabia: The Curation of a National Metaverse" and Vahid Vahdat, "The Second Fall of Man: A Filmic Narrative of Consumerist Interiorities in WALL·E."
13. Vahdat, "Meta-Virtuality."

interiorities.[14] Mirrors in games, as Gerber discusses, breaks the fourth wall of the virtual experience.[15] Disturbances in the familiar causal logic external to a virtual world, as Tortum describes, can produce an alienating effect.[16] "The Second Fall of Man" similarly engages in the discussion of discarding interiorized virtual distractions by showing its ecological consequences.[17]

The socio-political implications of mediated interiorities of the virtual are, however, discussed under the section of "Commoditized Virtualities." Freitag looks into the selective nature of paratexts in theme parks as a means to represent the sanitization of their undesirable histories;[18] Mittermeier unearths the colonial ideology underlying the practices of transmedia storytelling and participatory culture, especially at the intersection of media and tourism;[19] Kokai and Robson discuss the collision of virtual experiences in occasions when the multiplicity of narratives are mapped over the same site;[20] and Klingmann explores themed cities as agents of neoliberal economic policies and nationalist ideologies by studying cases in Saudi Arabia.[21] Ontological discussions of virtuality will be left for last, as Book Three offers a critical outlook to anthropocentric theorizations of virtuality.

14. See Ágnes Karolina Bakk, "The Hunter and the Horrors: Impossible Spaces in Analog and Digital Immersive Environments."
15. See Andri Gerber, "The Mirror Chiasm: Problematizing Embeddedness in Video Games Through Mirrors."
16. The concept of *verfremdungseffekt* (distancing effect) was introduced by the German dramatist-director, Bertolt Brecht, as a strategy to detach the audience from becoming emotionally consumed in the play. Bertolt Brecht, *Brecht on Theatre: The Development of an Aesthetic*, trans. John Willett (New York: Hill and Wang, 1964), 136.
17. see Vahdat, "The Second Fall of Man."
18. See Florian Freitag, "The Happiest Virtual Place on Earth: Theme Park Paratextuality."
19. See Sabrina Mittermeier, "Transmedia Storytelling in Disney's Theme Parks: Or How Colonialism Underpins Participatory Culture."
20. See Jennifer A. Kokai and Tom Robson, "Competing Interiorities in the Theme Park Space."
21. See Klingmann, "Rescripting Saudi Arabia."

The quirky-cat approach used in this introduction—mooning over the content of the book, rubbing against chapters, and selectively kneading some of the themes—is meant to provide a territorial view of *Virtual Interiorities* that helps the reader navigate through the chapters without spilling the depths, nuances, and complexities that each author offers.

Bibliography

Bachelard, Gaston. *The Formation of the Scientific Mind: A Contribution to a Psychoanalysis of Objective Knowledge*, Beacon Press: 1986.

Baudrillard, Jean. *Simulacra and Simulation*, trans. Sheila Glaser. Ann Arbor, MI: University of Michigan Press, 1994.

Bazin, André. "The Myth of Total Cinema," in *What is Cinema: Volume II*, ed. and trans. Hugh Gray, Berkeley: University of California Press, 1967.

Brecht, Bertolt. *Brecht on Theatre: The Development of an Aesthetic*, trans. John Willett, New York: Hill and Wang, 1964.

Bolter, Jay David, and. Grusin, Richard A. *Remediation: Understanding New Media*, Cambridge, MA: The MIT Press, 2000.

Tortum, Deniz. "Embodied Montage: Reconsidering Immediacy in Virtual Reality," Master's thesis, Massachusetts Institute of Technology, 2016.

Vahdat, Vahid. "Meta-Virtuality: Strategies of Disembeddedness in Virtual Interiorities." *Journal of Interior Design* (October 2022): 1-14. https://doi.org/10.1111/joid.12230.

III. (DIS)EMBEDDEDNESS

The Second Fall of Man
A Filmic Narrative of Consumerist Interiorities in WALL·E

Vahid Vahdat

Guilt-Free Consumption

Pixar's WALL·E[1] (2008) is an excuse for this essay to think about questions of ecology and consumption through an architectural lens. And much like the movie, this chapter, too, adopts a dichotomous structure. Similar to WALL·E, the first part of this chapter focuses on our ecological crises and the second half addresses mediated spaces of consumption. Rather than a thematic homogeneity, it is the animation that brings cohesion to the theoretical discussions. And rather than filmic techniques and processes, it is the cinematic narrative that feeds the arguments.

While the freedom and power of the cinematic narrative to fictionalize unexplored spaces, cities, and landscapes has made it a rich source of inspiration for those involved in the design of the built environment, Hollywood's post-apocalyptic productions have often failed to generate a viable utopian alternative to the hyper-consumerism that has exceedingly deepened our ecological crisis. Colonizing space offers a blank slate to reinvent a socio-political order that is devoid of the malpractices of human history. But despite the escapist, redo mentality of outer-space

1. In this essay, "WALL·E," when italicized, refers to the animation. Otherwise, it signifies the main character of the movie. This logic does not apply in direct quotes from other sources, as the original format has been kept.

utopias, much of Hollywood's sci-fi fantasies retain the same ill-informed logic of hyper-consumption that initially brought about the disastrous consequences. Despite the tabula-rasa convenience of imaginary outside worlds in films such as *Interstellar* (2014) and *Elysium* (2013), the supposedly utopian colonies are nothing more than a cleaner, well-maintained, solar-powered version of the suburban consumerism that was complicit in the socio-ecological apocalypse in the first place. It is as if picturing the end of the world, as Fredric Jameson famously proclaims, is easier than imagining the end of capitalism.[2]

The end of the pre-Anthropocene world would not have been preventable with solar-paneled water heaters, reusable straws, and "half-rotten and expensive 'organic' apples," as Žižek sarcastically suggests. "The predominant ecological ideology," Žižek writes elsewhere, "treats us as a priori guilty, indebted to Mother Nature."[3] And how do we reconcile with this environmental guilt? More consumption; eco-consumption. "Blending environmentalism with consumerism," writes Tae-Wook Cha, "resolves two major forms of guilt at once. It alleviates both environmental anxiety and consumer desire by encouraging the consumption of products that contribute to a cleaner environment."[4]

Feeling the pressure of the ecological superego that constantly monitors our deeds to repay our debt to nature, "[we] regress to frantic obsessive activities: recycling paper, buying organic food, just so that we can be sure that we are doing something . . . but I am not ready to do anything really radical and change my way of life."[5] The vast number of wind turbines pointlessly-rotating among mountains of garbage and the decaying corpses of hundreds of formerly solar-powered robots in *WALL·E* may in fact be a reminder that when facing a crisis of grave magnitude, without a global political will, such minor interventions will not save the planet.

2. Fredric Jameson, *The Seeds of Time* (New York: Columbia University Press, 1994).
3. Slavoj Žižek, *Living in the End Times* (London; New York: Verso, 2010), 423.
4. Tae-Wook Cha, "Ecologically Correct," in *Harvard Design School Guide to Shopping*, ed. Chuihua Judy Chung et al. (Köln: Taschen, 2001), 305.
5. Slavoj Žižek, *First as Tragedy, Then as Farce* (London: Verso, 2009), 53.

But "what if 'saving the planet' were [sic] not the issue?" This question is posed by Timothy Morton in response to a discussion about *WALL·E*. "Saving the planet," he continues, "relies on a conceptual distance that is precisely part of the problem."[6] When it comes to the audacious claim of "saving the planet," the dark humor of George Carlin powerfully captures the critical position of dark ecology. "Saving endangered species," he suggests,

> is just one more arrogant attempt by humans to control nature . . . Leave nature alone. Haven't we done enough? We're so self-important . . . and the greatest arrogance of all: "Save the planet!" . . . We don't even know how to take care of ourselves yet! We haven't learned how to care for one another and we're gonna save the fucking planet? . . . I'm tired of these self-righteous environmentalists; these white, bourgeois liberals who [are] trying to make the world safe for their Volvos! Besides, environmentalists . . . don't care about the planet—not in the abstract they don't. You know what they're interested in? A clean place to live: their own habitat . . . The planet will be here for a long, long, long time after we're gone.[7]

And a long time after we are gone, this human-less, desert-like, garbage-ridden world of rubble and decay is what the post-apocalyptic narrative of *WALL·E* depicts, and even romanticizes. This longing for a "trash planet," which was the original title of the movie,[8] is quite uncharacteristic for a film (let alone an eco-didactic, children's animation), especially when

6. Timothy Morton, "We had to destroy Nature before ecology could save it," *Ecology Without Nature* (blog), July 12, 2008, http://ecologywithoutnature.blogspot.com/2008/07/we-had-to-destroy-nature-before-ecology.html.
7. George Carlin, "George Carlin: Saving the Planet – Full Transcript," *Scraps From the Loft* (blog), August 22, 2019, https://scrapsfromtheloft.com/2019/08/22/george-carlin-saving-planet-transcript/.
8. Tim Hauser, *The Art of WALL·E* (San Francisco: Chronicle Books, 2008), 11.

compared to the limitless cinematic imagination of sci-fi productions that aim to expand human territory beyond this planet. After all, space, as the media, from popular culture[9] to political discourse,[10] reminds us, and as *WALL·E* refreshingly satirizes,[11] is the final frontier.[12]

Abandon Ship!

WALL·E, as one would expect from an animation made primarily for an audience of children, is clearly a didactic film, if not purely ideological. Given its not-so-hidden biblical references, the film has received praise from religious commentators.[13] After all, the Axiom, as a vessel with the mission to transport the last of all living species to safety, resembles Noah's ark. And much like Noah's dove who brought back an olive branch as a sign of proximity to habitable land, the Axiom would send out Extraterrestrial Vegetation Evaluators (EVE) in search of vegetative life forms. But as the unconvincing line up of these three words that are forcefully put together to generate the desired abbreviation suggests, the main theological reference of the film is to Genesis: EVE and WALL·E, and a group of primitive Homo sapiens, abandon their heavenly lives for life on a clearly less-desirable earth.

9. The rhetoric of "Space: The Final Frontier" is repeated at the beginning of each episode in the 1966 TV series *Star Trek.*
10. "New Frontier" was a common theme in John F. Kennedy's acceptance speech in the 1960 presidential election.
11. Life on the Axiom is advertised in the film with the slogan, "Space: The Final Fun-tier."
12. In his now-disqualified frontier thesis, Frederick Jackson Turner argues that the frontier experience stripped European immigrants of their heritage and civilization. By forcing them to adopt survival skills from the Natives, it offered them qualities such as appreciation of individualism and democracy. The thesis has been rejected for its historical inaccuracies, American exceptionalism, and racist/chauvinistic views. Frederick Jackson Turner, *The Significance of the Frontier in American History* (Ann Arbor, MI: University Microfilms, 1966).
13. *Movieguide,* an online venue with the mission "to redeem the values of the entertainment industry, according to biblical principles," gives *WALL·E* four stars for its "Biblical worldview." It praises the film for its manifestation of "virtues that Christians and most conservatives would commend," and for its "very strong Christian, redemptive worldview without mentioning Jesus." "Wall-E: 'Great Love Conquers Time and Space,'" *Movieguide,* https://www.movieguide.org/reviews/walle.html.

But what the conservative proponents of the film fail to see is its subversive adoption of biblical narratives. While the "fall of man" aims to show its audience that their temporary life on the earthly dwelling will pass away and they should, through a virtuous life, seek return to their eternal house in heaven, *WALL·E* seems to prescribe a second fall, not through expulsion, but with a choice that requires courage, sacrifice, and hard, messy work. This anti-transcendental position in articulating a theme that is clearly ecological is best justified by Timothy Morton in his 2009 *Ecology without Nature*.

"Ecology without Nature," as Morton proclaims, "examines the fine print of how nature has become a transcendental principle."[14] In the book, Morton investigates how the idea of nature "is set up as a transcendental, unified, independent category."[15] Much like how William Cronon showed that the concept of wilderness is "quite profoundly a human creation,"[16] and a product of civilization that hides its unnaturalness, and similar to how Alan Liu asserted that there is "no nature except as it is constituted by acts of political definition made possible by particular forms of government,"[17] Morton discusses how the concept of nature, as an arbitrary textual signifier, refuses to maintain semantic consistency. It is a container that holds collective projections, expectations, and aspirations that constitute our subjective identity. Throughout centuries, the concept has housed our subliminal aestheticizations, romantic fantasies, nostalgic longings, primitivist inclinations, sadistic admirations, and guilt-driven venerations. The concept of nature in any given time says more about us and the internal consistencies of our aspirations than any imaginary external referent.

14. Timothy Morton, *Ecology without Nature: Rethinking Environmental Aesthetics* (Cambridge, MA: Harvard University Press, 2009), 5.
15. Ibid., 27.
16. William Cronon, *The Trouble with Wilderness: Or, Getting Back to the Wrong Nature* (New York: Norton, 1995), 7.
17. Alan Liu, *Wordsworth: The Sense of History* (Stanford, CA: Stanford University Press, 1989), 104.

It is following Morton's logic that Žižek proclaims "the first premise of a truly radical ecology should be, 'Nature doesn't exist,'"[18] certainly not in a fetishized, transcendental, anthropocentric way. In ecological discussions, this anthropocentric approach to nature (a natural consequence of subject-object dualism) is often regarded "as the fundamental philosophical reason for human beings' destruction of the environment. If we could not merely figure out but actually experience the fact that we are imbedded in our world, then we would be less likely to destroy it."[19] But canonizing Nature, putting it on a pedestal, and admiring it from afar, as a pristine untouched wilderness beyond human contamination, "re-establishes the very separation it seeks to abolish."[20]

This is where Morton's commitment to flat ontology helps de-anthropocentrize nature. Flat ontology is a theory that suggests all objects have the same degree of being-ness as any other object. A rusticated part from a broken garbage disposal machine, in this viewpoint, exists equally to an overweight person playing virtual golf. The reality of their existence is non-hierarchical and irreducible. A diamond ring's ontological value is no more than its felt box. Flat ontology, as Levi Bryant asserts, "rejects any ontology of transcendence."[21] Likewise, Morton's ecological thought abandons the concept of nature as some sort of a transcendental unified whole, external to human thought and culture, within which beings reside. Ecology, once situated on a flat ontological plane, would not privilege humans over non-human agents. A cockroach in a de-aestheticized ecology is no less cute than a fluffy bunny thumping his foot; a messy urban ecology is as real as some artificially bordered national park.

18. "Zizek on 'Ecology without Nature,'" *Harvard University Press Blog*, November 6, 2007, https://harvardpress.typepad.com/hup_publicity/2007/11/zizek-on-ecolog.html.
19. Morton, *Ecology without Nature*, 64.
20. Ibid., 125.
21. Levi Bryant, *The Democracy of Objects* (Ann Arbor, MI: Open Humanities Press, 2011), 245.

The landing of the Axiom should thus be read as an attempt to bring down humans from the privileged, subjective position they have occupied and immanently relocate them on a flattened ecological system that includes technology and urbanity, as well as pieces of Styrofoam cups from hundreds of years ago. The flatness can additionally be extended to the hierarchical relationship between the physical and the virtual.

The Ecoethics of Consumption

But how does developing an ecological ontology that deviates from anthropocentrism and transcendentalism lead to forms of action? In the introduction, I discussed how small measures of ecological consumerism are often frantic activities aiming to reassure our a priori sense of guilt that despite (and sometimes because of) our continued consumption, we have not remained passive. Žižek explains the logic of ethical consumerism through a simple but frighteningly clear example—the Starbucks logic:

> Are we aware that when we buy a cappuccino from Starbucks, we also buy quite a lot of ideology? . . . it is usually always displayed in some posters there, their message which is: "Yes our cappuccino is more expensive than the others but," and then comes the story, "we give one percent of all our income to some Guatemala children to keep them healthy. For the water supply for some Sahara farmers, or to save the forests, enable organic growing coffee, whatever, whatever." Now I admire the ingeniousity of this solution. In the old days of pure simple consumerism, you bought a product and then you felt bad. "My God, I'm just a consumerist while people are starving in Africa." So the idea was you had to do something to counteract your pure distractive consumerism . . . you contribute to charity and so on. What Starbucks enables you is to be a consumerist and . . . be a consumerist without any bad conscience because the price for the counter measure for fighting consumerism is already included into the price of a commodity. Like, you pay a little bit more and you are not just a consumerist but you do also your duty towards environment.[22]

22. Slavoj Žižek, "The Pervert's Guide to Ideology (Transcript/Subtitles)," *Žižek.uk*, December 24, 2016, https://zizek.uk/the-perverts-guide-to-ideology-transcriptsubtitles/.

But regardless of their motivation, be it self-reassurance or selfless activism, such small measurements of "sustainability" are clearly insufficient in the face of the ecological crisis we face. "No amount of individual action," according to a *CNN Business* report, "will address the magnitude of the problem."[23] In the built environment, both in practice—where the obsessive accumulation of points in pursuit of LEED certificates is the standard measure of sustainability—and in academia—where chunky graphic arrows on student sketches are somehow proof of including wind direction and sunlight in the design process, or renderings with a ghosted entourage of a happy group of racially diverse children (and often an over-excited dog) reflects attention to local community—such symbolic gestures, as necessary as they are, are nevertheless forms of folk politics at best and are thus insufficient.

Folk politics, as defined by Nick Srnicek and Alex Williams, is a form of political action that is reactive and therefore remains a defensive strategy and a form of resistance: it privileges horizontalist grass-roots movements from below at the expense of not engaging in structural change to socio-economic power relations at a global scale; it refuses to move beyond the sphere of immediacy to include mediated activism; it is incapable of planning long-term strategies; it fetishes small organizational practices; it is obsessed with personal forms of direct democracy; it focuses on the local and the spontaneous; and it is thus shown to be "incapable of articulating or building a new world."[24]

Localism, as Srnicek and Williams elaborate, "represents an attempt to abjure the problems and politics of scale involved in large systems such as the global economy, politics and the environment. Our problems are increasingly systemic and global, and they require an equally systemic response."[25] Small-scale actions, local economies, and immediate communities, as important and necessary as they are, are incapable of absorb-

23. Rachel Ramirez and Alexis Benveniste, "Meaningful Ways Individuals Can Put Pressure on Corporations to Solve the Climate Crisis," *CNN Business*, August 10, 2021, https://www.cnn.com/2021/08/10/business/what-can-you-do-about-climate-change/index.html.
24. Nick Srnicek and Alex Williams, *Inventing the Future: Postcapitalism and a World without Work* (United Kingdom: Verso Books, 2015), 3.
25. Ibid., 43.

ing the systemically interconnected nature of today's problems, including the ecological crisis. The enormity of the ecological crisis we face requires forms of political agency that can effectively organize to undertake the difficult labor of constructing persistent political structures that address complex global issues in the long term.

The Broken Robots

A form of large-scale action that has a clear agenda, is organized, disturbs the dominant forms of social order, and revolutionizes the masses is narrated in *WALL·E*—in a cartoonish way, of course. The revolution is not pessimistic towards technology; robots accelerate[26] the revolution and are an integral part of the post-revolutionary society/ecosystem. It is true that WALL·E (both the film and the character) hints at questions about human essence.[27] The anthropomorphic robots of the film, with their strong individuality, compassion, sensation, and love, are, as the film expects us to understand, much more human than the devolved, childlike, obese creatures on hovering chairs, floating endlessly in their world of idleness, leisure, and complacency. After all, as John Lasseter, *WALL·E*'s executive producer, suggests, "there's more humanity in this little robot WALL·E than there is in all the beings up on the Axiom." But this humanlike quality of the robots does not take away from the film's optimism towards a harmonious ecology that includes technology.

A harmonious ecology, however, needs to distance itself from discourses that, as Daniel Vella discusses elsewhere in this book, only grant preservational value to constructed, discrete categories known as species at the expense of the uniqueness of each individual being. In the exhibitionary

26. Accelerationism is a sociopolitical theory built on the premise that a combination of rapid technological change and an aggressive form of capitalism will inevitably trigger radical change.
27. "The film's presentation of a robot protagonist who develops sentience, intelligence, and human characteristics," as Eric Herhuth suggests, "raises questions about the essence of the human and what the stakes are if a discernible human essence manifests in entities that are politically and ethically treated as other than or less than human. Central to the human essence presented in the film's robots is a self-fashioning quality demonstrated by their deliberate choices ... The presence of such an essence provides the political justification for apparent equal treatment of robots and humans in the society that emerges at the film's end." Eric Herhuth, "Life, Love, and Programming: The Culture and Politics of Wall-E and Pixar Computer Animation," *Cinema Journal* 53 (2014): 53.

order of the Axiom,[28] best represented in the scene where a Soviet-era Sputnik 1 satellite is demonstrated in the captain's cabinet, outdated beings are discarded while a sample of the species is mummified for its display value. WALL·E signifies this overlooked individuality.

What makes WALL·E and the rest of his robot crew qualified to lead the revolution is not the clichéd sentiment that their cute, zoomorphic emotions bestow some form of humanity in them, it is rather their brokenness that gives them their superpowers. The broken tool theory, as Graham Harman expands on Heidegger's famous example,[29] describes how a piece of functioning equipment like a hammer withdraws from our conscious perception and only becomes present-at-hand when broken.[30] "It is this very tool," proclaims Morton,

> that is the "saving power" of which Hölderlin and Heidegger speak, a mute, brutal thing resonant with all the anthropocentric force of accumulated human prejudice. The Pixar movie *WALL·E* is the story of how broken tools save the Earth . . . In *WALL·E*, the broken tools are two obsessive robots: one, the protagonist, with his melancholy collection of human trinkets; the other, a cleaning robot whose compulsion to wipe every surface forces him between two closing sliding doors at a crucial juncture.[31]

WALL·E is considered a "foreign contaminant" to the social order of the Axiom, and is, according to Jim Reardon, one of the film's screenwriters, "willing to screw up the equilibrium of everything that exists—just because he's in love."[32] WALL·E has the power to "affect other robots so much that they betray their programming or go beyond it."[33] His army of revolutionaries is basically a group of crazy robots who escape from some sort of a futurist, robotic madhouse. Simply by being dislocated

28. For a discussion on how modern forms of representation and knowledge take part in the construction of the colonial order, see Timothy Mitchell, "The World as Exhibition," *Comparative Studies in Society and History* 31, no. 2 (1989).
29. Martin Heidegger, *Being and Time: A Revised Edition of the Stambaugh Translation*, trans. Joan Stambaugh (Albany, NY: State University of New York Press, 2010).
30. Graham Harman, *Tool-Being: Heidegger and the Metaphysics of Objects* (Chicago and La Salle, IL: Open Court, 2011).
31. Timothy Morton, *Hyperobjects: Philosophy and Ecology after the End of the World* (Minneapolis, MN: University of Minnesota Press, 2014), 23.
32. Tim Hauser, *The Art of Wall·E* (San Francisco, CA: Chronicle Books, 2008), 12.
33. Ibid., 126.

from their asylum, they disrupt the meticulously engineered order of Axiom, symbolized in the patterns that direct the movement of bodies, goods, and services. This unlikely army of rebels are instantly considered "rogue robots" by the dominating system of Buy-N-Large (BnL)—a corporate state that has monopolized economic activities and usurped governmental powers.[34]

The marginalization of this group of non-conforming robots that fail to follow the directives of the dominant social order is much more meaningful when we consider the clinical vocabulary that justifies their exclusion from the larger robotic society. Concepts such as the repair "ward" and "diagnostics" in *WALL·E* allow for a Foucauldian reading of the power structure on the Axiom. By looking at the history of medical institutions in the West, Foucault discusses how the authority of the medical gaze was appropriated for the socioeconomic interests of power.[35] He particularly looks at the medicalization of insanity to illustrate how the concept of madness was socially constructed as a means to confine socially undesirable individuals.[36] The undesirable robots are incarcerated in a medical deck through clinical justification, possibly because they deviate from the "normal" robotic behavior and thus disturb the dominant social order on the Axiom through the sheer power of their individuality and nonconformity. And the spatial layout of the Axiom, which Ralph Eggleston, *WALL·E*'s production designer, refers to as an "antiseptic, sterile environment," is complicit in enforcing this order.[37]

34. BnL, as Addey observes, "uses the exact same typeface and color scheme as real-world retail giant Costco Wholesale Corporation." Dave Addey, *Typeset in the Future: Typography and Design in Science Fiction Movies* (New York: Abrams, 2018), 187.
35. Michel Foucault, *The Birth of the Clinic: An Archaeology of Medical Perception* (New York: Vintage Books, 1975).
36. Michel Foucault, *Madness and Civilization: A History of Insanity in the Age of Reason*, trans. Richard Howard (New York: Vintage Books, 1965).
37. Ralph Eggleston, "Design with a Purpose: An Interview with Ralph Eggleston," by Ron Barbagallo, *Animation Art Conservation*, 2009, http://www.animationartconservation.com/design-with-a-purpose,-an-interview-with-ralph-eggleston.html.

To understand the imposing order of the Axiom, an archeology of its morphological inspirations becomes unexpectedly helpful. From touring cruise ships and studying robots at the Jet Propulsion Laboratory (JPL) to attending lectures from Apple designers,[38] the Pixar team had sought inspiration anywhere they could. Eventually, a range of themes, spaces, objects, and technologies inspired the crew, from the streamlined surfaces of Apple's designs and the futuristic yet organic forms in the architecture of Santiago Calatrava to the artwork of John Berkey, gentlemen's clubs in Las Vegas, the Mars rover film, and Seattle's Space Needle.[39]

But "the single biggest influence for [the Axiom]" as Eggleston emphasizes on multiple occasions, was an exhibit of original sketches, drawings, artifacts, models, and promotional material of Tomorrowland.[40] Tomorrowland is one of the themed areas of Disneyland that depicts an advanced, space-age future. The first Tomorrowland opened in 1955. The exhibit at the Oakland Museum of California that inspired Eggleston and his team was called *Behind the Magic—50 Years of Disneyland*. It was a travelling show that originated from the Henry Ford Museum in Dearborn, Michigan, honoring the fiftieth anniversary of Disneyland.[41]

The production team's attraction to Tomorrowland might have been mostly visual, as Anthony Christov, *WALL·E*'s set art director, implies that the team was shocked by "the colorful, almost retro naiveté of 1950s and 1960s design sensibility."[42] This purely aesthetic sensibility that somehow felt right for the city-scale interiority of the Axiom's BnL social model

38. The involvement of Apple in the design of objects and spaces in *Wall·E* even included a phone conversation with Steve Jobs and a day of consultation with Apple design head Jony Ive at the Pixar headquarters. Addey, *Typeset in the Future*, 196.
39. Eggleston, "Design with a Purpose"; Hauser, *The Art of Wall·E*, 100–101; Addey, *Typeset in the Future*, 189, 214, 217, 220.
40. "Our main inspiration," Eggleston reminds us elsewhere in his interview with Barbagallo, "was paintings of the future by Disney artists designing the original Tomorrowland at Disneyland." Eggleston, "Design with a Purpose." But the effect of Tomorrowland on the design of the Axiom is voiced by many other members of the team as well. For Hauser, for example, "Walt Disney's ultramodern redesign of his 1967 'World on the Move' inspired the Axiom's optimistic futurism." Houser, *The Art of Wall·E*, 100–101.
41. Karal Ann Marling and Donna Braden. *Behind the Magic: 50 Years of Disneyland* (Dearborn, Michigan: The Henry Ford Museum, 2004).
42. Hauser, *The Art of Wall·E*, 101.

nevertheless hints at a deeper unconscious political awareness. After all, as architectural historian Vincent Scully observes, "when we come upon a place of absolute vernacular integrity, where people are also buying things . . . we are reminded of Disneyland."[43]

But what is the cause of this unconscious association? For one, as American architect Charles Moore responds, Disneyland is not free.[44] To access its public life, one must pay. Second, it delegates civic responsibility to private development, and by doing so it has transformed public space into a commodity. Since Disneyland's opening, according to Chuihua Judy Chung, "the use of commercial private space as public property has become commonplace," so much so that "[it has] resulted in the radical conversion of the city, from public to private . . . [and] noncommercial to commercial."[45]

But aside from the commercialization of public space, Disneyland is also about control. "Disney strives to control . . . the built environment," as Terry Brinkoetter, a Disney representative, puts it. "We believe that to the degree that an environment can be controlled, the appropriate reactions of people within that environment can be predicted."[46] This combination of environmental control, commercialization of space, and privatization of civic realms can be further traced back to Disneyland's source of inspiration.

When looking further into the Axiom's family tree, genes of consumption and control keep showing up. According to Chung, one of the most influential sources of Walt Disney's utopian vision was Victor Gruen.[47] Gruen, who is known as the inventor of the shopping mall, contributed 44 million square feet of shopping to the postwar city. But Gruen's main ambition was to extend the logic of the mall to the entire city. This may further

43. Vincent Scully, "Disney: Theme and Reality," in *Building a Dream: The Art of Disney Architecture*, ed. Beth Dunlop (New York: Disney Editions, 2011), 9.
44. Charles Moore, *You Have to Pay for the Public Life: Selected Essays of Charles W. Moore*, ed. Kevin P. Keim (Cambridge, MA: The MIT Press, 2001).
45. Chuihua Judy Chung, "Disney Space," in *Harvard Design School Guide to Shopping*, ed. Chuihua Judy Chung et al. (Köln: Taschen, 2001), 280.
46. Ibid., 282.
47. Ibid., 288.

explain Walt's interest—after all, he too intended for EPCOT (Experimental Prototype Community of Tomorrow) to be a model for future urban developments. In his book, tellingly titled *Shopping Towns USA*, Gruen justifies his proposed merger between urbanity and shopping.[48] As Leong puts it, "for Gruen, the mall was the new city."[49]

Leong, however, goes on to suggest that, for Gruen, basing the template of urbanity on malls is tied to his deep desire for order.[50] Law, order, stability, and control—concepts that come up rather frequently in Gruen's book and prerequisites to the uninterrupted flow of consumption—possibly explain why Walt Disney owned multiple copies of Gruen's books and later used them as inspiration for his Disney World. The same combination of order and consumption might also have attracted Pixar artists in their search for a formal language for the Axiom.

Enjoy-n-Large

But behind the axiomatic space of consumption rests an axiomatic mentality of excess. To uncover the hidden psychology behind axiomatic consumption, Žižek's concept of the "anal father of enjoyment" is illuminating. Unlike the Freudian oedipal father who commands the subject to sacrifice enjoyment as a price for entry into the social order, excessive enjoyment is the directive from the anal father. While both the oedipal and the anal fathers, as Felicia Cosey clarifies, "function as an authority that mediates the relationship between the subject and objects in her environment,"[51] with the loss of the oedipal father's authority in the capitalist social order, the anal father has filled the void with the demand of excessive enjoyment. "With global capitalism," writes Fabio Vighi, "we enter a 'post-historical' era dominated by the ubiquitous injunction to consume in excess."[52] This excess and aggression is a result

48. Victor Gruen and Larry Smith, *Shopping Towns USA: The Planning of Shopping Centres* (New York: Reinhold, 1965), 11.
49. Sze Tung Leong, "Gruen Urbanism," in *Harvard Design School Guide to Shopping*, ed. Chuihua Judy Chung et al. (Köln: Taschen, 2001), 381.
50. Ibid., 384–85.
51. Felicia Cosey, "What Wall-E Can Teach Us About Global Capitalism in the Age of the Anal Father," *International Journal of Žižek Studies* 12, no. 1 (2018): 12.
52. Fabio Vighi, *On Zizek's Dialectics: Surplus, Subtraction, Sublimation* (New York: Continuum, 2010), 11.

of the subject being persistently reminded of how she has failed to meet the level of enjoyment by the Other.[53] Any delay in consumption can thus cause anxiety in meeting the anal father's expectation. This strive for immediate consumption is perfectly captured in the advertisements by BnL, e.g., "drink now," "hungry now," "run now," and "'consume."[54]

Cosey has provided a thorough account of the parallels between the unrestricted culture of consumption on the Axiom and Žižek's theory of the anal father of enjoyment,[55] and therefore its repetition in this chapter is unnecessary. What is relevant here is the role of private urban interiorities disguised as public space, functioning as a site for hedonistic hyper-consumption. The Axiom epitomizes a capitalist utopia that seems devoid of its defects, particularly the exploitation of labor, social segregation, and wealth inequality. It is post-labor (thanks to full automation or machinic enslavement, if you will), class-less, and provides all imaginable public services and amenities for the welfare of its citizens.

The Axiom is a fully controlled, well-tempered, interconnected, inverted city full of neon lights, floating screens, super-sized malls, interior plazas, artificial lakes, AI-monitored movements, automated amenities, self-driving individual and public transportation, computer-augmented sports, and total automation. It is an endless interiority; no citizen of the Axiom has ever experienced its exterior. Is it not that this sealed, inescapable interiority follows the logic of shopping malls? Is it not that shopping, as Leong and Weiss suggest, "has historically preferred to do away with outside"?[56]

The seemingly infinite extent of this confined space, as paradoxical as it may seem, is both the cause and effect of the desire for total control. The controlled environment of an air-conditioned space, as Leong and Weiss show, causes the "explosion of the depth of the interior, creating spaces

53. Ibid., 12.
54. Addey, *Typeset in the Future*, 186.
55. Cosey, "What Wall-E Can Teach Us."
56. Sze Tung Leong and Srdjan Jovanovich Weiss, "Air Conditioning," in *Harvard Design School Guide to Shopping*, ed. Chuihua Judy Chung et al. (Köln: Taschen, 2001).

increasingly divorced from the outside [and] increasingly inescapable."[57] This magical ability "in providing a year-round climate of 'eternal spring,'" as Gruen unapologetically suggests, is a conscious attempt by architects and engineers to pamper the shoppers and thereby "contribute to higher sales figures."[58] "The city," in Leong's words from two decades ago, "*is* being configured according to the mall,"[59] and this is by no means a speculation of a sci-fi future.

Yet, while Earth is filled with towers of garbage, it is the Axiom that is the junkspace par excellence. As Dietmar Meinel observes, "Buy-n-Large superstores, megastores, ultrastores, malls, banks, transit stations, gas stations, and trains litter the landscape as prominently as the junk itself."[60]

Junkspace, as Rem Koolhaas articulates, "simulates the city. . . . Monumental partitions, kiosks, mini-Starbucks on interior plazas."[61] Continuity, he continues, "is the essence of junkspace; it exploits any invention that enables expansion, deploys the infrastructure of seamlessness . . . It is always interior, so extensive that you rarely perceive limits; it promotes disorientation by any means."[62] Intended for the interior, junkspace, according to Koolhaas,

> can easily engulf a whole city. . . . outdoors itself is converted: the street is paved more luxuriously, shelters proliferate carrying increasingly dictatorial messages, traffic is calmed, crime eliminated. . . . The global progress of Junkspace represents a final Manifest Destiny: the World as public space.[63]

57. Ibid.
58. Ibid., 123.
59. Sze Tung Leong, "And Then There Was Shopping," in *Harvard Design School Guide to Shopping*, ed. Chuihua Judy Chung et al. (Köln: Taschen, 2001), 132, emphasis added.
60. Dietmar Meinel, *Pixar's America: The Re-Animation of American Myths and Symbols* (Switzerland: Palgrave Macmillan, 2016).
61. Rem Koolhaas, "Junkspace," *October* 100 (2002): 186, http://www.jstor.org/stable/779098.
62. Ibid., 175.
63. Ibid., 186.

The pseudo-public space of a consumerist city is the natural habitat for the children of the anal father. According to Todd McGowan, to avoid situations that may require surrendering enjoyment, the subject retreats from public spaces to private ones.[64] The shared and egalitarian nature of public space, according to McGowan, demands a willingness from the subject to share the public sphere with others; private spaces, however, allow subjects to exclude any form of compromise in their quest for enjoyment. This retreat to private space paradoxically does not increase the subject's enjoyment, but rather results in an ever-increasing desire to maximize its means of enjoyment.

Ecological Odyssey

When designing the environments of *WALL·E*, Eggleston and his team were speculating on questions such as, "what were humans thinking? . . . Why were they unable to solve the problem?"[65] These questions are posed in the past tense because the narrative of the animation occurs in a dystopian future, but perhaps they should remain a matter of bygone inaction because, with the lack of political will to confront our ecological crisis, *WALL·E*'s prophecy is more imminent than we would like to accept.

"The futuristic city" of Eggleston's vision, "based on consumerism run amok, where advertising has become more important than the product itself,"[66] is unfortunately not as futuristic as he would hope. City planners, as McMorrough observes, have already adopted the consumption model of the mall as a blueprint to envision the city itself:[67]

64. Todd McGowan, *The End of Dissatisfaction: Jacques Lacan and the Emerging Society of Enjoyment* (Albany, NY: State University of New York Press, 2004).
65. Eggleston, "Design with a Purpose."
66. Ibid.
67. John McMorrough, "City of Shopping," in *Harvard Design School Guide to Shopping*, ed. Chuihua Judy Chung et al. (Köln: Taschen, 2001), 194.

As a result of this diminishing of the city as a vibrant force, and the decreasingly delineated public realm, the reconstituted world of the mall established shopping as the principal means left by which to perceive urbanity. Operating as a model for envisioning the city, then, the shopping mall has proliferated to the extent of conditioning the experience and planning of the city.[68]

But what *WALL·E* has failed to grasp is that Gruen and Disney's vision for extending the theme park logic of control and consumption to cities has already materialized. The presence of mediated space of virtuality is way beyond the visible forms of mediation in screens, models, and renderings. Assuming there is some emancipatory power in putting down the phone, turning off the TV, exiting the game, or shutting off the headset is naïve. To think that human characters immersed in "holo-dates" and "virtual golf" will rise to overthrow the order of consumption simply because they are able to see beyond their screens is wishful at best. Their moment of realization is limited to the great discovery that the Axiom has a pool. But the pool, the trees, and even the sky above them is also part of their simulacra: the screens simply mask the virtuality of the Axiom. As Baudrillard brutally reveals,

> Disneyland exists in order to hide that it is the "real" country, all of "real" America that is Disneyland . . . Disneyland is presented as imaginary in order to make us believe that the rest is real, whereas all of Los Angeles and the America that surrounds it are no longer real, but belong to the hyperreal order and to the order of simulation. It is no longer a question of a false representation of reality (ideology) but of concealing the fact that the real is no longer real, and thus of saving the reality principle.[69]

Floating in the blissful virtuality of our shopping towns, we may need an unsettling wake-up call towards the ecological conditions that affect us. The ship of excessive enjoyment will continue its disastrous course as long as it remains on the current capitalist autopilot while localist sentimentalities of folk ecology are doomed to fail, as did "operation clean-up" in *WALL·E*. Enviropreneurial marketing is the new consumption model,

68. Ibid., 201.
69. Jean Baudrillard, *Simulacra and Simulation*, trans. Glaser Sheila Faria (Ann Arbor: The University of Michigan Press, 2020), 12, 13.

much like how "blue is the new red." Landing in the messy reality of our complex and ever-changing ecosystem requires disturbing the sociopolitical orders of mass consumption as well as abandoning the transcendental high ground of "saving nature."

Bibliography

Addey, Dave. *Typeset in the Future: Typography and Design in Science Fiction Movies.* New York: Abrams, 2018.

Baudrillard, Jean. *Simulacra and Simulation.* Translated by Glaser Sheila Faria. Ann Arbor: The University of Michigan Press, 2020.

Bryant, Levi R. *The Democracy of Objects.* Ann Arbor, MI: Open Humanities Press, 2011.

Carlin, George. "George Carlin: Saving the Planet – Full Transcript." *Scraps From the Loft* (blog), August 22, 2019. https://scrapsfromtheloft.com/2019/08/22/george-carlin-saving-planet-transcript/.

Cha, Tae-Wook. "Ecologically Correct." In *Harvard Design School Guide to Shopping*, edited by Chuihua Judy Chung, Jeffrey Inaba, Rem Koolhaas and Sze Tsung Leong. Köln: Taschen, 2001.

Chung, Chuihua Judy. "Disney Space." In *Harvard Design School Guide to Shopping*, edited by Chuihua Judy Chung, Jeffrey Inaba, Rem Koolhaas, and Sze Tsung Leong. Köln: Taschen, 2001.

Cosey, Felicia. "What Wall-E Can Teach Us About Global Capitalism in the Age of the Anal Father." *International Journal of Žižek Studies* 12, no. 1 (2018).

Cronon, William. *The Trouble with Wilderness: Or, Getting Back to the Wrong Nature.* New York: Norton, 1995.

Eggleston, Ralph. "Design with a Purpose: An Interview with Ralph Eggleston," by Ron Barbagallo. *Animation Art Conservation*, 2009. http://www.animationartconservation.com/design-with-a-purpose,-an-interview-with-ralph-eggleston.html.

Foucault, Michel. *The Birth of the Clinic: An Archaeology of Medical Perception.* New York: Vintage Books, 1975.

———. *Madness and Civilization: A History of Insanity in the Age of Reason.* Translated by Richard Howard. New York: Vintage Books, 1965.

Gruen, Victor, and Larry Smith. *Shopping Towns USA: The Planning of Shopping Centres.* New York: Reinhold, 1965.

Harman, Graham. *Tool-Being: Heidegger and the Metaphysics of Objects.* Chicago and La

Salle, IL: Open Court, 2011.

Hauser, Tim. *The Art of Wall·E*. San Francisco: Chronicle Books, 2008.

Heidegger, Martin. *Being and Time: A Revised Edition of the Stambaugh Translation*. Translated by Joan Stambaugh. Albany: State University of New York Press, 2010.

Herhuth, Eric. "Life, Love, and Programming: The Culture and Politics of Wall-E and Pixar Computer Animation." *Cinema Journal* 53 (2014): 53–75.

Jameson, Fredric. *The Seeds of Time*. New York: Columbia University Press, 1994.

Koolhaas, Rem. "Junkspace." *October* 100 (2002): 175–90.

Leong, Sze Tung. "And Then There Was Shopping." In *Harvard Design School Guide to Shopping*, edited by Chuihua Judy Chung, Jeffrey Inaba, Rem Koolhaas, and Sze Tsung Leong. Köln: Taschen, 2001.

———. "Gruen Urbanism." In *Harvard Design School Guide to Shopping*, edited by Chuihua Judy Chung, Jeffrey Inaba, Rem Koolhaas, and Sze Tsung Leong. Köln: Taschen, 2001.

Leong, Sze Tung, and Srdjan Jovanovich Weiss. "Air Conditioning." In *Harvard Design School Guide to Shopping*, edited by Chuihua Judy Chung, Jeffrey Inaba, Rem Koolhaas, and Sze Tsung Leong. Köln: Taschen, 2001.

Liu, Alan. *Wordsworth: The Sense of History*. Stanford, CA: Stanford University Press, 1989.

Marling, Karal Ann, and Donna Braden. *Behind the Magic: 50 Years of Disneyland*. Dearborn, Michigan: The Henry Ford Museum, 2004.

McGowan, Todd. *The End of Dissatisfaction: Jacques Lacan and the Emerging Society of Enjoyment*. Albany, NY: State University of New York Press, 2004.

McMorrough, John. "City of Shopping." In *Harvard Design School Guide to Shopping*, edited by Chuihua Judy Chung, Jeffrey Inaba, Rem Koolhaas, and Sze Tsung Leong. Köln: Taschen, 2001.

Meinel, Dietmar. *Pixar's America: The Re-Animation of American Myths and Symbols*. Switzerland: Palgrave Macmillan, 2016.

Mitchell, Timothy. "The World as Exhibition." *Comparative Studies in Society and History* 31, no. 2 (1989).

Moore, Charles. *You Have to Pay for the Public Life: Selected Essays of Charles W. Moore*, edited by Kevin P. Keim. Cambridge, MA: The MIT Press, 2001.

Morton, Timothy. *Ecology without Nature: Rethinking Environmental Aesthetics*. Cambridge, MA: Harvard University Press, 2009.

———. *Hyperobjects: Philosophy and Ecology after the End of the World*. Minneapolis, MN:

University of Minnesota Press, 2014.

———. "We had to destroy Nature before ecology could save it." *Ecology Without Nature* (blog), July 12, 2008. http://ecologywithoutnature.blogspot.com/2008/07/we-had-to-destroy-nature-before-ecology.html.

Ramirez, Rachel, and Alexis Benveniste. "Meaningful Ways Individuals Can Put Pressure on Corporations to Solve the Climate Crisis." *CNN Business*, August 10, 2021. https://www.cnn.com/2021/08/10/business/what-can-you-do-about-climate-change/index.html.

Scully, Vincent. "Disney: Theme and Reality." In *Building a Dream: The Art of Disney Architecture*, edited by Beth Dunlop. New York: Disney Editions, 2011.

Srnicek, Nick, and Alex Williams. *Inventing the Future: Postcapitalism and a World without Work*. United Kingdom: Verso Books, 2015.

Turner, Frederick Jackson. *The Significance of the Frontier in American History*. Ann Arbor, MI: University Microfilms, 1966.

Vighi, Fabio. *On Zizek's Dialectics: Surplus, Subtraction, Sublimation*. New York: Continuum, 2010.

"Wall-E: 'Great Love Conquers Time and Space.'" *Movieguide*. https://www.movieguide.org/reviews/walle.html.

"Zizek on 'Ecology without Nature.'" *Harvard University Press Blog*, November 6, 2007. https://harvardpress.typepad.com/hup_publicity/2007/11/zizek-on-ecolog.html.

Žižek, Slavoj. "The Pervert's Guide to Ideology (Transcript/Subtitles)." *Žižek.uk*, December 24, 2016. https://zizek.uk/the-perverts-guide-to-ideology-transcriptsubtitles/.

———. *First as Tragedy, Then as Farce*. London: Verso, 2009.

———. *Living in the End Times*. London; New York: Verso, 2010.

The Mirror Chiasm

Problematizing Embeddedness in Video Games Through Mirrors

Andri Gerber

Introduction

Human society has always dealt with virtual extensions of its "reality." These were used to open the everyday to spaces of magic or myth. Forms of virtuality can be found as early as in cave paintings and have ever since accompanied the way human beings have tried to make sense of their existence. Video games can be seen as the peak of this evolution, generating fantastic game spaces in which the players actively experience narrations of all kinds. The evolution of games was paralleled by an evolution of the simulation of space, going from simple 2D to full immersive spaces in virtual reality.[1] The strive for a perfect illusion and all the consequences that go with it—which has already been the subject of novels and movies for centuries—has been accelerated by new technologies. The recent creation of the Metaverse by Marc Zuckerberg has triggered a competition among the key players—mainly Microsoft—to create the most perfect virtual reality into which we can transfer many of our activities, from work to leisure. Virtual realities are created with new technologies, and they are completely isolated from the actual, thus helping us to forget our limited, human condition. This detachment is not only given by the degree of virtuality of game environments, but also by their mechan-

1. Friedrich von Borries, Steffen P. Walz, and Matthias Böttger, eds., *Space Time Play: Computer Games, Architecture and Urbanism: The Next Level* (Basel: Birkhäuser, 2007).

ics, which leads the player to constantly follow a goal without the time to be concerned with anything else. While on the one hand video games offer a more active spatial perception than other media such as cinema or theater, the activity of the player is strongly channeled by its rules.[2] The higher the degree of illusion is achieved, the less a player can refer himself to his actual condition. This calls for devices that can problematize this perfection and disturb the embeddedness of the player in the virtual reality of a game.

In fact, the argument I would like to bring forward in this chapter is that the quality of virtual—be it on screen or VR devices—as a corollary to actual space is only given when the former still leaves open a door to the latter. That is, when a threshold between virtual and actual remains open and can be experienced or trespassed and when we can map the virtual on our daily life experience. It is not by chance that myths, fables, tragedies, and comedies—as fantastic as they might be—are always somehow related to everyday situations. And for their enactment, they have always been tied to some spatial thresholds, such as the fireplace, the theater, or the cinema. On the contrary, the current tendency of virtual reality is to make us completely immersed in it without any ties to the actual condition. The question is: how we can problematize this situation and lever on the mediation of this experience? One of the most powerful tools in this sense is unplanned: glitches and bugs of all kinds and sorts. These have been analyzed and discussed widely, as they manage to make us discover "beyond the scenes" of games and of programs.[3] Glitches often generate impossible spatial situations, with unprogrammed places that should not be accessible, like the hospital set in *Grand Theft Auto IV* (2008) where you can suddenly enter an undefined space. The possibilities of glitches have created an interesting movement of "countergaming," or working against the game by trying to directly modify it to make it function differently.[4]

2. Stephan Schwingeler, *Kunstwerk Computerspiel – Digitale Spiele als künstlerisches Material.Eine bildwissenschaftliche und medientheoretische Analyse* (Bielefeld: Transcript, 2014).
3. Rosa Menkman, *The Glitch Moment(um)* (Amsterdam: Network Notebook Series, 2011).
4. Alexander Galloway, *Gaming Essays on Algorithmic Culture* (Minneapolis: Electronic Mediations, 2006).

Andri Gerber

This opens an interesting aspect of the nature of space in video games: while games might suggest the existence of both "exterior"—landscapes, cityscapes—and "interior"—apartments, prisons etc.—spaces, these are experienced as seamless landscapes with no real difference, because of the same constraints and mechanics they are subjected to. Players are constantly moving in a "landscape of events," to quote French philosopher Paul Virilio.[5] The example of this "other space" in *GTA IV* is thus particularly enlightening because it opens and disturbs our embeddedness in the virtual space of the game. That is, the appearance of a space that can be perceived as an "exterior" to the "interior" where we act as characters allows us to understand and acknowledge its mediateness. As such, glitches can help us to relate the (virtual) interior to an (virtual) exterior and thus to the actual.

In everyday life, an interior always implies the existence of an exterior, and there are many possible thresholds that define intensities and degrees of the relation of these two. It appears evident that there can be no interior if not in relation to some exterior; my apartment is an interior to the city outside, which is its exterior. There are many thresholds with different ways to connect the two, such as doors, windows, or balconies.

Game spaces are representations of the actual world, but they are not simply copies of it. The transformation in the virtual space of games also implies a transformation of houses and cities to something different. And as such, windows, balconies, or doors are not the same as they are just connections without any kind of "thickness" and do not represent thresholds, only passageways.[6]

5. Paul Virilio, *A Landscape of Events* (Cambridge, MA: The MIT Press, 2000).
6. About the possible quality of in-betweenness in video games, see Ulrich Götz, "Zugänge zu Zwischengängen—Konstruktion eines räumlichen Modells," in *Digitale Moderne: die Modellwelten von Matthias Zimmermann*, ed. Natascha Adamowsky (München: Hirmer, 2018): 231–248.

Mirrors: Agents of Reflection

It appears thus important, in the light of the increasing closeness of games and virtual reality, to reflect on agents, which are capable of troubling the illusion and suspend the separation. For this chapter, I would like to move the attention to another device which has the potential to generate the same effect as glitches and bugs. It is a device with a long history we can refer to, but which in video games has not received the attention it deserves: the mirror. Mirrors are rare in video games, primarily due to insufficient rendering power on the part of the CPU and GPU. Mirror effects have only recently become more sophisticated and life-like; it is now possible to realistically reflect a character, for example, through water. As game spaces are graphical simulations, the effect of mirroring must also be simulated. This can be achieved by introducing materials which reflect the environment or by doubling and inverting spaces, thus simulating the effect of an actual mirror. These representations are very taxing for one's computer, and this is only compounded exponentially when a series of mirrors face each other. As computing power has increased, more mirrors have appeared with the potential to effectively disturb our embeddedness. They open the interior of games to another space that remains inaccessible and as such is perceived as "exterior" unless the mirror can be trespassed. Mirrors then can become agents of "reflections" both literally and metaphorically.[7]

Mirrors appear to be particularly fitting for this task, as they have always been agents of magic and were used to "communicate" with other worlds. They were part of several ancient myths, such as the killing of Medusa by Perseus through a deflecting shield which prevented him turning to stone, or Narcissus, famous for falling in love with his own reflection. Mirrors also represent thresholds to grim worlds, where souls are taken

[7]. The etymology of "to reflect" is complex and leads back to the Latin term "reflectere," which means to "bend back." Reflecting, in the sense of thinking, then implies a movement of thought back and forth inside the head. It is the movement which generates the thought.

away and demons lurk. Because of this, some cultures cover mirrors in houses of mourning. Most children know that vampires do not cast reflections in mirrors, a source of visual humor in films as recent as *What We Do in the Shadows* (2014).

Mirrors are ambiguous thresholds that hold the potential of opening a pathway in both directions. Not surprisingly, they have also played a major role in magic and alchemic procedures, such as the *Spirit Mirror* allegedly owned by Anglo-Welsh astronomer and occultist John Dee to summon spirits and angels. Mirrors, because of their ambiguous nature and the capacity to transform what is reflected and not simply represented, were ideal instruments for any kind of magic or spiritual rituals. We can also find examples of exterior uses of mirrors to modify the reality of landscapes: in England the upper class would wander through their incredibly artificial "natural" landscapes—the "English landscape garden"—by holding a so called "Claude Glass," named after French painter Claude Lorrain, and looking back through it. The small mirror, convex and often cased in a powder box, was sensed to reproduce the landscape in the mirror in a way to be closer to the landscape paintings that had influenced their design. This was a virtual reality device *ante litteram*!

The mirror as device to question reality and perception, to break the boundaries of media, and thus to problematize the relationship of exterior and interior, has been used often in painting or cinema. Three well known paintings are particularly enlightening in this sense: Jan van Eyck's *The Arnolfini Portrait* (1434), Diego Velázquez's *Las Meninas* (1656), and Parmigianino's *Self-portrait in a Convex Mirror* (c.1524).

van Eyck's *The Arnolfini Portrait* (1434) is such an example: at the two sides of the stage we find the married couple looking at the observer and holding hands. It has been suggested by art historian Erwin Panofsky that the painting might have had a legal character,[8] but what is troubling is the presence in the middle upper part of the painting of a round, convex mirror which inevitably attracts the attention of the observer. Not only do we

8. Erwin Panofsky, "Jan van Eyck's *Arnolfini* Portrait," *The Burlington Magazine for Connoisseurs* 64, no. 372 (Mar. 1934): 117–119; 122–127.

see the reverse of the couple, but two more persons which stand behind them and would be invisible if not for the mirror. Furthermore, the small dog which stands at the foot of the couple interestingly is not mirrored. Thus, the small mirror breaks the boundaries of the frame and extends the space of the painting to the actual observer, who would hypothetically be mirrored into the scene, but is obviously not.

An even more famous and often discussed painting with a mirror playing a major role is *Las Meninas* by Diego Velázquez (1656).[9] Here, it is the painter that stands in the scene, and he is caught in the act of looking towards the observer, where (supposedly) the royal couple, which he is portraying, is standing (see image 3.1). Here again, not least also because of the disposition of the other figures in the painting, the space of the scene is exploded, and, through the mirror, it opens a new dimension in which the observer is projected. The staging of the figures and of the rooms is extended to the observer by the space he is standing and the space of the royal couple, which would be hypothetically identical.

Of a different order is the painting by Parmigianino, *Self-portrait in a Convex Mirror* (c. 1524), when the painter was only twenty-one. Here, the mirror does not act as a threshold and multiplier of spaces but as a device troubling and problematizing perception: the convex mirror creates a distorted image of the painter which he reproduces into the painting. This allows Parmigianino to question the canons of perfection and of identity by representing his distorted body with a huge hand and arm in the foreground and a small head in the background. These examples show very well how mirrors can be used as devices that problematize the medium in which they are used, and, because of their reflecting nature, they break the isolation of the medium.

9. See, for example, the analysis of this painting by Michel Foucault in *L'archéologie du savoir*, 1969.

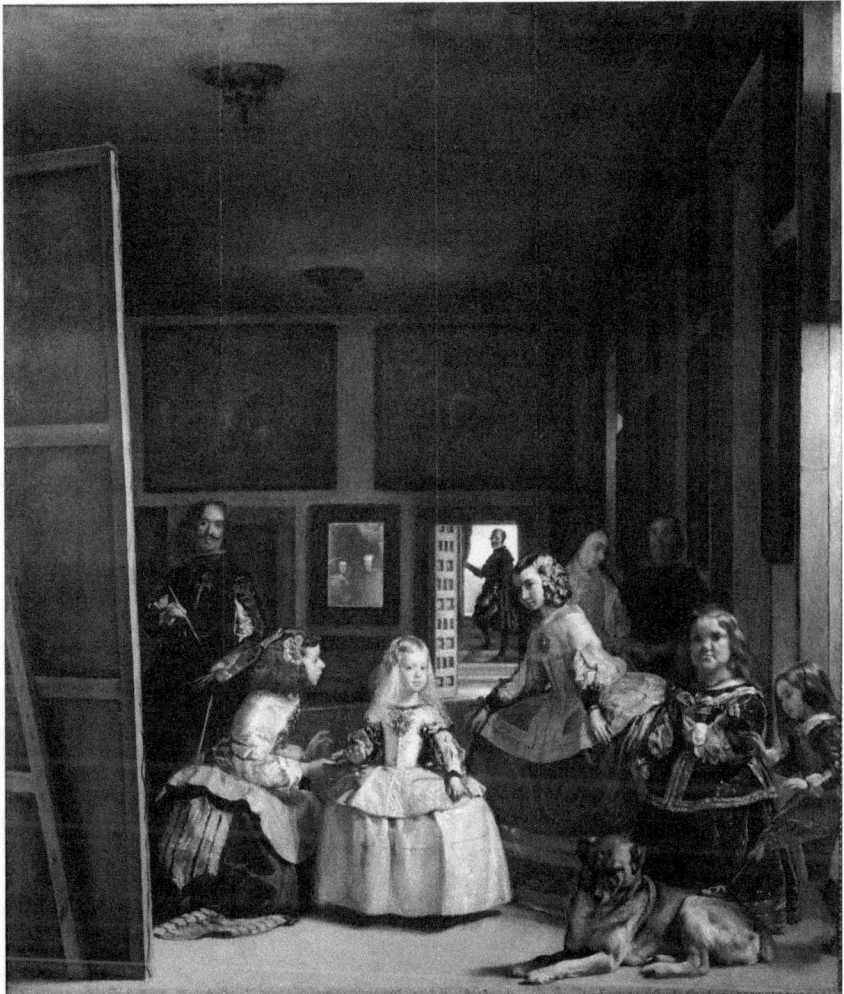

Image 3.1: Diego Velázquez, Las Meninas, 1656, Museo del Prado (Wikipedia).

Mirrors continue to be an inspiration for art. Conceptual practitioner Dan Graham uses them extensively. His model installation *Alteration to a Suburban House* (1978) shows how the mirror, both literally and metaphorically, can suspend a divide and problematize it by creating a reflected threshold. The work is based on a series of small-scale models of single-family houses without façades. Mirrors are placed on the whole long side

in the interior of the houses. Thus, the interior of one house is projected into the interior of the next, creating a new exterior based on these two interiors. The resulting play of reflections questions the enclosed nature of suburbia.

In the Italian *giallo* horror film *Profondo Rosso* (1975, dir. Dario Argento) the protagonist walks through a hall with creepy paintings looking for a murderer. It is only at the end of the movie that one realizes that one of the paintings in reality was a mirror in which the murderer was reflected, which is profoundly uncanny and shows to what extent our attention can be steered. Hopefully, similar approaches will be used in the medium of video games to explore the potential of mirrors. As Georges Teyssot has underscored, *play* and *mirror* in German have the same root: "Spiegel" and "Spiel."[10] Mirrors are close to play as their effect opens a set of effects and a game of reflections, which seems unstoppable at times (see image 3.2).

Image 3.2: Dario Argento, Profondo Rosso, 1975, film still.

10. "Play and mirror share the same root in German: *Spiegel* (mirror) and *spiel* (play, or game). During the baroque and rococo periods, with its fictive perspectives, the *Spiegelkabinett* creates a theatre of illusion which celebrates the collective narcissism of the princely court. The resulting abyss (the *mise-en-abyme*), first blurs and then ruins the mimetic chain of (social) representations, in effect creating Trauerspiel, a baroque drama." Georges Teyssot, "Mapping the Threshold: A Theory of Design and Interface," *AA Files*, no. 57 (2008): 7.

Mirrors also play an important role in cultural history in the establishment of bourgeois interiors and their separation from a dangerous exterior. With the serial production of mirrors, these were not confined to the houses of the few wealthy, but also seen in many private houses and mansions: everywhere, the bourgeoisie was emerging as a new social class. The increasing call for security resulted in closing houses and apartments to the dangerous outside, but through mirrors it was possible to again have an opening to a magical exterior. The mirror thus took over the role of windows and doors as a different kind of opening, as the actual outside was too dangerous to be kept open. The exterior to which these interiors were relating to are now the virtual exteriors created by the mirrors. These would produce a secure opening to a magical world, seen best if they were put in front of each other, thus creating the well-known effect of the "infinite mirror." The disposition of mirrors in apartments and mansions became a design discipline of its own, and nothing was left to chance. Paintings of interiors of the time always show a precise disposition of mirrors with different angles of inclination to obtain the best effect.

The use of mirrors became ubiquitous in almost every bourgeois *intérieur* to the point of a true fashion, which became criticized by many, including Edgar Allen Poe. In an essay published in 1840, Poe fiercely criticized the use of mirrors as in bad taste as they would create both uniformity and chaos. But, at the same time, the success of mirrors as an element of decoration was enormous.[11] Despite such critiques, mirrors entered so many houses and apartments at the time. Mirrors allowed for an opening of the interior to a seamless exterior that would not bare danger for the inhabitants. The exterior was the modern city, a city of rising industrialization, chaos, danger, noise, and pollution. No wonder the fine gentleman didn't want to put his apartment in touch with this reality. He was striving for privacy and for "Gemütlichkeit," coziness.

11. Edgar Allen Poe, "The Philosophy of Furniture," *Burton's Gentleman's Magazine*, no. 5, (May 1840): 243–245.

With the advent of modern architecture and this obsession for transparency, the bourgeois *intérieur* and all its possible thresholds would steadily disappear towards a continuous space merging inside and outside. While architecture in the nineteenth century was all about design from the exterior—the city and the façade—to the interior, modernism's design procedure was inverted, moving from the interior to the exterior, from the furniture to the city. While mirrors played no particular role in modern architecture, which was all about clarity—both literally and metaphorically—and transparency, the contemporary advent of new technologies in the houses—the modernist "house as machine"—led to a "complexification" of the interior. And while the modernist radicality was not embraced by the masses, the rising complexity of networks would open the house to a new "digital" exterior.[12] This process is still ongoing, and the devices have multiplied: from electricity, radio, phone, and television to portable devices, virtual reality, and video games. This leads to the observation made above of virtual realities that suggest a transparent relation to our actual life but are in reality separated from it by the increasing capacity of technology.

Everything is connected, even if in an invisible way. The completely cut off house is unimaginable, seen only in stories such as E.T.A. Hoffmann's "Ein Brief von Hoffmann an Herrn Baron de la Motte Fouqué" (1818) where the protagonist, Rat Krespel, would have his house built with no plan. Instead, he would let walls and ceilings without opening creating an inaccessible hollow space. Only in a second moment he would start to determine where the workers would have to place an opening.[13] The house is then metaphorically tied to our faces, with the windows representing our eyes. How disturbing is the association of windows with mouths, as in the movie *The House with Laughing Windows* by Pupi Avati (1976)

12. "En fait, puisque la maison devient l'endroit de passions contradictoires, elle apparaîtra, d'un côté, comme la forteresse de l'intimité' (la notion anglaise de '*privacy*,' ou celle de '*Gemütlichkeit*' en allemand), alors que, de l'autre, elle se présentera comme un microcosme quadrillé de frontières mobiles." Georges Teyssot, "Fenêtres et écrans: entre intimité et extimité," in *Appareil*, MSH Paris Nord, École doctorale "Pratiques et théories du sens" (2010), https://doi.org/10.4000/appareil.1005.
13. E. T. A. Hoffmann, *Die Serapionsbrüder*, ed. Wulf Segebrecht and Ursula Segebrecht (Frankfurt am Main: Deutscher Klassiker Verlag im Taschenbuch, 2008), 17–29.

Andri Gerber

where the eyes of the house—the windows—are painted as mouths. It is all about inside and outside, interior and exterior, and the relation that is installed between the two. This is exactly what virtual reality is cutting off.

Mirrors in Games

On the backdrop of this rich history, it is evident that mirrors are more than just reflecting surfaces. The question arises if we can transfer their qualities to video games to problematize their closeness as they do in other media.

One of the characteristics of mirrors is to create confusion. Just think of the *Hall of Mirrors* in Versailles, which is an excellent example of what mirrors can achieve in an interior space when they are paired and put in front of each other, creating the effect of multiple reflections. One can only imagine the gaiety and delight of the dancers and covenants during a party in this room, accompanied by the music of Jean-Baptiste Lully, or later Jean-Philippe Rameau, with a wild play of reflections.[14]

Again, Paul Virilio, when discussing the nature of virtual space, makes an analogy between virtual reality and the *Hall of Mirrors* in Versailles:

> We have before us a stereo reality. Like the lows and the highs that create a field effect, a relief effect, we have now actual space and virtual space. And the architect has to work with both. Just as the architects of Versailles worked with the gallery of mirrors. Except that no it is not simply a phenomenon of representation; it is a place of action.[15]

14. The *Hall of Mirrors*, on a side note, was an important step towards the industrial production of glass. It should in fact not be forgotten that the production of mirrors in the past was difficult and expensive. Up to the seventeenth century, mirrors were a rare product and in the hands of few specialists. At the time, Venetians were holding the monopoly of glass production and the famous *Hall of Mirrors* in Versailles, realized between 1678 and 1684 by Jules Hardouin-Mansart, was an important touchstone for the *Manufacture royale de glaces de miroirs* (later Compagnie de Saint-Gobain) created by Jean-Baptiste Colbert to break this monopoly. Venetian glassmakers were invited to Paris in an early example of industrial espionage.
15. Paul Virilio and Sylvère Lotringer, "After Architecture: A Conversation," trans. Michael Taormina, *Grey Room* 3, (Spring 2001): 41.

Note that Virilio underscores how the virtual world is not a space of representation, but of action. If we look at the virtual worlds of video games, there is obviously an aspect of (mis)representing the actual world, at the same time, at the core of these spaces is the possibility of action, of manipulating something, be it only the character played in them.

The ultimate confusion and, in a sense, perversion, of the baroque "Spiegelkabinett" or "Cabinet des Glaces" was the house of mirrors in funfairs and amusement parks. German born Gustave Castan would file the first series of patents for an "Irrgarten" maze. An American version would soon appear and be one of the attractions of the Chicago 1893 World's Fair. The "Mystic Labyrinth" was advertised with the following words:

> The Labyrinth and Crystal Palm Garden seem ABSOLUTELY WITHOUT END, yet when one tries to penetrate he constantly finds himself FACE TO FACE with his own image. Endless vistas appear, etc., and one always seems to be standing in the identical same spot, and wholly ROBBED of all ideas of direction—as great a MYSTERY as human ingenuity can provide.[16]

At the same time, this kind of use of multiple mirrors in games still challenges calculation power. We can only imagine the effect of such a play of mirrors and how this would open infinite exteriors to the interior of video games.

The effect of opening up a door to another dimension which cannot be entered, if not by one's own reflection, is more likely to be already found in video games. French philosopher Michel Foucault, in his lecture "Des espaces autres"[17] (1967), defines the mirror as something in-between utopia and heterotopia. It is a utopia because it is a place without a place, but also a heterotopia as it is a real object through which I am at the same time real and unreal. It is this quality which could make the mirror so powerful in video games. Unfortunately, so far, not many games have used the potential of mirrors to problematize the embeddedness of

16. Handbill for the "Mystic Labyrinth" mirror maze at the Chicago 1893 World's Fair.
17. Michel Foucault, "Des espaces autres," *Empan* 54, no.2 (2004): 12–19, https://www.cairn.info/revue-empan-2004-2-page-12.htm.

the player. Often mirrors are used literally as doors, and by doing so they lessen their quality as the mirrored space becomes accessible and is again nothing but a seamless interior. If the mirror is used as a tool of reflection, then it opens a continuous interior of the game as an inaccessible exterior that could help the player to refer his virtual game to his actual experience.

Good examples of mirrors in video games can be found in the survival horror game series *Silent Hill* (1999–2012). In *Silent Hill 2* (2001), the protagonist James looks at himself in a mirror in the intro scene, but he is actually looking outside the game to the player. In *Silent Hill 3*, the potential of mirrors is really unlocked: here a creepy room has a full-size mirror where the character is reflected up to a point before the mirrored image detaches itself and remains still. The effect is troubling as we see something which is at the same time inside and outside of the game. In *Doom 3* (2004) there is also a mirror scene in a toilet, and, once the character looks at itself in the mirror, a video shows the character aging very quickly. In *Control* (2019), the game's female protagonist must unlock a room with a mirror in a particular level and pass through it. She then enters a mirrored space in which she faces an army of doppelgängers generated by the very same mirror (see image 3.3).

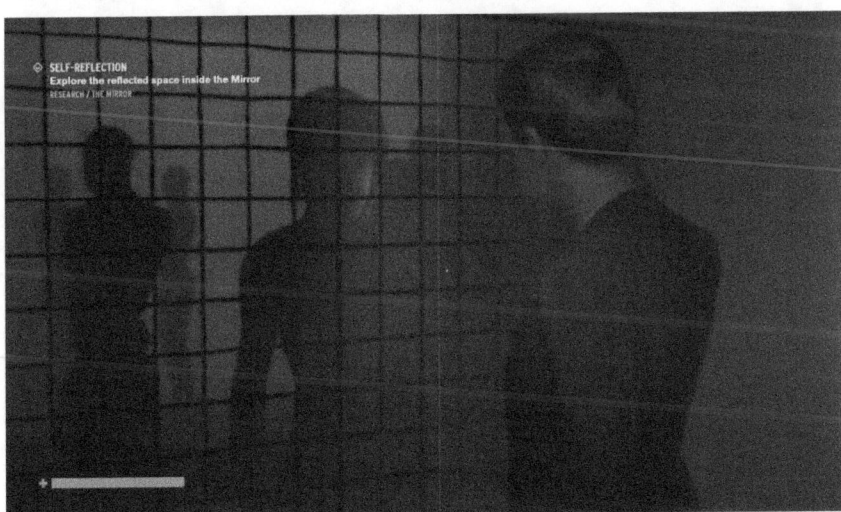

Image 3.3: *Remedy Entertainment, Control, 2019, screenshot.*

These are some examples that show us what mirrors can do in video games and how they can be used to open the interior of games to an exterior, which is special, as it cannot be accessed. Yet, in order to do so, the mirrors must remain static and not be portals or screens, because then the magic of its reflection is gone, and we identify the mirrors as elements of the interior of games. That is, they are not opening up a virtual exterior, but remain part of the seamless interior. The mirror as a magical portal to another world is obviously a well-established literary trope, as in how Lewis Carroll's Alice enters Wonderland:

> In another moment Alice was through the glass, and had jumped lightly down into the Looking-glass room. The very first thing she did was to look whether there was a fire in the fireplace, and she was quite pleased to find that there was a real one, and blazing away as brightly as the one she had left behind.[18]

The mirror here is a barrier between reality and fiction, between the interior of the room and the interior or exterior of the fantasy world. Similarly, in *Le sang d'un poète* (1930, dir. Jean Cocteau) a young poet is urged by an animated statue to pass through a mirror, which then transforms into a surface of water and allows him to travel back and forth between a kind of alternate dimension. This dimension is filled with other rooms, other interiors to explore, again suggesting further portals and doorways (see image 3.4).

18. Lewis Carroll, *Through the Looking-glass, and What Alice Found There* (London: Macmillan, 1930 [1871]).

Image 3.4: Jean Cocteau, Le sang d'un poète, 1930, film still.

My point is that, to act as devices that reveal the mediateness of the game environment to the player, mirrors should simply be tools of reflection and not portals. That is, the complexity and refinement of video games calls for a downscaling of the mirror to its simplest effect, which is just reflection.

A last aspect emerges here which concerns matters of identity. The moment a character sees itself in the mirror, particularly in first-person perspective, the player sees "himself" in the mirror for the first time. Thus, he must question his identity as player—as a mediated character—and about the relation of these two. French psychoanalyst Jacques

Lacan has done extensive work on the process of apperception of infants and calls the moment of self-recognition a child's "mirror stage."[19] For Lacan, the infant's discovery of the self in the mirror is an important step in the construction of identity, which is processed through difference (oneself to others) and helps babies interpret and cope with the absence of a mother. The moment a player sees "himself," one is recalled of the moment a child sees and recognizes himself. But here, on the contrary, there is a moment of detachment, as the player for the first time consciously realizes he is not the character or exits the illusion the game has created. Here, mirrors again act against the embeddedness of the players and map the space of the game to the actual space. Foucault has extended Lacan's insight by pairing mirror and corpses as devices that help us to perceive the existence of our body.[20] Every time my character dies in a game, I see its corpse on the ground, and I am then projected out of the interior of the game to "game over." We should not forget that the root of "illusion" comes from "in-ludere," to play in. The death of my character then sanctions my "ex-ludere," my exit from the magical world of the game. Mirrors, on the other hand, allow me to experience an exterior during the game, and this is an argument in favor of a more extensive use of them in video games.

19. Jacques Lacan, *Le Stade du miroir comme formateur de la function du Je: telle qu'elle nous est révélée dans l'expérience psychanalytique* (Paris: Presses universitaires de France, 1949).
20. "C'est grâce à eux, c'est grâce au miroir et au cadavre que notre corps n'est pas pure et simple utopie. Or, si l'on songe que l'image du miroir est logée pour nous dans un espace inaccessible, et que nous ne pourrons jamais être là où sera notre cadavre, si l'on songe que le miroir et le cadavre sont eux-mêmes dans un invincible aillleurs, alors on découvre que seules des utopies peuvent refermer sur elles-mêmes et cacher un instant l'utopie profonde et souveraine de notre corps." Michel Foucault, *Les Corps utopique, Les Hétérotopies* (Paris: Lignes, 2009): 19.

Andri Gerber

Bibliography

Borries, Friedrich von, Steffen P. Walz, and Matthias Böttger, eds. *Space Time Play: Computer Games, Architecture and Urbanism: The Next Level*. Basel: Birkhäuser, 2007.

Carroll, Lewis. *Through the Looking-glass, and What Alice Found There*. London: Macmillan, 1930 (1871).

Foucault, Michel. "Des espaces autres." *Empan* 54, no. 2 (2004): 12–19. https://www.cairn.info/revue-empan-2004-2-page-12.htm.

———. *L'archéologie du savoir*. Paris: Gallimard, 1969.

———. *Les Corps utopique, Les Hétérotopies*. Paris: Lignes, 2009.

Galloway, Alexander. *Gaming Essays on Algorithmic Culture*. Minneapolis: Electronic Mediations, 2006.

Götz, Ulrich. "Zugänge zu Zwischengängen—Konstruktion eines räumlichen Modells." In *Digitale Moderne: die Modellwelten von Matthias Zimmermann*, edited by Natascha Adamowsky. München: Hirmer, 2018.

Hoffmann, E. T. A. *Die Serapionsbrüder*, edited by Wulf Segebrecht and Ursula Segebrecht. Frankfurt am Main: Deutscher Klassiker Verlag im Taschenbuch, 2008.

Lacan, Jacques. *Le Stade du miroir comme formateur de la function du Je: telle qu'elle nous est révélée dans l'expérience psychanalytique*. Paris: Presses universitaires de France, 1949.

Menkman, Rosa. *The Glitch Moment(um)*. Amsterdam: Network Notebook Series, 2011.

Panofsky, Erwin. "Jan van Eyck's *Arnolfini* Portrait." *The Burlington Magazine for Connoisseurs* 64, no. 372 (1934): 117–119; 122–127.

Poe, Edgar Allen. "The Philosophy of Furniture." *Burton's Gentleman's Magazine* 6, no. 5, (May 1840): 243–245.

Schwingeler, Stephan. *Kunstwerk Computerspiel—Digitale Spiele als künstlerisches Material. Eine bildwissenschaftliche und medientheoretische Analyse*. Bielefeld: Transcript, 2014.

Teyssot, Georges. "Fenêtres et écrans: entre intimité et extimité." *Appareil*, MSH Paris Nord, École doctorale "Pratiques et théories du sens" (2010). https://doi.org/10.4000/appareil.1005.

———. "Mapping the Threshold: A Theory of Design and Interface." *AA Files*, no. 57 (2008).

Virilio, Paul, and Sylvère Lotringer. "After Architecture: A Conversation." Translated by Michael Taormina. *Grey Room* 3 (Spring 2001): 41.

Virilio, Paul. *A Landscape of Events*. Cambridge, MA: The MIT Press, 2000.

The Hunter and the Horrors
Impossible Spaces in Analog and Digital Immersive Environments

Ágnes Karolina Bakk

Introduction

The rise of immersive experiences is due to many factors. As Pine and Gilmore point out,[1] the way we consume products and services has changed because now we prioritize experiences. In order to create more and more compelling experiences, various brands make use of mechanics that offer unique experiences for their consumers who want to satisfy their hunting attitude.[2] This represents an important milestone in the proliferation of immersive events. While the term "immersive" has increasingly become a marketing buzzword due to the proliferation of VR technologies, the notion of immersivity is also changing in the performing arts.

1. B. Joseph Pine and James H. Gilmore, *The Experience Economy* (Boston, MA: Harvard Business Review Press, 2011).
2. Adam Alston, "Audience Participation and Neoliberal Value: Risk, Agency and Responsibility in Immersive Theatre," *Performance Research* 18, no. 2 (2013): 128–38.

What "immersive" means in the context of an analog or digital stage production is debatable. Nilsson et al. suggest a new typology for the concept, which consists of the following: "(a) immersion as a property of the system, (b) immersion as a response to an unfolding narrative, the diegetic space, or virtual characters, and (c) immersion as a response to challenges which demand the use of one's intellect or sensorimotor skills."[3]

The first type is primarily a manifestation of technological devices which enable virtual environments to respond to a user's actions. Yet the latter two types are also partially psychological. Immersive theatre—leveraging virtual technologies or not—can be considered as such due to how the genre subtly challenges the sensorimotor and meaning-making skills of the audience members, as well as how stage space is utilized in such scenarios.

How to Approach the Concept of Immersion?

When the experiencers step into an immersive environment, they find themselves in a state of "willing suspension of disbelief"[4] that will be followed by "active creation of belief."[5] This latter stage is what Ryan describes as "a process involving the mind, [that] turns the user's sojourn in the virtual world into a creative membership. For an agent embodied in a multi-dimensional environment, selective and productive interactivity can no longer be rigidly distinguished, because navigating the virtual world is a way to bind with it, a way to make it flow out of the acting body."[6] According to Ryan, the key to immersive interactivity "resides in the participation of the body in an art-world," and thus reconciling

3. Niels Christian Nilsson, Rolf Nordahl, and Stefania Serafin, "Immersion Revisited: A Review of Existing Definitions of Immersion and Their Relation to Different Theories of Presence," *Human Technology* 12, no. 2 (2016), 11.
4. A term coined by Samuel Coleridge in *Biographia Literaria* (1817).
5. Janet Horowitz Murray, *Hamlet on the Holodeck: The Future of Narrative in Cyberspace* (New York: Free Press, 1997).
6. Marie-Laure Ryan, *Narrative as Virtual Reality 2: Revisiting Immersion and Interactivity in Literature and Electronic Media* (Baltimore: Johns Hopkins University Press, 2015), 286.

immersion and interactivity "will propose a genuine simulation."[7] But how does the participant identify that they are in a space for simulation—in an immersive simulation—that does not jeopardize the safety of the audience members while still creating a liminal experience?

Erving Goffman's "frame analysis"[8] can help us in this regard. Goffman deeply scrutinizes William James's question, "under what circumstances do we think things as real?" As a possible way to address this, he created the frame analysis, which deals with the issue of how experiences are defined and organized, attempting to explain how various actions are acknowledged, for instance, as "play" or as "serious." If we see two girls, one running from the other one, we see this event as an exercise. This framework is primary as it does not depend on a more fundamental interpretation, and it can be transformed into further scenarios. If we look again, then we can see that one girl is chasing the other one. Here, the primary framework has changed into "they are chasing each other." Goffman calls this transformation "keying," and this can take various forms such as make-believe, practicing or demonstrating. As an addition to keying, another way to transform the meaning of an action is "fabrication," which is an "intentional effort of one or more individuals to manage activity so that a party of one or more others will be induced to have a false belief about what it is going on."[9] A crucial element of keying is that, unlike fabrications, there are no false beliefs involved and the viewers are aware of the transformation.[10]

7. Ryan, *Narrative as Virtual Reality 2*, 286.
8. Erving Goffman, *Frame Analysis: An Essay on the Organization of Experience* (Cambridge, MA: Harvard University Press, 1986).
9. Ibid., 83.
10. Here I won't discuss Goffman's "theatrical frame" concept, as he applies this term to traditional theatre, attributing a crucial function to the 4th wall.

The concept of keying can help us understand the perceptual process taking place when entering an immersive world. We perceive something that happens to us as something impossible, and we wonder about this impossibility while we also feel it as very real—we are the subject of a liminal experience. Yet immersion does not involve fabrication, it does not fool us; rather, we explicitly key this transformation as voluntarily entering into an illusory or fictional world with the aim of being immersed in it.

Immersion as the Sense of Impossibility—Entering Liminal Dimensions

I have argued elsewhere that in putting on a VR headset, "by the combination of the use of 'human interface' with the ritualistic situation of taking on the virtual reality headset, participants can be part of an initiation ceremony, a rite of passage."[11] These rites of passage are characteristic to the situation of switching between worlds, between immersive environments. This switching constitutes the keying in this case: it is not a real liminal experience but represents a threshold.

Here, I will use the concept of liminality as it was defined by Victor Turner as a quality that creates disorientation for the participant when he/she is no longer in the pre-ritual status, but also has not begun the transition yet.[12] Later, I will present case studies where we can see how the creators make use of these keying techniques and how they create various types of liminal experiences and immersive spaces that enable these.

When discussing techniques of engagement, Griffith mentions that spectacles create engrossment by virtue of three defining characteristics "that not only separate them from ordinary two-dimensional representational forms but also come to infuse their very ontologies."[13] These characteristics are the following:

11. Ágnes Karolina Bakk, "Magic and Immersion in VR," in *Interactive Storytelling. ICIDS 2020. Lecture Notes in Computer Science*, ed. Anne-Gwenn Bosser, David E. Millard, and Charlie Hargood (Cham: Springer, 2020), 327–331, https://doi.org/10.1007/978-3-030-62516-0_29.
12. Victor Tuner, "Liminal to Liminoid in Play, Flow and Ritual: An Essay in Comparative Symbology," *Rice University Studies* 60, no. 3 (1974): 53–92.
13. Alison Griffiths, *Shivers Down Your Spine: Cinema, Museums, and the Immersive View* (New York: Columbia University Press, 2013), 285.

1. Remediation: co-opting existing tropes and ways of seeing and "resignify[ing] within stunningly new environments."
2. Reverence: this is the "revered gaze" which is the response of the audience to the recognition of labor and effort involved in creating the spectacle.
3. Fantasy: "The desire to be elsewhere without actually going elsewhere seems to be hardwired into the human psyche as the evidence of centuries both secular and profane culture suggests. Immersive technologies bring that fantasy a bit closer to our reality."

This last characteristic is what constitutes an important perceptual response on the side of the participant. Fantasy is an important factor that can influence how intensely we feel immersed in a space, but this sense of immersion provided by the space can also be due to the remediation phenomenon that one can identify in immersive spaces.

Immersion in Theatre

Immersive theatre can be called a separate genre that does share common traits with theatre but focuses more on the audience and their participation in the process of performance. Bennett suggests that there are developments in sociology of theater parallel to developments in immersive theatre. Audience studies conducted mainly by governmental bodies are increasingly using social science methods. As Bennett states, "the audience has become an important object of study, not necessarily or even frequently motivated by the discourses of theatre studies, nor by our theatre history making, but by the economic realities of the cultural industries."[14] This is leading to a new style of immersive performance genre that appeals to a wider audience and is encouraged not only by the creators but perhaps by all of the stakeholders in the world of theatre, including the audiences and the governmental bodies. One of the inclusive experiences which these new theatre performances can offer is to erase the border between the performer and the audience, transforming

14. Susan Bennett, *Theatre Audiences: A Theory of Production and Reception* (London: Routledge, 1990), 226.

spectators into participants via high levels of interactivity and the illusion of agency. This erosion of the fourth wall is not only happening physically: different performative mechanisms help the audience members step into the magic circle on a cognitive level. These performative mechanisms and design choices, such as 360-degree freedom of movement within a stage space, moments of audience interaction, sensory overloads which offer subtle meaning-making strategies for the audience, and a narrative arc that can promise surprise, help the productions to create a more engaging world[15] and constitute the basis of the burgeoning genre of "immersive theatre." Biggins, relying on a cognitive theatrical approach to stage audiences, states that such immersive experiences "can be defined as a sensation of complete engagement to the point of forgetting anything outside the immediate moment."[16]

Looking at Physical Spaces through the Lens of VR Design

With cinema, animation, and other screen-based experiences, a sense of immersion is manifested by the interweaving of the represented and perceived spaces. With immersive theatre—as within the theme park model—immersion is manifested in a designated space.[17] One of the key factors that can enhance immersion in these spaces is the multilayered space design that creates a certain sense of virtual interiors. In order to create the sense of the multilayered design, the creators take into consideration the specificities of a space and overload it with sensorial and iconic set design elements that have a very strong stylistic characteristic as well as a worldbuilding potential—sometimes having references to the plot as well—and thus enable the participants to feel they are in a maze-like world that has many story potentials to be unfolded.

15. Ágnes Karolina Bakk, "CURATE IT YOURSELF! Game Mechanics and Personalized Experience in the Immersive Performance Installation Strawpeople (Das Heuvolk) by Signa," *Well Played* 10, no. 2 (2021): 116–134, https://doi.org/10.1184/R1/14919645.v4.
16. Rose Biggin, *Immersive Theatre and Audience Experience Space, Game and Story in the Work of Punchdrunk* (London: Palgrave, 2017), 13.
17. Florian Freitag et al, "Immersivity: An Interdisciplinary Approach to Spaces of Immersion," *Ambiances* (2021), https://doi.org/10.4000/ambiances.3233.

A new way of addressing immersive virtual interiors is through the lens of the VR headset itself. Design strategies can be used to create new spatial experiences for interactive and location-based VR experiences which can be adapted for creating physics spatial sensations as well. The analog or mixed-reality performance spaces that I will present below rely on the technical concept of "impossible spaces" (used in VR studies) and offer a new way for us to understand how these immersive productions can create such virtual interiors that seem rather impossible.

Designing Impossible Spaces in VR

Research in spatial cognition shows that people typically form inaccurate cognitive maps "that often contain not graphical, but categorical and hierarchical representation of the given world."[18] Impossible spaces[19] refer to a design mechanic for virtual environments which aims at maximizing the virtual space in which the experiencer navigates. These spaces are virtual environments "that violate the laws of Euclidean space and because of that cannot exist in the real world."[20] In VR, this concept applies especially to environments that employ natural locomotion, for example, productions which incorporate self-overlapping architectural layouts and create a maze-like trajectory for the experiencer. Fitting large virtual environments into smaller physical spaces, where participants are guided in their physical location in a way that they do not encounter the boundaries of the world, is also another sense of spatial impossibility. All contribute to more seamless expressions of virtual reality by using redirection techniques.

18. Khrystina Vasylevska, Hannes Kaufmann, Mark Bolas, and Evan Suma Rosenberg, "Flexible Spaces: A Virtual Step Outside of Reality," *2013 IEEE Virtual Reality* (VR) (2013), 109.
19. Evan Suma et al, "A Taxonomy for Deploying Redirection Techniques in Immersive Virtual Environments," *2012 IEEE Virtual Reality Workshops* (VRW) (2012): 43–46, https://doi.org/10.1109/VR.2012.6180877.
20. Ibid., 44.

Suma et al. identify various types of redirection techniques that can be used when designing a digital virtual environment with the aim of creating the sense of impossible space. By taking into consideration several aspects such as geometric applicability, noticeability to the user, and content-specific implementation details, the researchers identify two primary modes of redirection: *repositioning* and *reorientation*.

Repositioning techniques are continuously translating the virtual environment about the user's position, which "allows the user to walk to areas in the virtual environment that were not previously accessible within the confines of the physical workspace. This may be disorienting if the virtual world is translated unexpectedly, and may make the virtual environment even appear unstable."[21]

The reorientation technique is used in VR when the user reaches the boundaries and then is instructed to turn around during which a rotation gain is applied.[22]

This latter technique can be used only in the case of digital environments, while the first one can be identified in several immersive artistic productions. I will point out that the repositioning technique can be identified in immersive productions as a sense of impossibility, and this is possible due to the remediated characteristic of immersive productions. Before I analyze these spaces, it will be useful to clarify what I mean by the sense of embodiment that helps the participant to feel present in these spaces.

Sense of Embodiment in VR and Analog Spaces

Having a sense of presence in VR can enable the users to feel as though they are in a virtually impossible space, and this presence is often discussed in the literature. Here, I rely on a particular understanding of the illusion of embodiment in VR that can be adapted to the sense of embodiment in analog and in mixed-reality immersive spaces as well. In their

21. Ibid., 44.
22. Suma et al, "A Taxonomy for Deploying Redirection."

analysis of "the sense of embodiment," Kilteni et al.[23] rely on the concept of a "strong sense of presence" that helps to define the term and characterize the sense of self-representation required for the sense of immersion as being constituted by the following elements:

1. The Sense of Self-Location: defined as one's spatial experience of being inside a body and which involves "the relationship between one's self and one's body," while presence is "the relationship between one's self and the environment."

2. The Sense of Agency: defined as the feeling of having "global motor control, including the subjective experience of action, control, intention, motor selection and the conscious experience of will."[24]

3. The Sense of Body Ownership: defined as the feeling of the body as being the source of the experienced sensation and one's self-attribution of a body.[25]

All these elements can be enhanced by using synchronous visuotactile correlations, "where the tactile event is seen visually on the body from the first-person perspective position of the eyes"[26] with haptic feedback or with individualized avatars that could strengthen the feeling of ownership. This visuotactile correlation can be used even more—as expected—in physical environments as a part of the set design, especially when the audience's attention is guided in a way that enables the audience members to observe the overlapping of the multisensorial elements. In the following section I present two case studies that create the sense of impossible space in physical environments with the help of multilayered spatial design by relying on the elements of New Horror and the mechanisms of science of magic.

23. Katerina Kilteni, Raphaela Groten, and Mel Slater, "The Sense of Embodiment in Virtual Reality," *Presence: Teleoperators and Virtual Environments* 21, no. 4 (2012): 373–387.
24. Olaf Blanke and Thomas Metzinger, "Full-Body Illusions and Minimal Phenomenal Selfhood," *Trends in Cognitive Science* 13, no. 1 (2009): 7–13, https://doi.org/10.1016/j.tics.2008.10.003.
25. Manos Tsakiris, Gita Prabhu, and Patrick Haggard, "Having a Body Versus Moving Your Body: How Agency Structures Body-Ownership," *Consciousness and Cognition* 15, no. 2 (2006): 423–432. https://doi.org/10.1016/j.concog.2005.09.004.
26. Ray Hyman, "The Psychology of Deception," *Annual Review of Psychology* 40 (1989): 133–154.

Case Studies in Analog and Mixed-Reality Immersive Spaces

Senses of impossibility can also be found in analog (traditional) immersive performances. For example, space can be utilized to disorient the audience. I use the term "virtual interiors" in the sense that the participants encounter these interiors as an enlarged space enabled by an approximation of the sense of lucid dreaming and of impossibility. This way, these elements of space design can change our mental map about these spaces by disorienting the audience members, making them feel lost. Creating a disorienting space can be a challenge for designers as spatial possibilities are often limited by physical borders and by the narrative framework.

Here are two cases to consider in the context of analog and mixed-reality spaces:

The Open Heart (2019) was created by Danish-Austrian theatre company SIGNA, and it is an example of an analog immersive experience. The performance was enacted in an actual hospital building in Aarhus, Denmark, on one of its floors. When entering the structure, participants were greeted as visitors who were there to learn about the suffering of others and—in a storytelling conceit—take the capacity to suffer away from the hospital residents. Participants were required to change clothes (including their undergarments) upon entering. Each performer then guided and mentored two participants throughout a twelve-hour performance. The set design of the various spaces was overcrowded and disorientating. The performers used various types of pace-changing and attention capturing techniques to ensure that participants had difficulty forming a realistic mental map of the spaces. Meanwhile, throughout the twelve hours, various grotesque and violent acts were performed: actors ate from filthy surfaces and some performers hurt themselves in close proximity to participants. SIGNA also set up dormitory areas where tired audience members could sleep, yet these spaces were also crowded and uncomfortable. Besides the violence, various picturesque elements from horror films were reenacted, such as being woken up by a performer wearing a pig-head mask or seeing performers in a trance caused by acts of violence.

An example of a mixed-reality immersive experience is *SOMNAI* (2018), created by American-New Zealand creative studio DOTDOT. In the performance, participants step into a building which appears to be a plain warehouse. They are greeted by an actor dressed in white who immediately offers non-alcoholic cocktails or bonbons. After presenting tickets, depositing personal items and smartphones in the cloakroom, and removing footwear, all are invited into a changing room, where those who wish can put on a bath gown. The participants are then divided into groups of six. They step into a room that radiates the atmosphere of a New Age cult: silent music, scents from various candles, and a very welcoming woman initiating a conversation. She asks about the participants' dream histories and explains that, in this sanatorium, one can master the skill of lucid dreaming—of remaining asleep yet aware of one's dream. The woman also tells a story of a nervous little boy who will do anything to fulfill his mother's (imagined) expectations. But he has lost his white handkerchief. As the woman tells this part of the story, she discreetly puts a handkerchief into the pocket of one of the participant's bath gowns. Thus begins a rushed experience of being shown through various analog and digital immersive spaces, and the resulting sensory overload leaves only blurred memories of the experiences. The performance takes place throughout a two-story venue in which the participants are guided by actors. The dramaturgical rhythm of the actions is not unified; there are moments of waiting and contemplation, especially when the audience encounters various screens and projections or when they are putting on VR headsets. Like with *The Open Heart*, here the creators have used many picturesque elements of New Horror. A performer playing a young boy (as in the woman's story) runs through hallways and demonstrates various magic tricks in a children's room with automated toys (swinging ponies and scary rabbits). All the spaces that participants are hurriedly guided through have designs evoking the 1970s and 1980s, recalling the look and feel of classic New Horror films.

Looking Back at the Multisensorial Effect of Horror Movies

It is important to note that in many cases, as in those above, the sense of immersion can be enhanced on a sensory level by the effects of the horror genre. The genre of horror, together with melodrama and pornography, is called a "body genre" by cinema theorist Linda Williams. She suggests this term because for her these genres go to extremes in their representation of the human body in distress or ecstasy. In these movies, as an audience perceives a (usually female) body they become "caught up in an almost involuntary mimicry of the emotion or sensation of body on the screen."[27] The cinema viewer experiences a kind of sensory empathy with the characters through both pleasure and pain, and the revulsion or elation felt is a large part of the appeal. Many film scholars point out how cinema has a multisensorial element, and the experiential film aesthetic gains a more emphasized presence with many interpretation possibilities about how movies can create sensorial experiences. Luis Rocha Antunes describes the experiential film, which for him implies:

> . . . not only the result of formal and compositional elements of style, narrative and themes but also the result of the intersection of those elements (especially film style created through camerawork, editing, light, colour and sound design) and our perceptual, multisensory nature as spectators. Our perceptual experience of a film is thus not a mechanistic method of receiving, processing and integrating a film's sensory information, but rather an active, dynamic set of perceptual processes that are proactive and creative (although its autonomic levels are not within the reach of our conscious control).[28]

According to Antunes, movies and similar media can elicit very strong responses from the vestibular system—the part of our inner ear which regulates balance and spatial orientation. He states that "cinematic walking demonstrates the possibility of an immersive experience of walking with a vestibular basis."[29] Antunes offers a thorough analysis of walking in film and emphasizes that while some movies demonstrate characters walking in ways which enhance the audience's sense of orientation and

27. Linda Williams, "Film Bodies: Gender, Genre, and Excess," *Film Quarterly* 44, no. 4 (1991): 374.
28. Luis Rocha Antunes, *The Multisensory Film Experience: A Cognitive Model of Experiential Film Aesthetics* (Bristol-Chicago: Intellect, 2016).
29. Ibid., 52.

balance, others do not. Movies can easily disorient us spatially because not only are they flat imagery, but we as an audience also lack kinetic agency completely: we're stuck in our seats. In general, loss of orientation is a side effect in film, and it enhances fearful elements in some horror movies.[30] The level of the kinesthetic engagement is higher in horror movies due to the genre's stronger sensorial characteristic. Losing the sense of orientation can enhance the effect of horror movies and can result in heightening the sensorial response of the viewer, creating more confusion and harsher responses to the expected horrific events that are manifested through the picturesque effects of New Horror.[31]

In her book *The Horror Sensorium*, Angela Ndalianis states that "[t]he spaces of horror media not only fictionalize—in vividly sensory ways—their own sensorium, but they also demand that we cognitively and physiologically respond to their fictions by translating their sensorial enactments across our bodies."[32] According to Ndalianis, New Horror films are a type of newly made horror film produced after 9/11 which, even though they belong to the experience economy era by offering sensorial and often haptic experiences, feel less real than the earlier horror productions. Immersive theatre performances have to directly engage multiple senses of the participants, and through this they can create very striking physical responses.[33] For Ndalianis, these horror films create a similar physicality because, "as a genre, [horror is] capable of intensifying the range of reactions and experiences in which we can become enmeshed when connecting with media texts and, over the last decade in particular, the proliferation of horror texts across media have amplified their focus on sensory encounters."[34] In the case of the cinematic medium, the horror environment constitutes the "aesthetic of disgust. In SIGNA's performance, the participants gain experience through 'carnal elements' such as sweat, saliva mixed with dirt, real time violence, and

30. See Antunes's analysis of the films of Gus Van Sant in *The Multisensory Film Experience*.
31. Angela Ndalianis, *The Horror Sensorium: Media and the Senses,* (Jefferson: McFarland & Co, 2012).
32. Ibid., 3.
33. This portion has been published before in Bakk, "CURATE IT YOURSELF!"
34. Ndalianis, *The Horror Sensorium*, 6.

also taxidermies." We can say that these "sources of disgust boost the hunting attitude of the audience, and it is this attitude that actually guides the experiencer through the performance space and unfolding story."[35]

Remediating Horror Movies in Immersive Spaces

The continuous disgust one encounters in almost every room in *The Open Heart* enhances the expectation of the next shocking element in yet another room. This disturbs the participants' attention and disrupts their sense of spatial orientation. It is not coincidental that immersive experience designers at companies like SIGNA and DOTDOT also rely on remediated picturesque elements of horror. As a defining characteristic of many new mediums, the act of remediation as described by Jay Bolter and Richard Grusin "ensures that the older medium cannot be entirely effaced; the new medium remains dependent on the older one in acknowledged or unacknowledged ways."[36] In this case, the immersive theatre makers rely on the remediation of horror elements (as Ndalianis also identifies in the context of dark rides), and they also use predefined trajectories in order to further enhance the sense of disorientation. In this way, they create a kind of impossible space that can seem bigger than the current physical space where the participant is located.

This sense of impossible space can be created by using a fixed trajectory for the audience members where the audience is invited to become an active participant in exploring the space by following a trajectory. This predefined scenography gives a sense of "impossible physical space" which the audience maps out with a special type of body awareness and proprioception. Benford and Giannachi define "trajectory" as the road of the spectator through the mixed-reality performance.[37] We can see that the spectacular character of the interfaces, the dramaturgy of various technologies (meaning how they follow each other), and the care-

35. Ágnes Karolina Bakk, "Sending Shivers Down the Spine: VR Productions as Seamed Media," *Acta Universitatis Sapientiae Film and Media Studies* 17, no. 1 (2019): 217.
36. J. David Bolter and Richard A. Grusin, *Remediation: Understanding New Media* (Cambridge, MA: The MIT Press, 1999), 47.
37. Steve Benford and Gabriella Giannachi, *Performing Mixed Reality* (Cambridge, MA: The MIT Press, 2011).

ful spatial guidance enhanced by the strict trajectory do not offer too many options to the members of the audience. The act of onboarding is one of the special elements of trajectories. Onboarding constitutes the preparatory phase which precludes the audience members stepping into an immersive space. In the very act of starting or finishing a VR production or stepping into an analog or mixed-reality immersive theatre experience, all the actions that are accompanying these acts can have a performative effect (this is why all these environments should have the potential to be interactive), which is a characteristic of the medium of performance. The participants of a VR production here enter the "magic circle"—a concept used in Live Action Role-Playing (LARP) design practices which refer to the participants' entering the storyworld of a LARP. The magic circle is the protocol where the LARP game starts or ends (in a physical, temporal sense as well), and in this protocol there are various rules pre-established by the given LARP's framework. This strategy is very similar to an actual magic trick: it is essential for the magician to convey relevant information about the conditions that are, seemingly, raising the chances of something impossible being about to happen.[38] In this way, the magicians are embedding the trick into a storyworld that enables the audience to perceive the trick as an impossible act. This act of embedding, which we can also call "onboarding" in this context, is an initiation stage of an experience that takes place in an immersive environment. For this process, creators can also use stage mechanisms developed by magicians that are described by the science of magic in detail. This interdisciplinary area studies the use of magic tricks and their effects on our cognition and perception, which can offer valuable insights for various types of experience design. The onboarding process can also borrow practices from the science of magic by making use of attention framing techniques, forcing techniques (e.g., the method of controlling a choice made by a spectator during a trick), and pseudo-explanations.

38. Peter Lamont, "A Particular Kind of Wonder: The Experience of Magic Past and Present," *Review of General Psychology* 21, no. 1 (2017): 1–8.

Besides relying on the previously mentioned mechanism, these productions exploit space in a way similar to Disneyland: the theme park "draws its power to entertain an international audience of all ages from its skillful incorporation of aesthetic effects that find their resonance in the visitor's genetically inherited ancestral memories—a nostalgia of considerably longer standing and more compelling power than a childhood devotion to Dumbo."[39] Especially in case of SIGNA's performance, the audience members enjoy an ongoing visuotactile input which promises a new layer of the storyworld to be unfolded by exploiting the hidden and less hidden corners of the immersive space, creating a sense of impossible space.

The concept of an impossible space, I believe, can also be applied to analog and mixed-reality spaces, mainly for these reasons:

1. In the case of VR productions experienced via headset, the user is presented with a technologically pre-designed sense of presence. The rendering of the images follows the body movements of the user, and these images provide immediate feedback if they interact with the virtual environment. The third characteristic—the sense of body ownership—in this case means that the user identifies themselves with an avatar image synchronized to a certain degree with their actual bodily movements.

2. In both analog and mixed-reality environments, these properties are still highly relevant but should be reinterpreted. In the case of mixed-reality performances where VR and/or AR productions are blurred with analog spaces, the following conditions should be fulfilled in order to enable the participants to experience a sense of embodiment. Sense of self is here tied to physical space: while virtual experiences might be embedded in a mixed-reality performance (like in the case of *SOMNAI*), participants orient their bodies to actual rooms with physical walls. On the other hand, the designated spaces in such environments

39. Charlie Haas, "Disneyland is Good for You," *New West Magazine*, December 4, 1978, https://www.dix-project.net/item/1633/new-west-magazine-disneyland-is-good-for-you.

where virtual or augmented reality spaces manifest can be considered as portals to another reality, meaning a magical entry point. The sense of agency might be limited in these cases, but the agency, when encountering such experiences, can be analyzed as the ability of the participant to switch between the digital and the analog environments. The sense of body ownership is manifesting in a different way than in the case of VR: as the digital and analog environments have a different effect on the experiencer, the perceptual system of the experiencer is carrying out an active sense-making procedure by which the proprioceptive senses of the participants can merge the two types of experience and become much more sensitive, this way also raising the experiencer's sense of body awareness.

In the case of analog performances (such as *The Open Heart*), the sense of self-location can be interpreted as such: the participant should localize their body in relation to the overall space of the immersive production. They should be able to construct a certain type of mental map, which can later be re-written or re-interpreted depending on how the participant's perception confirms or gets confused by the initial mental map. The sense of agency in these spaces means that the audience members not only have the possibility to move around, but also to have some agency on the narrative and to be in control of what experiences they want to gather throughout the production.[40] As for the sense of body ownership, in digital cases, a heightened level of immersion is established if the system is designed in such a way that enables the participant to identify oneself with the virtual body—which is obviously not a requirement for analog cases—as we (leaving aside pathological cases) identify ourselves with our physical bodies. However, a heightened level of awareness of one's own body can be brought on by all the sensorial aspects of the virtual interiors of an analog immersive space that can have an effect on the body.

40. See Alston, "Audience Participation and Neoliberal Value."

Conclusion

In some cases, immersive performances can be interpreted as theme parks[41] and as video games, especially due to the mechanics they use in their world-building procedure. They build on a specific sense of immersion that I have defined with the help of impossibility: one is transported into a virtual environment that requires the participant to accept this impossible event. In order to familiarize the audience members with the fictional world of the performance in the quickest way, creators use various initiation and guiding techniques and rely on well-known film genres that can help the audience understand their role. One of the easiest solutions to establish this is to rely on the horror movie genre, maintaining the audience members' sense of moving throughout a space with the hope (and fear) of witnessing an act of violence with a feeling of safety, as they know that nothing can happen to them. According to Alston,[42] the participants of these experiences often have a neoliberal hunting attitude of being responsible for their own luggage of experiences and they are easily guided by various attention-manipulating mechanics. He further states that the immersive productions often mirror the neoliberal value set and so they also address the participant's sense of risk that manifests in the hunting attitude. This and the horror effects (that many of these productions use) create a special type of somaesthetic experience. Somaesthetics encompass the theoretical, empirical, and practical disciplines related to the bodily perception and performance. In the case of these productions, the sense-making through the special design that mobilizes the experiencer's body creates a long-term effect in the body that enhances the sense of presence. This sense of presence becomes stronger as the horror triggers dopamine and adrenalin, and, as a result, a heightened effect of participation and risk taking can be observed.

41. Ágnes Karolina Bakk, "How Interactivity Is Changing in Immersive Performances," in *Interactive Storytelling. ICIDS 2017. Lecture Notes in Computer Science*, ed. Nuno Nunes, Ian Oakley, and Valentina Nisi (Cham: Springer, 2017).
42. Alston, "Audience Participation and Neoliberal Value."

These effects and mechanics lead to a sense of impossible space, as the experiencers are immersed in the fictional space of the production—in the virtual interiors—rather than attending to the architectural and spatial characteristics of the actual, limited physical space. Some other mechanics that enable the audience to follow the trajectory designed for them can be better understood and framed with the help of the science of magic such as forcing techniques (e.g., used during onboarding) which create specific types of liminal spaces and a specific type of sense of embodiment that is required when stepping into the virtual environment and the impossible space.[43]

The concept of impossible space applied to designing physical immersive experiences can be a novel approach to enhance the engagement of the participants. It requires a thorough overview of the storyworld but also a deep understanding of what feelings the creators intend to enable by their productions. Immersive theatrical experiences, and installations as well, can acquire a new significance by creating a novel sense of liminal space that engages the experiencers' senses and allows them, through the maze-like experience, to have new encounters and learn more about the world and themselves.

43. I would like to express my gratitude to Işık Sarıhan for taking care of my texts and also of the versatile approaches indicated in my thought experiments.

Bibliography

Alston, Adam. "Audience Participation and Neoliberal Value: Risk, Agency and Responsibility in Immersive Theatre." *Performance Research* 18, no. 2 (2013): 128–38. https://doi.org/10.1080/13528165.2013.80717710.1080/13528165.2013.807177.

Antunes, Luis Rocha. *The Multisensory Film Experience: A Cognitive Model of Experiential Film Aesthetics*. Bristol-Chicago: Intellect, 2016.

Bakk, Ágnes Karolina. "CURATE IT YOURSELF! Game Mechanics and Personalized Experience in the Immersive Performance Installation Strawpeople (Das Heuvolk) by Signa." *Well Played* 10, no. 2 (2021): 116–134. https://doi.org/10.1184/R1/14919645.v4.

———. "How Interactivity Is Changing in Immersive Performances," In *Interactive Storytelling. ICIDS 2017. Lecture Notes in Computer Science*, edited by Nuno Nunes, Ian Oakley, and Valentina Nisi. Cham: Springer, 2017.

———. "Magic and Immersion in VR." In *Interactive Storytelling. ICIDS 2020. Lecture Notes in Computer Science*, edited by Anne-Gwenn Bosser, David E. Millard, and Charlie Hargood, 327–331. Cham: Springer, 2020. https://doi.org/10.1007/978-3-030-62516-0_29.

———. "Sending Shivers Down the Spine: VR Productions as Seamed Media." *Acta Universitatis Sapientiae Film and Media Studies* 17, no. 1 (2019): 143–156. https://doi.org/10.2478/ausfm-2019-0020.

Benford, Steve, and Gabriella Giannachi. *Performing Mixed Reality*. Cambridge, MA: The MIT Press, 2011.

Bennett, Susan. *Theatre Audiences: A Theory of Production and Reception*. London: Routledge, 1990.

Biggin, Rose. *Immersive Theatre and Audience Experience Space, Game and Story in the Work of Punchdrunk*. London: Palgrave, 2017.

Blanke, Olaf, and Thomas Metzinger. "Full-Body Illusions and Minimal Phenomenal Selfhood." *Trends in Cognitive Science* 13, no. 1 (2009): 7–13. https://doi.org/10.1016/j.tics.2008.10.003.

Bolter, J. David, and Richard A. Grusin. *Remediation: Understanding New Media*. Cambridge, MA: The MIT Press, 1999.

Freitag, Florian et al. "Immersivity: An Interdisciplinary Approach to Spaces of Immersion." *Ambiances* (2021). https://doi.org/10.4000/ambiances.3233

Goffman, Erving. *Frame Analysis: An Essay on the Organization of Experience*. Cambridge, MA: Harvard University Press, 1986.

Griffiths, Alison. *Shivers Down Your Spine: Cinema, Museums, and the Immersive View*. New York: Columbia University Press, 2013.

Haas, Charlie. "Disneyland is Good for You." *New West Magazine*, December 4, 1978. https://www.dix-project.net/item/1633/new-west-magazine-disneyland-is-good-for-you.

Hyman, Ray. "The Psychology of Deception." *Annual Review of Psychology* 40 (1989): 133–154.

Kilteni, Katerina, Raphaela Groten, and Mel Slater. "The Sense of Embodiment in Virtual Reality." *Presence: Teleoperators and Virtual Environments* 21, no. 4 (2012): 373–387. 10.1162/PRES_a_00124.

Lamont, Peter. "A Particular Kind of Wonder: The Experience of Magic Past and Present." *Review of General Psychology* 21, no.1 (2017): 1–8. https://doi.org/10.1037/gpr0000095.

Murray, Janet Horowitz. *Hamlet on the Holodeck: The Future of Narrative in Cyberspa*ce. New York: Free Press, 1997.

Ndalianis, Angela. *The Horror Sensorium: Media and the Senses*. Jefferson: McFarland & Co, 2012.

Nilsson, Niels Christian, Rolf Nordahl, and Stefania Serafin. "Immersion Revisited: A Review of Existing Definitions of Immersion and Their Relation to Different Theories of Presence." *Human Technology* 12, no. 2 (2016), 108–134. https://doi.org/10.17011/ht/urn.201611174652.

Pine, B. Joseph, and James H. Gilmore. *The Experience Economy*. Boston, MA: Harvard Business Review Press, 2011.

Ryan, Marie-Laure. *Narrative as Virtual Reality 2*: *Revisiting Immersion and Interactivity in Literature and Electronic Media*. Baltimore: Johns Hopkins University Press, 2015.

Suma, Evan et al. "A Taxonomy for Deploying Redirection Techniques in Immersive Virtual Environments." *2012 IEEE Virtual Reality Workshops* (VRW), (2012): 43–46. https://doi.org/10.1109/VR.2012.6180877.

Tsakiris, Manos, Gita Prabhu, and Patrick Haggard. "Having a Body Versus Moving Your Body: How Agency Structures Body-Ownership." *Consciousness and Cognition 15*, no. 2 (2006): 423–432. https://doi.org/10.1016/j.concog.2005.09.004.

Tuner, Victor. "Liminal to Liminoid in Play, Flow and Ritual: An Essay in Comparative Symbology," *Rice University Studies* 60, no. 3 (1974): 53–92.

Vasylevska, Khrystina, Hannes Kaufmann, Mark Bolas, and Evan Suma Rosenberg. "Flexible Spaces: A Virtual Step Outside of Reality." *2013 IEEE Virtual Reality* (VR) (2013). https://doi.org/10.1109/VR.2013.6549386.

Williams, Linda. "Film Bodies: Gender, Genre, and Excess." *Film Quarterly* 44, no. 4 (1991): 2–13.

Simulation Arts and Causality Montage
Miracle as Metaphor

Deniz Tortum

Simulation Arts: Strange Physics as a Medium

A new type of image appears more and more frequently in our media environment. Hyperrealistic visually, and yet utterly impossible, these animations and models play with and undermine our expectations for the behavior of material in the world. Where hard bodies are soft bodies, where glasses don't break but break things, where everything solid turns out to be inflatable. A world constantly in motion, a world we are not sure of. It is what it is not. Some examples of this are Ed Atkins's piece *Safe Conduct*, where a man at airport security keeps removing parts of his body to put into the X-ray machine; Albert Omoss's *Forms*, where human bodies come together and form new fluid colonies; and John Gerrard's *Western Flag*, where a flag is formed out of perpetually-renewing black smoke at the simulated sight of world's first major oil find.

Works in this vein are widely varied, but they share the use of certain software in their construction and thus certain aesthetics made accessible by this software. Unlike traditional animation, which has also easily bent reality, this cohort of work relies on the existence—and modification—of a computational representation of reality. Thus, I will call them "simula-

tion arts."[1] Simulation arts are works that use physics engines. Simulation arts can be real-time as seen in video games or virtual reality experiences or pre-rendered as seen in film or video art. This term is not about what the media is, for example, digital animation or interactive media, but more about how it is produced through the extensive use of physics engines which enable "simulations" of rule-based reality.

These types of work can employ a technique I propose to call causality montage that uses tools of physics simulation, not to simulate reality, but to depict and imagine phenomena that are difficult to perceive or don't exist in reality. In this chapter, I also look at causality montage as a mechanism to apprehend issues pertaining to the climate crisis, a highly urgent condition we live in where human comprehension is mediated and difficult.[2] We don't understand the complexity of the earth system and how our actions affect and influence change. Before exploring examples of causality montage, I will lay out more specifically what is involved in creating works of simulation arts.

Causality Montage: Cause and Effect Remapped

In simulation arts, the physics of the world are arbitrary and can be changed using physics engines. Physics engines are found in diverse software, from game engines such as Unreal Engine to animation software such as Cinema 4D. A physics engine is a set of rules that govern the universe of the project, though they generally begin or have standard settings "out of the box" that are identical to our physical world. A creator working with these tools can easily change the physics of the game world by modifying a few parameters. For example, a creator can change how the sun moves, the gravitational constant, and how different objects interact with each other: do solids carom off each other, pass

1. There are several degree programs with "Simulation Arts" in their name, but as far as I know, there is no definitive description of what simulation arts is. It is often used interchangeably with "games." We still lack a broader term to describe work that is created using game engines and simulation-based animation software; because of that lack, I use simulation arts in this chapter.
2. Timothy Morton's concept of the "Hyperobject" is very useful in thinking about the complexity and incomprehensibility of climate change. See Morton, *Hyperobjects: Philosophy and Ecology after the End of the World* (Minneapolis: University of Minnesota Press, 2013).

through one another, accrete? A physics engine allows artists to modify the "physical" behavior of the game world or simulation. Put differently, an artist can take very fundamental elements of "cause and effect," and use that "causality" for artistic aims. This may mean drawing relationships between the laws of physics and other elements of the world or the characters residing within it. Because most people have an intuitive grasp of physical cause and effect, changing or modifying that creates a new sensation along the lines of a physical or performative metaphor created with the environment. Thus, a physics engine allows artists to modify and create causality for artistic aims, leading to causality montage.

Causality montage is a narrative technique where cause and effect are changed in a simulated environment.[3] Similarly to the dialectical meaning created in film montage through the juxtaposition of disparate images and sounds, a novel and dialectical meaning can be created through causality montage. Instead of juxtaposing images, the artist juxtaposes disparate causes and effects, such that the participant sees the causality as a creative decision intended to convey a meaning, no matter how contradictory, elusive, or disparate it is.

Simulation Arts and Extro-Science Fiction

The first time the idea of causality montage started to take root in my mind was when I watched Anne Macmillan's video work *Open Seating* (2015).[4] In *Open Seating*, the camera moves in a mostly empty room: several steel folding chairs are sparsely scattered around the room, far apart from each other. As the camera (and the observer) moves closer to the chairs, and as the gaze of the camera focuses on the chairs, the chairs rotate around in their place according to the camera's position. The camera is never able to see the front of the chairs and always looks at their backs. The chairs never show their faces to the camera, or to us, the audi-

3. I have previously proposed the term "embodied montage," a narrative technique in virtual reality for creating new relations between the body and the environment. Embodied montage is not only possible in virtual reality but also in other simulation arts. Causality montage is a more descriptive term for this broader application. See Halil Deniz Tortum, "Embodied Montage: Reconsidering Immediacy in Virtual Reality" (master's thesis, MIT, 2016).
4. http://www.annemacmillan.com/#/openseating/.

ence. Chairs in everyday life are not animated by the gaze of a viewer, but in this piece they are. The physics engine binds the rotation of the chair to the viewer's gaze, and this new physics is intentional and part of the artistic gesture. This in-universe physics creates a new causality where chairs move in response to the viewer's attention by some novel but invisible force.

Turning back to how simulation arts and causality montage are urgent in the present moment, I want to discuss the relationship between simulation and climate crisis. The climate crisis is primarily revealed to us via simulations. "Simulations are necessary precisely because there is no real climate in itself, no hyperobject called global warming," writes Mark B.N. Hansen.[5] Climate change is only understood through our tools of measurement, collected weather data, and simulations that provide probability about future events.[6] The unique, sprawling, and somehow imperceptible new reality of climate change is perceived in its real scale only through simulations. Therefore, artistic work grappling with it can uniquely benefit from also seizing the "simulation" as its medium. What tools and resources do simulation arts provide us in order to think about the climate crisis?

In *Science Fiction and Extro-Science Fiction*, Quentin Meillassoux proposes a new literary genre: the extro-science fiction. Science fiction, he writes, "implicitly maintains the following axiom: in the anticipated future it will still be possible to subject the world to a [sic] scientific knowledge."[7] But what if the underlying laws of the universe were changing, such that science is not reproducible anymore, that our ability to predict events no longer exists, that the future would not resemble the past?[8] This genre would have the power to explain the world we live in: the world in climate crisis, where everything we know slips under our feet as we enter a period of terra incognita. The works that I discuss here can be seen

5. Mark B.N. Hansen, "Media Entangled Phenomenology," in *Philosophy after Nature*, ed. Rosi Braidotti (London; New York; Lanham: Rowman & Littlefield International, 2017), 92.
6. Ibid., 92–94.
7. Quentin Meillassoux, *Science Fiction and Extro-Science Fiction*, trans. Alyosha Edlebi (Minneapolis, MN: Univocal, 2015), 5.
8. Ibid., 5–6; 37–38.

as extro-science fiction, as training modules for the Anthropocene and spaces for contemplating the impossible. They depict a world in which every action—walking, staring at objects, opening doors—can have a new consequence: nothing is stable with causality montage.

To return to *Open Seating*, this work would have been more difficult to imagine without software that has physics engine capabilities.[9] An artist, spending a lot of time with the software's interface and becoming familiar with its capabilities and properties, can see how this engine, intended to make realistic physics possible for game developers, can be used as a tool for expression. Because of how a physics engine works, every object in this virtual space has a relationship to all other objects, a rule set about how they interact. This could either be pre-set by the software or intentionally set by the artist. Defining such a relationship, akin to the relationship between the camera and the chair, has become part of an artist's toolkit with software like Cinema 4D, Blender, or Unreal Engine.

In *Open Seating*, the relationship is defined as follows: the rotation of the chair is connected to the position of the camera. In other words, the camera position affects the chair rotation. This is already a new perspective on virtual objects, one that requires an artist to make a conceptual leap: the virtual gaze itself, though it is by default a massless entity, can also be included in the physical rules of the environment. With physics engines, relationships between different virtual bodies have become straightforward to experiment with and modify, to play with and try new relationships out. This question of "why not?" makes the work possible. You can imagine an artist, experimenting with a physics engine, asking: If we set such a relationship between the observer and the chair, what would be the result? What type of affective feelings could it inspire? Would we believe that a chair can have this kind of responsiveness, such that it almost seems alive or has some agency? What would a chair with agency look like? How does it make us feel when the chair turns away from us?

9. It could technically be accomplished in older animation techniques, such as stop motion, or CGI. Alternative physics exist in partial in mythology, architecture (from Trompe l'oeil effects to upside down Wonderwork attractions), magic tricks, futurist novels, cartoons (from Road Runner to Tom and Jerry), and films (from Star Wars to Marvel). A key difference here, however, is that alternative physics becomes the foundational aesthetics through the use of physics engines.

Does it turn with embarrassment, with anger, with shame—what is it? If we throw a chair, we expect it to go a short distance, fall or otherwise hit the ground, and act predictably. When there are new causalities, we find ourselves at a starting point: what is governing the chair's movement? Is it us? The chair itself? The new causality imbues the relationship with possibility.

In *Open Seating*, this unexpected and fresh relationship between the chair and the observer is almost like a new law of nature. In fact, it is a law of nature within the world of the video. Like flowers turning to face the sun, or the fact that we never see the dark side of the moon from the Earth, it is a new causality. The position of the viewer's camera causes the chairs to swivel. What does this new causality in the world of *Open Seating* mean? Is it a metaphor? It has poignancy, but, for me at least, its meaning is both evasive and somehow expansive. The novel aesthetic of the piece offers us a productive ambiguity and a wide range of possible meanings. What could a larger world be like where this is the order of things? A world where agency is not only limited to humans, but in which even an object we consider inanimate and banal, like a chair, can respond to us.

Embodied Meaning

Causality montage can provide us with tools to think about non-human agency and invisible causality. It also helps us to understand the world through the logic of simulation. In reverse, it can help us to recognize where and how the world already runs on the logic of simulation. Causality montage can go beyond understanding and recognition and create experiences and works that break out of the current mold. Perhaps it is a way to think new thoughts, create new embodied metaphors, new miracles, and contribute to a foundation for a reconceptualized relationship to the world we inhabit

Viewing Rachel Rossin's virtual reality piece *The Sky is a Gap* (2017)[10] through this lens helped to clarify and reinforce this aesthetic technique of causality montage, as well as provide another example of its use. In this piece, when the viewer puts on the VR headset, they find themselves in a room.[11] Although they don't know it yet, this room is in the midst of an explosion. As long as the viewer remains stationary, the room also remains stationary. However, if the user walks forward, the room begins to explode. When they walk backwards, the explosion reverses: the room "de-explodes," moves backwards, and becomes whole again. This is an impossible spatio-temporal logic as the viewer's position in the room is tied to the progression of the explosion. Walking is the cause of time moving either forward or backward. In everyday life, this is certainly not a cause and effect of physics we expect, but, in this simulation, physics is re-organized around this new relationship: walk forward, time moves forward; stop, time stops; walk back, time moves backwards. It is a novel mapping of time and space, a new law of nature, a new causality

In the first year of life, infants build their expectations of the physical world, by observing how things move, fall, progress, and break. Humans can make predictions about "the trajectory of a thrown ball, the direction that a chopped tree will fall, or the path of a breaking wave."[12] This knowledge is called intuitive physics. Humans learn, early on, that dropped objects fall to the ground; gravity is one of the first things that we understand about physics. We also know that we stand upright when we are energetic, and we lie down when we feel tired. Our relationship with the world, guided by causality, allows us to create meaning and new conceptual structures driven by embodied cognition.

10. https://www.xrmust.com/xrdatabase/all-experiences/the-sky-is-a-gap/.
11. Although *The Sky is A Gap* is not photorealistic like *Open Seating*, the viewer is situated bodily in the space and controls the movement of the virtual camera with their gaze. Because of this, both pieces produce a strong first-person perspective, regardless of visual realism.
12. James R. Kubricht, Keith J. Holyoak, and Hongjing Lu, "Intuitive physics: Current research and controversies," *Trends in Cognitive Sciences* 21, no. 10 (2017): 750.

The writers Lakoff and Johnson, in their work *Metaphors We Live By*, suggest that our lived, physical, and sensorimotor experience of the environment can underpin our metaphorical sense-making of the world we live in. For example, a person saying they're feeling "on top of the world," is referencing a metaphorical relationship between "up" and "happy" or "good," internalized and part of that person's mental and verbal model for the world.[13] Metaphors can draw on human embodiment as well as on the rules of physics in regard to how different bodies relate to each other and the parameters of spatio-temporal mappings to derive new, unexpected meanings. Causality montage provides a sort of sideways approach to the model of language and sensorimotor development, where new metaphors can skip over language and be built from new physical experiences—new causalities—that are in dialogue with our learned or internalized causality.

In *The Sky is a Gap*, the new mapping of time to space feels as essential in the world of the piece as gravity does in our world: it presents the viewer a space with different intuitive physics. Just as they understand that objects fall under gravity, the viewer learns that in this world, time will move forward if they walk forward. The capability of the body and the (virtual) world is changed, meaning new metaphors can emerge. What new, embodied meanings does this give rise to? How can our thinking change in a world in which walking is given new meaning? To return to my earlier observation about simulations and complex concepts like climate change, maybe it can produce a new sensitivity to connections we previously could not perceive. In *The Sky is a Gap*, every step we take has consequences and changes the environment. We know with our whole body that the world is constantly shaped by ourselves and countless other agents at each moment.

13. George Lakoff and Mark Johnson, *Metaphors We Live By* (Chicago: University of Chicago Press, 2003), 15.

Miracle as Metaphor

In Universal Everything's *Emergence* (2019),[14] the player controls a person that is made of light. This light-person is in the middle of a desert surrounded by a large crowd of people. As they move, the crowd moves; as they stop, the crowd stops. The body of the light-person is also the body of the crowd: there is an invisible tie between the person and the crowd in a way that evokes murmurations of birds or schools of fish but does not replicate this. There are several vertical beams of light dispersed in the desert, and each time the player moves the light-person into the beam, the relationship between the light-person and the crowd changes. New rules govern the crowd's movement, driven by the player's actions but mediated by unknown or invisible forces. Throughout the experience, different causalities form between the light-person and the crowd. At times, the crowd runs away from the light-person; at times, the crowd forms a large circle around the light-person; at other times, the crowd forms small groups and changes position depending on the light-person's position. In *Emergence*, a crowd is a strange, unpredictable extension of one's own body, moving with and driven by one's own movements but rendered strange through the application of regularly changing physical rulesets.

Causality montage has echoes of a religious story as myth and miracle. Other myths and miracles carry similar mechanics where the cause (physical action) and the effect (manipulation of the physical world) are both impossible, yet meaningful: "In the Bible, Lot's wife looks back when leaving Sodom and turns into a pillar of salt; Medusa turns onlookers into stone by making eye contact; Midas turns everything he touches into gold."[15] With physics engines, myths and miracles become reproducible events. They are metaphors, narrative techniques, and physical experiences. Through causality montage, miracles and myths can be studied as narrative form and lived as physical experience. Furthermore, new mira-

14. https://store.steampowered.com/app/1337820/Emergence/.
15. Tortum "Embodied Montage," 67.

cles can be built through causality montage as new metaphors that reconceptualize the world. Causality montage produces and constructs new worlds: it is not only a tool of storytelling, but a tool that enables emergent stories.[16]

Revealing Invisible Causalities

In her lecture "Causality is Broken: Can We Fix It With Art Design?" Pinar Yoldas talks about how causality is invisible in our world: "Drinking water from a plastic bottle kills a marine bird somewhere, buying tomatoes grown in a greenhouse in Spain murders a whale."[17] Often, we cannot see the effects of our actions as these effects are imperceptible to us, even as we "know" of their abstract possibility. A bottle of plastic water we drink may cause an albatross to die, but there is a disconnection in time and space between these two actions. Yoldas suggests something like this: what if a dead albatross fell on our head every time we drank water from a plastic bottle?[18] What if this invisible causality became physical knowledge that we could comprehend not only with our minds, but with our bodies? An albatross falls on our heads when we drink water from a plastic bottle: this is a causality montage—a new creation of causality explaining the world, making the invisible visible, providing us with moments of recognition—a miracle.

Amitav Ghosh asks a crucial question in his book *The Great Derangement: Climate Change and the Unthinkable*. Outside of genre fiction, climate change has been rarely depicted in literature. This is a phenomenon we could say is the most urgent issue facing our time. What is the blind spot? For Ghosh, the modern novel took shape when a "regime of statistics, ruled by ideas of probability and improbability" was shaping society

16. Some other examples of causality montage can be found in Ian Cheng's *Emissaries*, David O'Reilly's *Everything*, and Alan Kwan's *Hallway*.
17. UCLA Design Media Arts, "PINAR YOLDAS CAUSALITY IS BROKEN: CAN WE FIX IT WITH ART DESIGN?" Counterforce Now Lecture Series 2019, streamed live on May 23, 2019, YouTube video, 1:25:26, https://youtu.be/7w0Uf_BKXJg.
18. Ibid.

and the tastes and ideas of the ruling class.[19] In this world, science led, and improbable events always had a scientific explanation. This world, in which we have lived in the last century, had "few surprises, fewer adventures, and no miracles at all."[20]

However, the world we are into right now is completely different. Improbable events, such as a 100-hundred-year storm happening every year, flash floods devastating major cities, heat waves killing millions in a single day, and aerosol-covered skies blocking sunlight, are now the realities (or imminently possible realities) of our world. We need a new literary or artistic aesthetic to communicate these realities. Causality montage can lead to moments of recognition that the world "as we know it" is not necessarily what it is or will be in the future. Ghosh starts *The Great Derangement* with the following observation:

> Who can forget those moments when something that seems inanimate turns out to be vitally, even dangerously alive? As, for example, when an arabesque in the pattern of a carpet is revealed to be a dog's tail, which, if stepped upon, could lead to a nipped ankle? Or when we reach for an innocent-looking vine and find it to be a worm or a snake? When a harmlessly drifting log turns out to be a crocodile?[21]

Causality montage can provide these moments of reveal and recognition. It can help us think through non-human agency, solidify invisible causality, and better understand the logic of simulations. It can also act as a miracle engine, creating experiences that inspire new thinking. Therefore, simulation arts stands at a very critical point. Will they make us look at the earth afresh, make the complex relations of the world more understandable? Can the uncanny relationships of causality montage enable us to see existing causality anew, and perhaps see as mutable dynamics that were previously accepted as given?

19. Amitav Ghosh, *The Great Derangement: Climate Change and the Unthinkable* (Chicago: The University of Chicago Press, 2017), 19.
20. Ibid., 19.
21. Ghosh, *The Great Derangement*, 3.

Bibliography

Ghosh, Amitav. *The Great Derangement: Climate Change and the Unthinkable*. Chicago: The University of Chicago Press, 2017.

Hansen, Mark B. N. "Media Entangled Phenomenology." In *Philosophy after Nature*, edited by Rosi Braidotti, 73–98. London; New York; Lanham: Rowman & Littlefield International, 2017.

Kubricht, James R., Keith J. Holyoak, and Hongjing Lu. "Intuitive Physics: Current Research and Controversies." *Trends in Cognitive Sciences* 21, no. 10 (2017): 749–759.

Lakoff, George, and Mark Johnson. *Metaphors We Live By*. Chicago: University of Chicago Press, 2003.

Macmillan, Anne. *Open Seating*. 2015. Composited Video, Duration: 4:34, 1920×1080. http://www.annemacmillan.com/#/openseating/.

Meillassoux, Quentin. *Science Fiction and Extro-Science Fiction*. Translated by Alyosha Edlebi. Minneapolis: University of Minnesota Press, 2015.

Morton, Timothy. *Hyperobjects: Philosophy and Ecology after the End of the World*. Minneapolis: University of Minnesota Press, 2013.

Rossin, Rachel. *The Sky is a Gap*. 2017. Mixed media with VR video (color, sound, indefinite duration). https://www.xrmust.com/xrdatabase/all-experiences/the-sky-is-a-gap/.

Tortum, Halil Deniz. "Embodied Montage: Reconsidering Immediacy in Virtual Reality." Master's thesis, MIT, 2016.

UCLA Design Media Arts. "PINAR YOLDAS CAUSALITY IS BROKEN: CAN WE FIX IT WITH ART DESIGN?" Counterforce Now Lecture Series 2019. Streamed live on May 23, 2019. YouTube video, 1:25:26. https://youtu.be/7w0Uf_BKXJg.

IV. COMMODITIZED VIRTUALITIES

The Happiest Virtual Place on Earth

Theme Park Paratextuality

Florian Freitag

Introduction

In his 2011 *Touristifizierung von Räumen* ("The Touristification of Spaces"), German tourism scholar Karlheinz Wöhler conceptualizes tourism as the "realization of the virtual."[1] What he means is that tourists arrive at their destination not just with their luggage, but also with a mental image of the site that they then, over the course of their vacation, performatively concretize and continually refine by sensorially experiencing and interacting with the space.[2] The tourist's "virtual" image of the destination that is thus "realized" during their stay there, Wöhler argues, is in turn based upon "medial constructions"—representations of the place as a tourism site in print media, radio, TV and movies, on websites, etc.[3] Tourism destinations are, of course, aware of these depictions (some of them are even created by the sites themselves) and may seek to more closely conform to them in order to facilitate the touristic "realization of the virtual," through processes of "Disneyfication."[4]

1. Karlheinz Wöhler, *Touristifizierung von Räumen: Kulturwissenschaftliche und soziologische Studien zur Konstruktion von Räumen* (Wiesbaden: VS, 2011), 72; my translation.
2. Ibid., 77.
3. Ibid., 77.
4. Ibid., 83; 172.

There are at least two ways in which Wöhler's model of tourism can be productively applied to theme parks. On the one hand, and as already suggested by his use of the term "Disneyfication,"[5] Wöhler offers us an interesting approach to the notion of "theming." Conventionally defined as "the use of an overarching theme or key concept (like Western) to organize a space,"[6] theming could also be conceptualized as the "realization of the virtual," i.e., the translation of medially constructed images of specific places, periods, cultures, etc., into instantly recognizable three-dimensional spaces. For example, several scholars have argued that the various pavilions at the World Showcase at Epcot in Orlando, Florida, do not simply represent the nation-states they are named after, but rather offer visitors precisely what, based on tourism media campaigns, they would expect to see on an actual vacation to these countries, and have therefore described the pavilions as "simulacra of the touristic world"[7] or "metatouristic spaces."[8]

On the other hand, and more importantly for my present purpose, the concept of the "realization of the virtual" can be related not only to the theming of theme parks but also to the parks themselves. Having been exposed to various medial representations of the site prior to their visit, even first-time visitors to a park may already have a quite specific idea of what it has to offer and how their experience will unfold, thus a mental or virtual image of the site that visitors then concretize and refine—in short, realize—over the course of their stay by experiencing and interacting with the space. The medial constructions upon which this virtual image of the

5. Coined by Richard Schickel in *The Disney Version: The Life, Times, Art and Commerce of Walt Disney* (New York: Simon and Schuster, 1968), 220, the term "Disneyfication" has frequently been used to criticize (especially Disney) theme parks for formularizing, oversimplifying, and even grossly misrepresenting their themes in the interest of mass appeal and, hence, profitability. Among the first to use it in the context of urban planning and place-making outside of theme parks was Richard V. Francaviglia. See Francaviglia, "Main Street U.S.A.: A Comparison/Contrast of Streetscapes in Disneyland and Walt Disney World," *The Journal of Popular Culture* 15, no. 2 (1981): 146.
6. Scott A. Lukas, *The Immersive Worlds Handbook: Designing Theme Parks and Consumer Spaces* (New York: Focal, 2013), 68.
7. Stephen M. Fjellman, *Vinyl Leaves: Walt Disney World and America* (Boulder: Westview, 1992), 223.
8. Florian Freitag, "'Who Really Lives There?': (Meta-)Tourism and the Canada Pavilion at Epcot," in *Gained Ground: Perspectives on Canadian and Comparative North American Studies*, ed. Eva Gruber and Caroline Rosenthal (Rochester, NY: Camden House, 2018), 167.

theme park is based may include printed and online travel guides, trip reports, etc., but—as in the case of other tourist destinations—also and especially the site's self-representations in poster, radio, and TV ads, in travel brochures, and on their websites and social media accounts.

Theme parks are private spaces of commerce, yet they are also creatures of media.[9] The medial self-representations listed above can thus be thought of as the parks' "paratexts." Introduced by French literary critic Gérard Genette in his *Palimpsestes* (1982), the term originally described "verbal or other productions, such as an author's name, a title, a preface, illustrations" that accompany and surround a literary text "in order to *present* it, in the usual sense of this verb but also in the strongest sense: to *make present*, to ensure the text's presence in the world, its 'reception' and consumption in the form (nowadays, at least) of a book."[10] Genette himself later opened the concept to other media; in *Paratexts* (1987) he granted that "some, if not all, of the other arts have an equivalent of our paratext," naming music, sculpture, painting, and film as examples.[11] In fact, referring to *Palimpsestes*, Robert Stam had applied Genette's concept to film as early as 1985,[12] and paratextual analysis remains popular within film studies.[13]

Given the close intermedial relationship between the cinema and the theme park,[14] it is somewhat surprising that it was not until very recently that the concept of paratextuality was also used in theme park scholarship. In her *Theme Park Fandom*, Rebecca Williams describes themed food

9. As early as in 1968, Richard Schickel spoke of Disneyland as a "new and unique medium." Schickel, *The Disney Version,*18.
10. Gérard Genette, *Paratexts: Thresholds of Interpretation*, trans. Jane E. Lewin (Cambridge: Cambridge University Press, 1997 [1987]), 1; emphases original.
11. Ibid., 407.
12. Robert Stam, *Reflexivity in Film and Literature: From Don Quixote to Jean-Luc Godard* (Ann Arbor: UMI Research Press, 1985), 22–24.
13. See Alexander Böhnke, *Paratexte des Films: Über die Grenzen des filmischen Universums* (Bielefeld: Transcript, 2007).
14. See Florian Freitag, "'Like Walking into a Movie': Intermedial Relations between Disney Theme Parks and Movies," *The Journal of Popular Culture* 50, no. 4 (2017): 704–22.

and drinks as "hyperdiegetic paratexts."[15] Here, I broadly sketch the field of theme park paratextuality by suggesting different categories of theme park paratexts in order to examine how they "medially construct" the theme park and, hence, to discuss their role in the parks' virtualites (i.e., visitors' "virtual image" of the park). Mainly, I will argue that, like other paratexts, these medial artifacts seek to guide the parks' "'reception' and consumption"[16] by establishing "frames and filters"[17] through which visitors experience the sites. Moreover, I will show that these frames and filters often closely resemble the "politics of inclusion/exclusion"[18] that theme parks use to avoid issues that might offend or alienate potential customers. By contributing to virtual images of the parks that layer on top of the physical space and the actual experience, theme park paratexts apply the techniques of theming to theme parks themselves.

This chapter contributes to the fields of both theme park studies and paratext studies by shedding more light on the complex relationship between park landscape and visitor behavior. In theme park criticism, this relationship has, as I will argue below, long been taken to be a highly deterministic one, with the park layout and design supposedly exercising almost complete control over visitors' movements and emotions—an assumption to which more recent scholarship has reacted by empha-

15. Rebecca Williams, *Theme Park Fandom: Spatial Transmedia, Materiality and Participatory Cultures* (Amsterdam: Amsterdam University Press, 2020), 163; emphasis original. Of course, earlier works sometimes discussed theme parks as paratexts (for movies; see Angela Ndalianis and Jessica Balanzategui, "'Being Inside the Movie': 1990s Theme Park Ride Films and Immersive Film Experiences," *The Velvet Light Trap* 84 (2019): 24), and critics have also analyzed medial artifacts that could be classified as paratexts (see Jay P. Telotte, *The Mouse Machine: Disney and Technology* (Urbana: University of Illinois Press, 2008), 96–116; Stephen Yandell, "Mapping the Happiest Place on Earth: Disney's Medieval Cartography," in *The Disney Middle Ages: A Fairy-Tale and Fantasy Past*, ed. Tison Pugh and Susan Aronstein (New York: Palgrave Macmillan, 2012), 24; and Carol J. Auster and Margaret A. Michaud, "The Internet Marketing of Disney Theme Parks: An Analysis of Gender and Race," *SAGE Open* 3, no. 1 (2013) as well as the paratexts of one particular part of a park (see Andrew Lainsbury, *Once Upon an American Dream: The Story of Euro Disneyland* (Lawrence: University Press of Kansas, 2000), 85–124; and Florian Freitag, *Popular New Orleans: The Crescent City in Periodicals, Theme Parks, and Opera, 1875–2015* (New York: Routledge, 2021), 160–64)—without, however, identifying them as such and thus also without considering them as part of the larger field of theme park paratextuality.
16. Genette, *Paratexts*, 1.
17. Jonathan Gray, *Show Sold Separately: Promos, Spoilers, and Other Media Paratexts* (New York: New York University Press, 2010), 3.
18. Scott A. Lukas, "A Politics of Reverence and Irreverence: Social Discourse on Theming Controversies," in *The Themed Space: Locating Culture, Nation, and Self*, ed. Scott A. Lukas (Lanham: Lexington, 2007), 277.

sizing the agency of visitors in general and fans in particular. Studying theme park paratexts, in turn, reminds us that control over visitors is exercised not just via environmental cues in the park landscape, but also via paratexts, whose consumption has become increasingly mandatory prior to, after, and even during the theme park visit. Indeed, it is the fact that visitors sometimes need to consume the park itself and its paratexts simultaneously that sets theme park paratexts apart from their literary, cinematic, and other counterparts.

Paratextual Control and Visitor Agency

Much has been written about Genette's distinction between "peritexts" (located close to the text itself; e.g. within the same work) and "epitexts," located "at a more respectful (or more prudent) distance" from a work.[19] Besides location relative to a work, Genette also suggested categorizing paratexts on the basis of their "*temporal* situation," i.e. their date of publication relative to the date of publication of the main text (prior, original, later, and delayed paratexts) and the lifetime of the latter's author (anthumous and posthumous paratexts).[20] Similarly, the temporal typology of paratexts offered by Jonathan Gray in *Show Sold Separately* differentiates between "entryway" and "in medias res" paratexts, "the first being those that we encounter before watching a film or television program, the latter those that come to us in the process of watching or at least interpreting the film or program."[21]

Yet even in the case of "original" (Genette) or "in medias res" (Gray) paratexts, text and paratext(s) are never quite consumed simultaneously. Tellingly, Gray chooses as "the most clear-cut example of an in medias res paratext" the "previously on..." segments of serial television programs, where the paratext links individual episodes and program segments rather than "intruding" into them.[22] Of course, theme parks have also been compared to television, with Karal Ann Marling considering

19. Genette, *Paratexts*, 4.
20. Ibid., 5; emphasis original.
21. Gray, *Show Sold Separately*, 18.
22. Ibid., 43.

the individual rides "slotted in among snacks, trips to the restroom, and 'commercials' in the form of souvenir emporia."[23] To this list of elements that link the park's rides by filling the gaps between them and creating what TV scholars term "flow,"[24] one could also add the consumption of such theme park paratexts as maps or apps—for which the parks, after all, even provide special places in the shape of "decision spaces."[25] Moreover, "in medias res" paratexts, such as souvenirs, could be argued to provide links and fill the gaps between theme park visits.

As obvious as it may seem—Disneyland (Anaheim, California) originally was a TV show, after all[26]—comparing theme park rides to television programs (and restaurants, shops, etc. to mere "fillers"), as Marling does, as well as categorizing theme park food as paratexts, as Williams does (see above), somehow misses the point of a theme park: what distinguishes the theme park from the amusement park or the fun fair is precisely that restaurants, shops, walkways, etc. are themed, too, and thus firmly integrated into and part of the overall experience. As is illustrated by the examples of decision spaces or so-called photo spots—locations marked by signposts that allow visitors to take supposedly well-composed photographs as souvenirs—theme parks do encourage visitors to consume and even produce their own paratexts at the very same time that they are in the park. And with online reservation systems for rides, restaurants, and shows, such theme park paratexts as apps sometimes even need to be consulted during the visit.

In addition to "entryway" paratexts (consumed before the visit) and "in medias res" paratexts (consumed after or in-between two visits), then, theme parks also feature paratexts that serve as medial interfaces between visitors and the park landscape during the very process of experiencing and consuming the site. These can therefore be termed "in situ"

23. Karal Ann Marling, "Disneyland, 1955: Just Take the Santa Ana Freeway to the American Dream," *American Art* 5, no. 1–2 (1991): 206.
24. See Raymond Williams, *Television: Technology and Cultural Form* (London: Fontana, 1974), 95.
25. Using the example of Disneyland's Central Plaza, David Younger defines a "decision space" as "an open, wider area that allows guests to . . . discuss their plans for the day, without causing a bottleneck." Younger, *Theme Park Design & the Art of Themed Entertainment* (N.P.: Inklingwood, 2016), 298.
26. *Disneyland*, broadcast weekly on ABC under this name from 1954 to 1958, could be regarded as one of the park's paratexts—or vice versa.

Florian Freitag 103

paratexts. If we subscribe to Genette's (and his followers') idea that paratexts seek to guide a text's "'reception' and consumption" by providing "frames and filters," then the fact that theme parks provide their visitors with such interpretive guidelines or scripts even during the visit points first and foremost to the extraordinary amount of control that the parks seek to exert over their virtual image. Besides their intricately designed landscapes (and the carefully scripted behavior of their front-line employees),[27] which seek to regulate visitors' cognitive, emotional, and behavioral responses to and their interactions with the themed space, theme parks also enlist paratexts to ensure a "proper" reading.

Theme park scholarship has long focused on the spatial determinism supposedly inherent in theme park landscapes. As early as 1968 and 1973, respectively, Richard Schickel and Christopher Finch commented on the techniques of forced perspective and *wienies* (Disney's concept of a visual magnet) used at Disneyland to subtly guide both visitors' emotions and their movements.[28] By the late 2010s and early 2020s, however, the scholarly debate shifted towards stressing visitors' agency.[29] Far from questioning visitor agency, my point here is simply that it is not, as Tom Robson maintains, just "[t]hrough their organization of the spatial text that is the

27. See John van Maanen, "The Smile Factory: Working at Disneyland," in *Reframing Organizational Culture*, ed. Peter J. Frost, Larry F. Moore, Meryl Reis Louis, Craig C. Lundberg, and Joanne Martin (Newbury Park: Sage, 1991), 58–77.
28. See Richard Schickel, *The Disney Version*, 323–24; and Christopher Finch, *The Art of Walt Disney from Mickey Mouse to the Magic Kingdoms* (New York: Harry N. Abrams, 1973), 390–93. More recently, Sharon Zukin, Norman Klein, Miodrag Mitrasinovic, and Brian Lonsway have all examined the deterministic strategies of (Disney) theme park landscapes, referring to them as "landscapes of power," "scripted spaces," "total landscapes," and examples of the "spatialization of control," respectively (see Sharon Zukin, *Landscapes of Power: From Detroit to Disney World* (Berkeley: University of California Press, 1991); Norman Klein, *The Vatican to Vegas: A History of Special Effects* (New York: New Press, 2004), 10; Miodrag Mitrasinovic, *Total Landscape, Theme Parks, Public Space* (Burlington: Ashgate, 2006); and Brian Lonsway, *Making Leisure Work: Architecture and the Experience Economy* (London: Routledge, 2009), 174–75).
29. See, for example, Jennifer A. Kokai and Tom Robson, "Introduction: You're in the Parade! Disney as Immersive Theatre and the Tourist as Actor," in *Performance and the Disney Theme Park Experience: The Tourist as Actor*, ed. Jennifer A. Kokai and Tom Robson (Cham: Palgrave Macmillan, 2019), 9; 14; or Williams, *Theme Park Fandom*, 9.

Magic Kingdom" that theme parks "seek to condition audience members to interpret that text in a particular way,"[30] but also through the paratexts that accompany this "spatial text." These paratexts, in turn, may also be spatial, but they come in many other forms and media as well.

The following discussion therefore uses not only the three temporal categories of theme park paratexts introduced above—entryway, in situ, and in medias res paratexts—but also six medial categories or genres of theme park paratexts—images, narratives, maps, historiographies, behind-the-scenes looks, and spaces and objects—to show how paratexts collaborate with the park landscape and with each other to create and maintain a specific "virtual" image of a given park. While spatial constraints allow me to focus on a mere selection of examples here, note that the two sets of categories, temporal and medial, freely intersect: for example, there are entryway, in situ, and in medias res narrative paratexts, just as in situ paratexts may come in the shape of images, narratives, maps, historiographies, behind-the-scenes looks, and spaces and objects. As it is its temporality that differentiates the theme park model from other paratextualities, however, my discussion is primarily organized according to temporal categories, starting with entryway paratexts in general and with paratexts published before the opening of a theme park in particular.

Entryway Paratexts

Images and other visualizations—conceptual drawings and architectural renderings, physical and virtual models, and, as construction progresses, photographic and film images—have played a pivotal role in promoting new theme parks (or new additions to existing theme parks). For the *Euro Disney Resort Paris Führer* guide book (1992), the undated *Euro Disney: The Heart of Make-Believe* booklet, and other pre-opening brochures of the Euro Disney Resort (now Disneyland Paris; Marne-la-Vallée, France), the Walt Disney Company relied heavily on existing photographs of its US-based parks and resorts, with Walt Disney World's Main Street, U.S.A.,

30. Tom Robson, "'The Future Is Truly in the Past': The Regressive Nostalgia of Tomorrowland," in *Performance and the Disney Theme Park Experience: The Tourist as Actor*, ed. Jennifer A. Kokai and Tom Robson (Cham: Palgrave Macmillan, 2019), 32–33.

and Grand Floridian Beach Resort "standing in" for the new park's Main Street section and the Disneyland Hotel, respectively.[31] As its retro-futuristic design radically departs from that of its Tomorrowland counterparts in Anaheim and Orlando, however, Euro Disney's Discoveryland section is frequently visualized in pre-opening brochures through conceptual drawings and paintings, which already instruct future visitors how and specifically when to experience this area of the park.

At least two panoramic views of Discoveryland were created during the design process: an aerial "daytime" view by an unknown artist and an eye-level "nighttime" rendering by Tim Delaney, the lead designer of the "land."[32] Both prominently feature the Space Mountain roller coaster, which would not open until 1995, three years after the park's debut, thus inviting visitors to imaginatively add the massive building to Discoveryland's skyline from the very beginning (as well as inducing repeat visits through anticipatory priming, a common practice also on in medias res souvenir maps; see below). However, to visualize Discoveryland pre-opening brochures primarily relied on (details of) Delaney's "nighttime" view,[33] which showcases lighting designer Michael Valentino's dramatic illumination of the area against a dark blue sky, thus more or less subtly encouraging potential visitors to experience Discoveryland after dark, when the "land" shows itself—quite literally—in its best light.[34]

Fittingly, it was also through a film shot after nightfall—and one which opens with an actor playing Jules Verne turning on the show lights in the area—that Discoveryland was introduced to viewers of the *Grand Opening of Euro Disney* television special,[35] another important visual pre-opening

31. See Régine Ferrandis, *Euro Disney Resort Paris Führer*, trans. Iris Michaelis et al. (Bern: Fink-Kümmerly Frey, 1992), 68; 121; and N.N., *Euro Disney: The Heart of Make-Believe* (N.P.: N.P., 1992), 3; 13.
32. Both artworks are included in Alain Littaye, "The Disneyland Paris That Never Was—Part 6: Discoveryland," *Disney and More,* April 25, 2010, https://disneyandmore.blogspot.com/2010/04/disneyland-paris-that-never-was-part_25.html.
33. See N.N., *Euro Disney: The Heart of Make-Believe*, 12.
34. In fact, a comment in *Disneyland Paris de A à Z* (2017) suggests that the nighttime lighting constitutes an integral part of Discoveryland's steampunk aesthetics, with the "modern" neon lights counterbalancing the Victorian design of the buildings. See Jérémie Noyer and Mathias Dugoujon, *Disneyland Paris de A à Z* (Chessy: Euro Disney S.C.A., 2017), 115.
35. See Gilles Amado and Don Mischer (dir.), *The Grand Opening of Euro Disney*, Buena Vista Productions, 1992, 01:12:10–01:12:42.

entryway paratext for this park. The success of the *Disneyland* television show prior to the opening of Disneyland itself, the live-televised broadcast of the opening of that park, and its later promotions in that medium throughout the 1950s and 1960s were evident to the Walt Disney Company. Hence, this media strategy was repeated for the opening of the Euro Disney Resort in 1992 with the weekly *Disney Club* television show on various European channels[36] and the *Grand Opening of Euro Disney* TV special aired in Europe and the US on April 11. But the television gala primed the resort's future visitorship in other ways as well.

Examining the *Grand Opening* special in his book *Once Upon an American Dream*, Andrew Lainsbury notes that the show sought to "forg[e] an all-new identity for the Euro Disney Resort."[37] Indeed, perhaps in response to the virulent public debate about American cultural imperialism sparked by the announcement of the project,[38] the *Grand Opening* included several segments that stressed the European roots of Disney in general and Euro Disney in particular: a "film clip of Roy Disney on location in the small village of Isigny-sur-Mer (from which the Disney name was derived) dramatized his family connection with France" and a "collage of Disney movies dubbed in continental languages demonstrated that Mickey Mouse and his friends were indeed citizens of Europe."[39] Much more than "just a preview,"[40] the *Grand Opening* thus sought to present—in Genette's use of the term (see above)—the Euro Disney resort to future visitors as a place where European folk tales and myths finally come home[41] or as Disney's "return gift" to Europe.

And the *Grand Opening* wasn't Euro Disney's only pre-opening paratext to do so. Just as they did for the opening of Disneyland in California with *Donald Duck in Disneyland* (1955), Disney also published a comic strip for the opening of Euro Disneyland in Paris in 1992. Written and drawn by

36. Lainsbury, *Once Upon an American Dream*, 89–90.
37. Ibid., 101.
38. See Richard Kuisel, *The French Way: How France Embraced and Rejected American Values and Power* (Princeton: Princeton University Press, 2012), 167–69.
39. Lainsbury, *Once Upon an American Dream*, 101.
40. Ibid., 85.
41. The *Euro Disney Resort Paris Führer* explicitly speaks of European fairy tales "coming home." See Ferrandis, *Euro Disney Resort Paris Führer*, 17, my translation.

Romano Scarpa, the 76-page "Die Jagd auf Karte Nr. 1" ("The Quest for Ticket No. 1") was first published in German in 1992 as the title story of volume 177 of the *Lustiges Taschenbuch* monthly comic book series. The "quest" motif is a popular one in comics and other narrative theme park paratexts, regardless of the temporal category, as it allows the creators to send the protagonists through the park in order to showcase its various attractions and landscapes. In *Donald Duck in Disneyland*, for example, Donald Duck roams the entire site in search for his nephews Huey, Dewey, and Louie, with whom he had planned to spend a "quiet visit" to the new park, but who had quickly abandoned him at the entrance to explore the premises on their own.[42]

By contrast, in the 1992 Euro Disney comic, the park merely appears as a construction site at the beginning and during the opening ceremonies at the end of the comic. In between, Scrooge McDuck, his family and friends, as well as his archenemies and rivals Flintheart Glomhold and the Beagle Boys, travel all over Europe—from London to Odense, Brussels, the Lorelei, the Cave of Altamira, Venice, and finally to Paris—on a scavenger hunt for the first ticket to Euro Disney, which is all part of the park's opening promotional campaign. Somewhat ironically, then, the comic dedicates much more space to Europe's established tourist destinations than to its newest one. However, it once again depicts the park as Disney's return gift to Europe: it was, we learn in a flashback, a Frenchman by the name of Gérard who gave a young Scrooge his very first gold nugget.[43] Now the "main shareholder" of Euro Disney, McDuck returns the favor by offering the Euro Disney resort to the French (and the titular "ticket number one" to a young French boy named Gérard).[44]

42. See Annie North Bedford, *Donald Duck in Disneyland* (New York: Simon and Schuster, 1955). For a similar storyline revolving around the Osmond Brothers, see the March 22, 1970, episode of *The Wonderful World of Disney* television series, which sought to promote the then newly opened Haunted Mansion ride at Disneyland. See Freitag, *Popular New Orleans*, 164.
43. Romano Scarpa, "Die Jagd auf Karte Nr. 1," *Lustiges Taschenbuch* 177 (1992): 75–76.
44. Ibid., 78–79.

In Situ Paratexts

While entryway paratexts are intended to be consumed before travelling to a theme park, paper guide maps are consumed on site during the park visit. Such maps also demonstrate the potential of a historical approach to paratextual artifacts: like theme parks themselves,[45] their paratexts constantly evolve and change—not just along with the parks, as they necessarily do in the case of guide maps, but also with respect to the particular virtual image of the site that they create. In a 2012 article, Stephen Yandell has examined Disney souvenir poster maps—the in medias res equivalent of the in situ guide maps that I focus on here, so to speak—arguing that they "manipulate [visitors] to preserve an illusion of perfection."[46] Indeed, in addition to sometimes also anticipating future attractions (see above), souvenir maps use innocuous "groves of trees, the default symbol used [on theme park maps] to indicate off-limit spaces,"[47] or blank spaces to hide whatever visitors are not supposed to notice during their visit—from construction and maintenance works to backstage areas and the outside world.

Hence, like in medias res souvenir books whose pictures always show comfortably populated yet not overcrowded theme park landscapes in a perfect state of maintenance and in ideal weather,[48] in medias res souvenir maps let visitors know exactly how to remember the site. Usually handed out for free at the park entrance, in situ guide maps, in turn, use the very same groves of trees and blank spaces in order to tell visitors how to perceive and experience the site during their visit. In fact, in listing the park's various attractions and services, guide maps may profess

45. Alan Bryman, *Disney and His Worlds* (London: Routledge, 1995), 83; and Stephen Yandell, "Mapping the Happiest Place on Earth, 24.
46. Yandell, "Mapping the Happiest Place on Earth," 24.
47. Ibid.
48. The 1992 Euro Disneyland souvenir book provides an interesting example since it was printed before the park opened and thus before such pictures were available. Therefore, in addition to a few extremely carefully framed photographs of the unfinished park, it mainly features, much like the pre-opening brochures discussed earlier (see above), pictures of Walt Disney World's Magic Kingdom and especially conceptual drawings of Euro Disney, which show the site in an even more highly idealized manner than any photograph ever could (see European Creative Center, *Euro Disney* (N.P.: Walt Disney Company, 1992)). Bypassing visitors' actual experiences in the park itself, the souvenir book thus invites visitors to remember the park exactly as the designers had originally envisioned it.

to inform visitors about their possibilities, but, like other maps, they also "reflect limitations."[49] Simply by suggesting that there is nothing to be seen or experienced there, the maps direct our attention away from backstage areas and the world beyond the park's boundaries and tell us "where we can't go and what we can't (or must [not]) do."[50] In this, guide maps are directly contradicted by yet another in situ paratext—namely, behind-the-scenes guided tours, which lead visitors backstage and thus suggest that there is indeed quite a lot to be seen there.[51]

Compared to traditional printed guide maps, contemporary virtual in situ maps may reflect even more limitations. The parks' websites and apps usually feature multiple filter options that allow visitors to look for the nearest restrooms, interactive rides suitable for small children, restaurants offering vegetarian food, or shops selling specifically themed merchandise. In addition, search results usually offer links to detailed descriptions of the respective space, including pictures and videos, technical data and safety restrictions (for attractions), and review options, and they can all be put on a personal "favorite" list.[52] Hence, the already highly selective paratextual representation of the park landscape on the printed guide map becomes even more selective in the electronic version as elements that do not match the visitor's filters are not even indicated. Indeed, on the virtual map, elements that have been filtered out by customers become as invisible to them as those already filtered out by the map designers.

Earlier Disneyland in situ guides, in turn, feature highly schematic park maps with the names of the park's various subsections as well as maps of each "land" labeled with numbers and symbols that allowed visitors to locate the area's specific attractions, shows, restaurants, shops, and ser-

49. Yandell, "Mapping the Happiest Place on Earth," 24.
50. Mark Monmonier, *No Dig, No Fly, No Go: How Maps Restrict and Control* (Chicago: The University of Chicago Press, 2010), 1.
51. See David L. Pike, "The Walt Disney World Underground," *Space and Culture* 8, no. 1 (2005): 47–65; and Mathew J. Bartkowiak, "Behind the Behind the Scenes of Disney World: Meeting the Need for Insider Knowledge," *The Journal of Popular Culture* 45, no. 5 (2012): 943–59.
52. See, for example, the Europa-Park & Rulantica App.

vices.[53] What is important here is the order in which the individual park sections are introduced to readers of the booklet: having arrived at the end of Main Street, U.S.A., visitors to Disneyland find themselves on Central Plaza, a decision space that offers equal access to all of the park's "lands."[54] This is where the booklet intervenes by ordering the sections and suggesting that visitors experience them in a "clockwise" or "chronological" way, from Adventureland and Frontierland (the past) to Tomorrowland (the future). Unsurprisingly, this order was kept for early in situ guides of Euro Disney, which thus identified Discoveryland as the last area to be visited, towards the end of the day and after nightfall.[55]

The very same order of lands is also suggested in "C'est magique/Feel the Magic," a musical revue performed at Disneyland Paris's Fantasy Festival stage from 1992 to 1994 (i.e., the first two years of the park's operation). Featuring scenes dedicated to each of the park's five themed "lands," the show could be considered an attraction that doubled as an in situ paratext (or vice versa). "C'est magique/Feel the Magic" may thus be regarded as part of an entire array of spatial and performative entryway and in situ theme park paratexts, with examples ranging from the "Espace Euro Disneyland" preview center (1990–1992)[56] to the stage show that toured China before the opening of Shanghai Disneyland in 2016[57] and from the "Europa-Park Historama" revolving theatre show (2010–2017)[58] to the Efteling Museum (since 2003).[59] Whereas the former two mainly sought

53. See the 1972 Disneyland guide map, which can be viewed at https://disneylandresortdaily.com/wp-content/uploads/2020/09/1972-SpringW.pdf.
54. The only exceptions here are the subsequently added "satellite lands" of New Orleans Square (1966), Critter Country (1972), and *Star Wars*: Galaxy's Edge (2019), which can only be reached via Adventureland, Frontierland, and Fantasyland.
55. See the 1993 Euro Disneyland guidebook (author's collection).
56. Lainsbury, *Once Upon an American Dream*, 87-88.
57. See Laura MacDonald, "Rising in the East: Disney Rehearses Chinese Consumers at a Glocalized Shanghai Disneyland," in *Performance and the Disney Theme Park Experience: The Tourist as Actor*, ed. Jennifer A. Kokai and Tom Robson (Cham: Palgrave Macmillan, 2019), 127.
58. See Freitag, *Popular New Orleans*, 132–35.
59. See https://www.efteling.com/en/park/attractions/efteling-museum.

to explain to visitors the concept and layout of the upcoming parks, the latter two have also offered visitors of Europa-Park and Efteling a highly selective look back at the histories of the respective sites and could therefore be considered both spatial and historiographic paratexts.

In Medias Res Paratexts

The soundtrack of "C'est magique/Feel the Magic" that was sold on cassettes and CDs at the park's souvenir shops, in turn, could be categorized as an in medias res narrative paratext that not only allows visitors to remember the show but also offers them a script of how to organize their entire next vacation there. The soundtrack contains two additional scenes that, by fall 1993 at least, had been cut from performances of the show at the park:[60] "Thank God, I'm a Country Bear" and "Night Life/Macho Duck," which refer to the Disneyland resort hotels (specifically the Davy Crockett Ranch and the Hotel Cheyenne) and the Festival Disney shopping and entertainment district, respectively.[61] With these two songs placed before and in between the musical tour of Disneyland's various "lands," the soundtrack not only introduces listeners to the park and its layout but scripts an "ideal" (from the point of view of the Walt Disney Company at least) two-day vacation at the resort, a truly—to use the title of the second scene—"Supercalifragi Euro Disneyland vacation."[62]

Just like other theme park paratexts, the "C'est magique/Feel the Magic" soundtrack is notable as much for what it includes as for what it excludes: the journey to the resort and back, rides closed for maintenance, money spent, and the time it took to wait in line (which, had it been included, may well have turned out to be the longest scene of the show). In their depictions of the theme park, paratexts frequently rely on the very same "politics of inclusion/exclusion" (see above) as the parks in their representations of particular themes. Another "spatial" in medias res paratext also illustrates this point: in the early 2000s, the then-newly opened Dis-

60. See amateur video recordings of the show, available at e.g., https://www.youtube.com/watch?v=3v6TmPSm3ng&t=296s.
61. N.N., *Euro Disney: Feel the Magic* (N.P.: Walt Disney Records, 1992), 06:35–08:12; 08:13–10:45.
62. N.N., *Euro Disney: Feel the Magic*, 03:26–06:32.

ney California Adventure park in Anaheim sold toy models of some of its signature rides, including "the *Orange Stinger*, complete with yellow-and-black bee abdomen seats, and the *Sun Wheel*, with the smiling California sun face in the center of the wheel."[63] In contrast to architectural models of these rides, what was missing from the toys were, of course, the waiting lines.

At the same time, what is rigidly excluded from the park landscape (as well as from some paratexts) may also become the focus of specific paratexts. This particularly applies to in medias res historiographic and behind-the-scenes paratexts such as coffee table books on the history, design, and construction of theme parks. Theme parks generally make enormous efforts to carefully hide their own history from visitors. Except for extremely rare cases in which theme parks choose to commemorate or pay tribute to former attractions (e.g., Disneyland planting characters from the closed Country Bear Jamboree show as "easter eggs" into The Many Adventures of Winnie the Pooh ride that replaced it), alterations and new additions are subtly integrated into the existing theme park landscape so as to avoid so-called theming palimpsests, i.e., situations "in which themes from different eras are visible in the same spaces."[64]

By contrast, and much like the "Europa-Park Historama" or the Efteling Museum do in situ and in the shape of spaces, historiographic in medias res paratexts such as *Disneyland: Dreams, Traditions and Transitions* (1995), *The Haunted Mansion: Imagineering a Disney Classic* (2015), and similar richly illustrated coffee table books dramatize and celebrate the histories of entire parks and individual rides (or, in the case of such meta-paratexts as *Maps of the Disney Theme Parks: Charting 60 Years from California to Shanghai* (2016), even those of specific paratextual genres themselves). To be sure, the "politics of inclusion/exclusion" have not been entirely suspended, and what Henry Giroux noted about historical theming in theme parks—namely, a tendency towards "historical era-

63. Werner Weiss, "The First Christmas at California Adventure," *Yesterland.com*, last modified December 20, 2019, https://www.yesterland.com/dcachristmas2001.html.
64. See Lukas, "A Politics of Reverence and Irreverence," 282.

sure"[65]—even more fundamentally applies to theme parks' paratextual approaches to their own history: unsuccessful rides, shows, restaurants, and shops, mishaps and accidents, and designs that no longer correspond to current notions of political or social acceptability and appropriateness are routinely excised from these paratexts.[66]

Similarly, while "autothemed" theme park spaces (i.e., spaces that are themed to the parks themselves),[67] such as Disneyland's Club 33 or Walt's—An American Restaurant at Disneyland Paris, frequently use concept art and architectural models for decorative purposes, theme parks usually seek to hide design, construction, and maintenance work from park visitors in back offices and behind themed construction walls and tarps, lest visitors' own visual in medias res paratexts (i.e., souvenir photos and videos) should be "spoiled." By contrast, behind-the-scenes in medias res paratexts such as *Imagineering: A Behind the Dreams Look at Making the Magic Real* (1996), *Imagineering: A Behind the Dreams Look at Making MORE Magic Real* (2010), and similar coffee table books reveal precisely what the construction walls and tarps seek to hide, inviting visitors to take a "revered gaze"[68] at the efforts that have gone into the design, construction, and maintenance of the landscapes they have enjoyed during their visit.

Like their historiographic counterparts, such behind-the-scenes in medias res paratexts use different scopes. Some, including the *Imagineering* books mentioned above, focus on the designs of a specific theme park company; others, like *Designing Disney: Imagineering and the Art of the Show* (2008), highlight the work of one particular designer (here, John Hench); still others, such as *Disneyland Paris de A à Z* (2017), look at one specific park. The latter example is also notable for its "Disneyland Paris around the Clock" segments, which over the course of the book

65. Henry A. Giroux, *The Mouse That Roared: Disney and the End of Innocence* (Lanham: Rowman & Littlefield, 1999), 34.
66. See Freitag, *Popular New Orleans*, 165-70.
67. See Florian Freitag, "Autotheming: Themed Spaces in Self-Dialogue," in *A Reader in Themed and Immersive Spaces*, ed. Scott A. Lukas (Pittsburgh, PA: ETC, 2016), 141.
68. Alison Griffiths, *Shivers Down Your Spine: Cinema, Museums, and the Immersive View* (New York: Columbia University Press, 2008), 286.

track twenty-four hours behind the scenes of the resort. Many theme park paratexts—from the in situ guide books and stage shows discussed earlier to reservation apps—seek to precisely schedule the visitors' experiences of the theme park space, resulting in what Aldo Legnaro, H. Jürgen Kagelmann, and Rebecca Williams have termed "Erlebnisarbeit" ("experience work"),[69] "Spaß-Arbeit" ("fun work"),[70] and "anticipatory labor."[71] The "Disneyland Paris around the Clock" segments match this schedule with a behind-the-scenes timetable that makes the employees' tasks seem at least as exciting as a regular visit to the park.

Conclusion

Theme park paratexts have sometimes been used as sources for historical approaches to theme parks.[72] More recently, Rebecca Williams has suggested using paratexts and other mediatizations of theme parks to address the ecological and health concerns that physical travel to the sites over long distances and during the COVID-19 pandemic may engender.[73] As my brief overview of the various medial and temporal categories of theme park paratexts has sought to show, these depictions of the parks as historical sources or as substitutes for the actual experience of theme park landscapes should be approached very carefully, as they always depict the site itself and visitors' experience of it in a highly selective manner. More specifically, theme park paratexts frequently employ exactly the same "politics of inclusion/exclusion" that theme parks them-

69. Aldo Legnaro, "Subjektivität im Zeitalter ihrer simulativen Reproduzierbarkeit: Das Beispiel des Disney-Kontinents," in *Gouvernementalität der Gegenwart*, ed. Ulrich Bröckling, Susanne Krasman, and Thomas Lemke (Frankfurt: Suhrkamp, 2000), 293.
70. H. Jürgen Kagelmann, "Themenparks," in *ErlebnisWelten: Zum Erlebnisboom in der Postmoderne*, ed. H. Jürgen Kagelmann, Reinhard Bachleitner, and Max Rieder (Munich: Profil, 2004), 175.
71. Williams, *Theme Park Fandom*, 67–99.
72. See Jon Wiener's short history of Disneyland's Frontierland. Wiener, "Tall Tales and True," *The Nation* (31 January 1994), 133.
73. Rebecca Williams, "Theme Parks in the Time of the Covid-19 Pandemic," in *Pandemic Media: Preliminary Notes toward an Inventory*, ed. Philipp Dominik Keidl, Laliv Melamed, Vinzenz Hediger, and Antonio Somaini (Lüneburg: Meson, 2021), 142.

selves use to translate particular themes into three-dimensional immersive spaces, emphasizing certain aspects of the parks while deemphasizing others in order to offer visitors guidelines, frames, filters, and scripts on how to anticipate, experience, and remember the site.

This is precisely the reason why theme park critics should not just draw on paratexts as sources, but also study them as objects in their own right as medial artifacts that significantly contribute to visitors' mental images of the parks or the latter's "virtuality" before, after, and, perhaps most importantly, even during the visit (and that sometimes even constitute visitors' sole access to the sites, as in 2020–2021, when many parks were forced to close due to the COVID-19 pandemic).[74] This is not to deny that theme park visitors have agency, as recent critics have emphasized, but to suggest that this agency is curtailed not just by the deterministic landscapes of the parks but also by their paratexts. To emphasize, it is the option—and sometimes the necessity—to consume text (the park landscape) and paratext (e.g., reservation apps) simultaneously that distinguishes the theme park model from other paratexts. Beyond these temporal considerations, theme park paratexts are above all marked by their medial variety. Quite appropriately so, paratextual portrayals of the hybrid, composite, or meta-medial landscapes of theme parks[75] come in the shape of still and moving images, maps, narratives, performances, and even themed spaces.

74. See Salvador Anton Clavé and Florian Freitag, "Introduction: Theme Parks and Covid-19," *Journal of Themed Experience and Attractions Studies* 2, no. 1 (2022).

75. Coined by Irina Rajewsky (Rajewsky, *Intermedialität* (Tübingen: Francke, 2002), 203), Werner Wolf (Wolf, "Intermediality," in *Routledge Encyclopedia of Narrative Theory*, ed. David Herman, Manfred Jahn, and Marie-Laure Ryan (New York: Routledge, 2005), 253), and Alexander Geppert (Geppert, *Fleeting Cities: Imperial Expositions in Fin-de-Siècle Europe* (New York: Palgrave Macmillan, 2010), 3), respectively, the terms "hybrid medium," "composite medium," and "meta-medium" denote media in their own right that from a historical perspective but fuse and combine various other media that have been conventionally viewed as distinct. In the case of the theme park, this includes architecture, landscaping, music, film, performance, and language (see Florian Freitag, "'This Way or That? Par ici ou par là?': Language in the Theme Park," *Visions in Leisure and Business* 23, no. 1 (2021): 73).

Of course, paratexts are far from the only medial portrayals of theme parks to have an impact on visitors' mental images of these sites. The virtuality of theme parks is based not just on their paratextuality, but also on their reception in independently produced medial depictions of them, be they the creations of artists (e.g. Banksy's *Dismaland*),[76] critics (e.g. Louis Marin's famous map of Disneyland),[77] journalists (e.g. travel articles), or fans (e.g. Werner Weiss's *Yesterland*);[78] be they created with a commercial agenda (e.g. the *Unofficial Guides to Walt Disney World*)[79] or not (e.g. fan discussion boards); and be they produced and distributed with the tacit approval and even support of the parks (as in the context of Disney's official fan club D23, founded in 2009, or in other cases of "fanagement")[80] or not. As with theme park paratexts, critics appear to have discovered such independent renditions of theme parks only recently, but the publication of Williams's *Theme Park Fandom* in 2020 as well as the much-expanded-on chapter "Disney and the World" in the revised edition of Janet Wasko's *Understanding Disney* (2020)[81] are encouraging signs. Theme parks, their paratexts, and their reception will definitely keep us busy in the future.

76. See Florian Freitag, "Critical Theme Parks: Dismaland, Disney, and the Politics of Theming," *Continuum* 31, no. 6 (2017): 923–32.
77. See Louis Marin, *Utopics: The Semiological Play of Textual Spaces*, trans. Robert A. Vollrath (New York: Humanity, 1984), 252.
78. See www.yesterland.com.
79. See Bob Sehlinger and Len Testa, *The Unofficial Guide to Walt Disney World 2021* (La Vergne: Unofficial Guides, 2021).
80. Matt Hills, "Torchwood's Trans-Transmedia: Media Tie-Ins and Brand 'Fanagement,'" *Participations Journal of Audience Studies* 9, no. 2 (2012): 409.
81. See Janet Wasko, *Understanding Disney: The Manufacture of Fantasy*, 2nd edition (Cambridge: Polity, 2020), 209–60.

Bibliography

Amado, Gilles, and Don Mischer, dir. *The Grand Opening of Euro Disney.* Buena Vista Productions. 1992. TV show.

Anton Clavé, Salvador, and Florian Freitag. "Introduction: Theme Parks and Covid-19." *Journal of Themed Experience and Attractions Studies* 2, no. 1 (2022). https://stars.library.ucf.edu/jteas/vol2/iss1/1.

Auster, Carol J., and Margaret A. Michaud. "The Internet Marketing of Disney Theme Parks: An Analysis of Gender and Race." *SAGE Open* 3, no. 1 (2013). https://doi.org/10.1177/2158244013476052.

Bartkowiak, Mathew J. "Behind the Behind the Scenes of Disney World: Meeting the Need for Insider Knowledge." *The Journal of Popular Culture* 45, no. 5 (2012): 943–59.

Bedford, Annie North. *Donald Duck in Disneyland.* New York: Simon and Schuster, 1955.

Böhnke, Alexander. *Paratexte des Films: Über die Grenzen des filmischen Universums.* Bielefeld: Transcript, 2007.

Bryman, Alan. *Disney and His Worlds.* London: Routledge, 1995.

European Creative Center. *Euro Disney.* N.P.: Walt Disney Company, 1992.

Ferrandis, Régine. *Euro Disney Resort Paris Führer.* Translated by Iris Michaelis et al. Bern: Fink-Kümmerly + Frey, 1992.

Finch, Christopher. *The Art of Walt Disney from Mickey Mouse to the Magic Kingdoms.* New York: Harry N. Abrams, 1973.

Fjellman, Stephen M. *Vinyl Leaves: Walt Disney World and America.* Boulder: Westview, 1992.

Francaviglia, Richard V. "Main Street U.S.A.: A Comparison/Contrast of Streetscapes in Disneyland and Walt Disney World." *The Journal of Popular Culture* 15, no. 2 (1981): 141–56.

Freitag, Florian. "Autotheming: Themed Spaces in Self-Dialogue." In *A Reader in Themed and Immersive Spaces*, edited by Scott A. Lukas, 141–49. Pittsburgh, PA: ETC, 2016.

———. "'Like Walking into a Movie': Intermedial Relations between Disney Theme Parks and Movies." *The Journal of Popular Culture* 50, no. 4 (2017): 704–22.

———. "Critical Theme Parks: Dismaland, Disney, and the Politics of Theming." *Continuum* 31, no. 6 (2017): 923–32.

———. "'Who Really Lives There?': (Meta-)Tourism and the Canada Pavilion at Epcot." In *Gained Ground: Perspectives on Canadian and Comparative North American Studies*, edited by

Eva Gruber and Caroline Rosenthal, 161–78. Rochester, NY: Camden House, 2018.

———. *Popular New Orleans: The Crescent City in Periodicals, Theme Parks, and Opera, 1875-2015*. New York: Routledge, 2021.

———. "'This Way or That? Par ici ou par là?': Language in the Theme Park." *Visions in Leisure and Business* 23, no. 1 (2021): 72–82.

Genette, Gérard. *Palimpsestes: La littérature au second degré*. Paris: Seuil, 1982.

———. *Paratexts: Thresholds of Interpretation*. Translated by Jane E. Lewin. Cambridge: Cambridge University Press, 1997 (1987).

Geppert, Alexander C.T. *Fleeting Cities: Imperial Expositions in Fin-de-Siècle Europe*. New York: Palgrave Macmillan, 2010.

Giroux, Henry A. *The Mouse That Roared: Disney and the End of Innocence*. Lanham: Rowman & Littlefield, 1999.

Gray, Jonathan. *Show Sold Separately: Promos, Spoilers, and Other Media Paratexts*. New York: New York University Press, 2010.

Griffiths, Alison. *Shivers Down Your Spine: Cinema, Museums, and the Immersive View*. New York: Columbia University Press, 2008.

Hench, John, and Peggy Van Pelt. *Designing Disney: Imagineering and the Art of the Show*. New York: Disney Editions, 2008.

Hills, Matt. "Torchwood's Trans-Transmedia: Media Tie-Ins and Brand 'Fanagement.'" *Participations: Journal of Audience and Reception Studies* 9, no. 2 (2012): 409–28.

Imagineers, The. *Imagineering: A Behind the Dreams Look at Making the Magic Real*. New York: Hyperion, 1996.

Imagineers, The, and Malody Malmberg. *Imagineering: A Behind the Dreams Look at Making MORE Magic Real*. New York: Disney Editions, 2010.

Kagelmann, H. Jürgen. "Themenparks." In *ErlebnisWelten: Zum Erlebnisboom in der Postmoderne*, edited by H. Jürgen Kagelmann, Reinhard Bachleitner, and Max Rieder, 160–80. Munich: Profil, 2004.

Klein, Norman. *The Vatican to Vegas: A History of Special Effects*. New York: New Press, 2004.

Kokai, Jennifer A., and Tom Robson. "Introduction: You're in the Parade! Disney as Immersive Theatre and the Tourist as Actor." In *Performance and the Disney Theme Park Experience: The Tourist as Actor*, edited by Jennifer A. Kokai and Tom Robson, 3–20. Cham: Palgrave Macmillan, 2019.

Kuisel, Richard. *The French Way: How France Embraced and Rejected American Values and*

Power. Princeton: Princeton University Press, 2012.

Lainsbury, Andrew. *Once Upon an American Dream: The Story of Euro Disneyland*. Lawrence: University Press of Kansas, 2000.

Legnaro, Aldo. "Subjektivität im Zeitalter ihrer simulativen Reproduzierbarkeit: Das Beispiel des Disney-Kontinents." In *Gouvernementalität der Gegenwart*, edited by Ulrich Bröckling, Susanne Krasman, and Thomas Lemke, 286–314. Frankfurt: Suhrkamp, 2000.

Littaye, Alain. "The Disneyland Paris That Never Was – Part 6: Discoveryland." *Disney and More*, April 25, 2010. https://disneyandmore.blogspot.com/2010/04/disneyland-paris-that-never-was-part_25.html.

Lonsway, Brian. *Making Leisure Work: Architecture and the Experience Economy*. London: Routledge, 2009.

Lukas, Scott A. "A Politics of Reverence and Irreverence: Social Discourse on Theming Controversies." In *The Themed Space: Locating Culture, Nation, and Self*, edited by Scott A. Lukas, 271–93. Lanham: Lexington, 2007.

———. *The Immersive Worlds Handbook: Designing Theme Parks and Consumer Spaces*. New York: Focal, 2013.

MacDonald, Laura. "Rising in the East: Disney Rehearses Chinese Consumers at a Glocalized Shanghai Disneyland." In *Performance and the Disney Theme Park Experience: The Tourist as Actor*, edited by Jennifer A. Kokai and Tom Robson, 127–48. Cham: Palgrave Macmillan, 2019.

Marin, Louis. *Utopics: The Semiological Play of Textual Spaces*. Translated by Robert A. Vollrath. New York: Humanity, 1984.

Marling, Karal Ann. "Disneyland, 1955: Just Take the Santa Ana Freeway to the American Dream." *American Art* 5, no. 1–2 (1991): 168–207.

Mitrasinovic, Miodrag. *Total Landscape, Theme Parks, Public Space*. Burlington: Ashgate, 2006.

Monmonier, Mark. *No Dig, No Fly, No Go: How Maps Restrict and Control*. Chicago: The University of Chicago Press, 2010.

Ndalianis, Angela, and Jessica Balanzategui. "'Being Inside the Movie': 1990s Theme Park Ride Films and Immersive Film Experiences." *The Velvet Light Trap* 84 (2019): 18–33.

Neary, Susan, and Vanessa Hunt. *Maps of the Disney Theme Parks: Charting 60 Years from California to Shanghai*. Los Angeles: Disney Editions, 2016.

N.N. *Euro Disney: Feel the Magic*. N.P.: Walt Disney Records, 1992. CD.

N.N. *Euro Disney: The Heart of Make-Believe*. N.P.: N.P., 1992.

Noyer, Jérémie, and Mathias Dugoujon. *Disneyland Paris de A à Z*. Chessy: Euro Disney S.C.A., 2017.

Pike, David L. "The Walt Disney World Underground." *Space and Culture* 8, no. 1 (2005): 47–65.

Rajewsky, Irina O. *Intermedialität*. Tübingen: Francke, 2002.

Robson, Tom. "'The Future Is Truly in the Past': The Regressive Nostalgia of Tomorrowland." In *Performance and the Disney Theme Park Experience: The Tourist as Actor*, edited by Jennifer A. Kokai and Tom Robson, 23–42. Cham: Palgrave Macmillan, 2019.

Scarpa, Romano. "Die Jagd auf Karte Nr. 1." *Lustiges Taschenbuch* 177 (1992): 5–80.

Schickel, Richard. *The Disney Version: The Life, Times, Art and Commerce of Walt Disney*. New York: Simon and Schuster, 1968.

Sehlinger, Bob, and Len Testa. *The Unofficial Guide to Walt Disney World 2021*. La Vergne: Unofficial Guides, 2021.

Shannon, Leonard. *Disneyland: Dreams, Traditions and Transitions*. N.P.: Kingdom Editions, 1995.

Stam, Robert. *Reflexivity in Film and Literature: From Don Quixote to Jean-Luc Godard*. Ann Arbor: UMI Research Press, 1985.

Surrell, Jason. *The Haunted Mansion: Imagineering a Disney Classic*. Los Angeles: Disney Editions, 2015.

Telotte, Jay P. *The Mouse Machine: Disney and Technology*. Urbana: University of Illinois Press, 2008.

Van Maanen, John. "The Smile Factory: Working at Disneyland." In *Reframing Organizational Culture*, edited by Peter J. Frost, Larry F. Moore, Meryl Reis Louis, Craig C. Lundberg, and Joanne Martin, 58–77. Newbury Park: Sage, 1991.

Wasko, Janet. *Understanding Disney: The Manufacture of Fantasy*, 2nd edition. Cambridge: Polity, 2020.

Weiss, Werner. "The First Christmas at California Adventure." *Yesterland.com*. Last modified December 20, 2019. https://www.yesterland.com/dcachristmas2001.html.

Wiener, Jon. "Tall Tales and True." *The Nation* (31 January 1994): 133–35.

Williams, Raymond. *Television: Technology and Cultural Form*. London: Fontana, 1974.

Williams, Rebecca. *Theme Park Fandom: Spatial Transmedia, Materiality and Participatory Cultures*. Amsterdam: Amsterdam University Press, 2020.

———. "Theme Parks in the Time of the Covid-19 Pandemic." In *Pandemic Media:*

Preliminary Notes toward an Inventory, edited by Philipp Dominik Keidl, Laliv Melamed, Vinzenz Hediger, and Antonio Somaini, 137–143. Lüneburg: Meson, 2021.

Wöhler, Karlheinz. *Touristifizierung von Räumen: Kulturwissenschaftliche und soziologische Studien zur Konstruktion von Räumen*. Wiesbaden: VS, 2011.

Wolf, Werner. "Intermediality." In *Routledge Encyclopedia of Narrative Theory*, edited by David Herman, Manfred Jahn, and Marie-Laure Ryan, 252–56. New York: Routledge, 2005.

Yandell, Stephen. "Mapping the Happiest Place on Earth: Disney's Medieval Cartography." In *The Disney Middle Ages: A Fairy-Tale and Fantasy Past*, edited by Tison Pugh and Susan Aronstein, 21–38. New York: Palgrave Macmillan, 2012.

Younger, David. *Theme Park Design & the Art of Themed Entertainment*. N.P.: Inklingwood, 2016.

Zukin, Sharon. *Landscapes of Power: From Detroit to Disney World*. Berkeley: University of California Press, 1991.

Transmedia Storytelling in Disney's Theme Parks

Or How Colonialism Underpins Participatory Culture

Sabrina Mittermeier

Introduction

As Henry Jenkins famously posited, "transmedia storytelling reflects the economics of media consolidation or what industry observers call 'synergy.' . . . [This means that] a media conglomerate has an incentive to spread its brand or expand its franchises across as many different media platforms as possible."[1] This phenomenon is most often attributed to developments in the media industries of the 21st century, but in the case of the Walt Disney Company, such synergistic efforts reach back to the 1955 opening of Disneyland Park. Making use of the then-new medium of television, the theme park was promoted by a TV series of the same name[2] that quickly garnered its own fandom, as evidenced by the so-called "Crockett craze" surrounding the *Davy Crockett* episodes.[3] More-

1. Henry Jenkins, "Transmedia Storytelling 101," *HenryJenkins.org*, March 21, 2007, http://henryjenkins.org/blog/2007/03/transmedia_storytelling_101.html.
2. Jay P. Telotte, *Disney TV* (Detroit: Wayne State University Press, 2004); Karal Ann Marling, "Disneyland, 1955," *American Art* 5 (Winter/Spring 1991): 167-207, https://doi.org/10.1086/424113.
3. Sabrina Mittermeier, *A Cultural History of the Disneyland Theme Parks* (Bristol: Intellect, 2021), 33-35.

over, the park also served as a marketing tool for all of the company's media properties from the get-go; even its famous icon, Sleeping Beauty Castle, was a clever synergistic effort to promote the then-upcoming animated film (released in 1957).[4]

This has only expanded further in the following decades, particularly with character meets, shows, and parades being introduced into the parks before films were released (such as the Captain Marvel character in early 2019). For Disney, inclusion in the parks has also foreshadowed the eventual takeover of Lucasfilm in 2016, with the Star Tours simulator ride in Disneyland opening as early as 1987 and *Star Wars* Weekends becoming a feature of Walt Disney World's Hollywood Studios Park in the 2000s. In many ways, the theme park has become a core of transmedia strategies as corporate practice, one which extends beyond Disney to Comcast-Universal and other global operators.

Despite their integral position in these strategies, theme parks present a special case in the study of transmediality, as they are physical places that must be visited to be experienced. As such, they exist at the intersection of media and tourism[5] and have become destinations of what can be called "fan tourism"[6] or "transmedia tourism."[7] As Rebecca Williams argues, theme parks

> ... seek to challenge the dominant view of transmediality as something that flows across and between different media spaces, "since this assumption does not match up with embodied and spatialized realities of transmedia branding/storytelling." ... the concept of "spatial transmedia" ... [thus] accounts for these moments of narrative extension and world-building that take place within a specific rooted location.[8]

4. Ibid., 45.
5. Sabrina Mittermeier, "Theme Parks—Where Media and Tourism Converge," in *The Routledge Companion to Media and Tourism*, ed. Maria Mansson et al. (New York: Routledge, 2020), 27–34.
6. Sabrina Mittermeier, "(Un)Conventional Voyages? *Star Trek: The Cruise* and the Themed Cruise Experience," *The Journal of Popular Culture* 52, no. 6 (January 2020): 1373.
7. Ross Garner, "Transmedia Tourism Editorial," *JOMEC Journal* 14 (2019): 1–10.
8. Rebecca Williams, *Theme Park Fandom: Spatial Transmedia, Materiality, and Participatory Cultures* (Amsterdam: Amsterdam University Press, 2020), 12.

This worldbuilding, in relation to the built environment I analyze here, draws upon recent efforts in transmedia storytelling for the first time interconnects all Disney theme parks globally with the Society of the Explorers and Adventurers (S.E.A.) and the Marvel Avengers Campus themed areas. I engage with concepts of "drillable immersion"[9] to unearth an underlying colonial ideology inherent in the "tourist gaze" that has continued to shape these virtual interiorities in the age of post-/mass-tourism and for which theme parks have become the epitome.[10]

The Society of Explorers and Adventurers and Theme Parks' Colonial Imagery

With the opening of Tokyo Disneyland in 1983, the Disney theme parks have expanded beyond the United States for the first time. Because of the surprising and massive success of this first overseas park, Disney soon opened gates outside Paris (1992), Hong Kong (2005), and, most recently, Shanghai (2016). Originally, local and national visitors were in the focus of the theme parks' marketing (with the exception of Paris's broader Western European focus), but in more recent years, the Walt Disney Company's strategy has more clearly shifted towards a global approach. This is noticeable in the increasing promotion of the international parks via the company's own social media channels (such as their *Disney Parks Blog*), but also through the immersive, transmedia storytelling at work in the parks' attractions. This marks a clear shift in marketing strategy and further positions the parks as key cogs in the multimedia conglomerate's machine.

The fictional "Society of Explorers and Adventurers" (S.E.A.) that serves as the narrative glue for several attractions (meaning rides, entertainment, and dining venues) ever since the 2001 opening of the Tokyo DisneySea theme park is one key example for this new strategy. It originated with the popular Adventurers Club, part of the now-defunct Pleasure Island district at the former entertainment complex Downtown Disney at

9. Besides the Screen, "Down Into the Vaults: Drillable Immersion at Franchise Lands (Carter Moulton, Northwestern)," uploaded on June 4, 2021, YouTube video, 25:01, https://www.youtube.com/watch?v=jNXiel-PjuQ.
10. John Urry and Jonas Larsen, *The Tourist Gaze 3.0* (London: SAGE, 2011).

Walt Disney World Resort, Florida. The immersive dining venue was created by a team led by Imagineer Joe Rohde and centered around a group of fictional characters played by an improv comedy troupe—a true foray into adult (rather than family) entertainment for the company. While the club had a more tongue-in-cheek take on colonial tropes, similar to the more recent incarnations of the Jungle Cruise ride at several of the so-called castle parks, the attractions found at Tokyo DisneySea elevate S.E.A. to a more sophisticated narrative. Introduced at the Fortress Explorations interactive walk-through and Magellan's restaurant, it connects back to an "Age of Explorers," AKA a time of European settler colonialism. DisneySea is also home to Lost River Delta—an area themed to the Indiana Jones franchise (which is possibly contemporary popular culture's most famous purveyor of colonial imagery), a good fit as they clearly share much common ideological ground.[11] thus adding yet another layer of hyperreality to this space—several levels of abstraction that arguably, blur the lines between fantasy and real-life colonial structures further. But it is the ride's storyline that reinforces the colonial narrative more clearly, centering on Lord Henry Mystic and his animal sidekick, the monkey Albert. Mystic is an aging British aristocrat (telling for this Hong Kong location, given its status as a former British colony) who collects artifacts from all over the globe. This is in line with S.E.A.'s official mission "to collect, conserve, and curate valuable cultural and artistic artifacts from around the world and make them available to the public in an artistically

11. Sabrina Mittermeier, "Indiana Jones and the Theme Park Adventure" in *Excavating Indiana Jones: Essays on the Film and Franchise*, ed. Randy Laist (Jefferson, NC: McFarland, 2019), 200.[/footnote Tokyo DisneySea introduces us to a member of S.E.A., Harrison Hightower III, the owner of this park's version of the popular Tower of Terror thrill ride. Hightower is portrayed as a wealthy white man who owns the hotel in a turn-of-the-century New York (part of the American Waterfront area). Hightower harkens back to Gilded Age millionaires like Rockefeller and Carnegie who shaped the city and the US at large. The attraction tells the story of a cursed artifact Hightower has acquired from his travels—the idol of Shiriki Utundu—which causes the hotel elevator to malfunction. The statue has also made Hightower—a painting of whom was modelled on the visage of one Joe Rohde—himself disappear. While this could be read as a critique of colonialism, in the same vein as film like *The Mummy* (1999) where a white man's hunger for exploration is punished, it also reinforces orientalist stereotypes of a mystical, magical, and foreign other (especially in contrast to modern, rational adventurers). The spatial elements of these S.E.A. attractions also contribute similarly to reinforcing these ideals, which are particularly visible at Hong Kong Disneyland's Mystic Manor. The ride is set in yet another colonial mansion, but one that is an amalgamation of several colonial architectural styles. It's reportedly been inspired by the Carson Mansion, a Victorian gingerbread house in Eureka, California,[footnote]"Mystic Manor," *The Disney Wiki*, https://disney.fandom.com/wiki/Mystic_Manor.

pleasing and sensitive manner. . . . [And] to equip and mount socio-cultural expeditions to discover, explore, chronicle and protect the artistic achievements of human society, past and present, exalted and forgotten."[12] This narrative of "forgotten" history is always one of whiteness, as history is framed as something to uncover and consequently make available to a Western audience, while erasing Indigenous knowledge and life worlds.

Deborah Philips has defined such exploration and adventure narratives as the "Empire Boys Genre": "the adventure story . . . dealing with areas of history and geography that placed [the colonizer] at the top of the racial ladder and at the helm of all the world."[13] The ride narrative of Mystic Manor centers on an enchanted music box's magical powers, set loose by Albert, which wreak havoc on Lord Henry's possessions. However, both Albert and the Lord, as well as the ride visitors, escape unharmed, as do the artifacts—in contrast to Hightower. Generally, then, these stories tie in with (Disney) theme park's general depictions of the "exotic" as part of Adventureland and similar themed areas as locales "without mosquitos, monsoons, and misadventures"[14] but with the "cute colonial racism"[15] very much intact. Such "armchair colonialism," as I have called it elsewhere,[16] "continue to give the West, and America in particular, the power to narrate."[17]

This also extends to the park's common paratext, the map,[18] as a powerful tool of colonial hegemony and narration, as it directly puts the visitor into the shoes of explorers. As John Urry has posited, tourism and its connected "tourist gaze" are direct outgrowths of colonialism.[19] The theme

12. "Society of Explorers and Adventurers," *The Disney Wiki*, https://disney.fandom.com/wiki/Society_of_Explorers_and_Adventurers.
13. Deborah Philips, *Fairground Attractions: A Genealogy of the Pleasure Ground* (London: Bloomsbury, 2012), 146.
14. Stephen Fjellman, *Vinyl Leaves: Walt Disney World and America* (Boulder, CO: Westview Press, 1992), 226.
15. Ibid., 225.
16. Mittermeier, *Cultural History*, 174.
17. Philips, *Fairground Attractions*, 163.
18. See Florian Freitag's chapter in this book, "The Happiest Virtual Place on Earth: Theme Park Paratextuality."
19. Urry and Larson, *Tourist Gaze*.

park, with its roots in World's Fairs and Expositions and racist history of "*Völkerschauen*" (human zoos) written back into such rides as the Jungle Cruise, is equally part of this. Arguably, none of this is new: such observations about theme parks, and particularly Disney theme parks, have long been the focus of scholarly works on the subject. I would also argue that this colonial ideology also underpins the larger project of transmediality.

Transmedia Storytelling

One central component of transmedia storytelling is "a process where integral elements of a fiction get dispersed systematically across multiple delivery channels for the purpose of creating a unified and coordinated entertainment experience. Ideally, each medium makes its own unique contribution to the unfolding of the story."[20]

S.E.A. clearly does this as it has been extended to include several global attractions—in addition to the aforementioned—including the Oceaneer club on the Disney cruise ships; the Trader Sam's Tiki bars in the resorts in California and Florida; the Miss Adventure Falls ride at Typhoon Lagoon water park at Walt Disney World; and Camp Discovery at Shanghai Disneyland while folding in existing staples such as the Jungle Cruise. The addition of the Skipper Canteen restaurant to Magic Kingdom Park built on some of the existing lore of this ride, such as the Schweitzer Falls waterfalls, named for Dr. Albert Falls, turning this fan-favorite pun into a fully-fledged character. The upcoming refurbishment of the ride will also further build on this by including his daughter, Sneh Falls[21] (herself a colonial subject), thus making the fictional family more clearly part of S.E.A. by tying into the additional worldbuilding done by the feature film *Jungle Cruise* (2021).

20. Jenkins, "Transmedia Storytelling 101."
21. Michael Ramirez, "Jungle Cruise Adds New Characters, Mischievous Wildlife and Skipper Humor to Classic Attraction," *Disney Parks* (blog), March 19, 2021, https://disneyparks.disney.go.com/blog/2021/03/jungle-cruise-adds-new-characters-mischievous-wildlife-and-skipper-humor-to-classic-attraction/.

At Disney Springs, the shopping and dining district at Walt Disney World, the themed bar Jock Lindsey's Hangar Bar now cements the connection between the Indiana Jones story world as S.E.A.'s Jock Lindsey was Indy's pilot, seen during the opening sequence in *Raiders of the Lost Ark* (1981). It remains to be seen whether the forthcoming *Indiana Jones and the Dial of Destiny* (2023) will include any nods to this; as Disney now owns the franchise outright after having acquired Lucasfilm, it would not be out of the question.

The multimedia conglomerate's strategies that make such transmedial narration roots in colonial ideology possible are food for another discussion, but let us turn here to the clear connections to the practices of participatory culture. As Williams has argued, "theme parks and the transmedia opportunities they present are often 'pieced together over time.'. . . transmediality in the theme park . . . is also frequently a more organic and fan-led process than more typical dominant models [of transmedia]."[22] At this point, only the most die-hard fans of Disney parks are likely aware of S.E.A., as clues to it are mostly hidden in waiting queues and absent from paratexts such as maps and park apps and puzzled together on fan-led online resources such as the *Disney Wiki* or Facebook groups. To know about S.E.A. and connect the dots, you need to put in active fan labor. As it is, S.E.A. as a story world mostly exists in virtual fan spaces. Megan Condis and Bobby Schweizer have studied this fan engagement and concluded that part of the draw of puzzling together these easter eggs is the feeling of being in a "secret society"—much like S.E.A. itself—and that this story world is seemingly only available to the interested fan, even if hidden in plain sight.[23]

Yet, it seems clear that Disney is willing to change this and elevate S.E.A. from a hardcore fan experience to a more broadly accessible story world. The official Disney fan club, D23, still caters to their most avid fans, but it is worth noting that their Destination D fan event in 2016 acknowledged the S.E.A. story world in panels with Imagineers and merchandise sold.

22. Williams, *Theme Park Fandom*, 12.
23. Megan Condis and Bobby Schweizer. "Enlisting Fans in the Society of Explorers and Adventurers." *Society for Cinema and Media Studies Annual Conference 2022*. Chicago, IL, 2022.

The blockbuster film *Jungle Cruise* (2021) also reaches out beyond this audience, as does a forthcoming book series, and most importantly, the forthcoming television series *Society of Explorers and Adventurers*. Created by Ronald D. Moore and set to premiere over the coming years on Disney+, it definitely has the potential to further expand S.E.A. into a viable franchise of its own. The show is also reportedly connected back to a larger Magic Kingdom framework that points to Disney's desire to keep building on their theme parks as source material for such a franchise (or even several franchises).

S.E.A., however, is not the only Disney Park story world that engages in these practices. One other key example for transmedia storytelling under the Walt Disney Company's roof is the Marvel Cinematic Universe (MCU), now also a source for an ever-expanding presence at the theme parks. The MCU is one of Disney's most elaborate transmedia franchises and it has expanded with the active intent of such fan engagement that Disney also wants to foster with S.E.A. (*Star Wars*, of course, has long grown into something similar). Due to an agreement born out of a long-standing court case over licensing rights with Comcast/Universal, Disney is only allowed to build theme park attractions themed to a select few of the Marvel properties they own east of the Mississippi, AKA at Walt Disney World.[24] This, however, has not hampered their ability to build these elsewhere, and Marvel-based attractions at Disney's other parks are on the march. Since 2018, an *Iron Man* simulator ride similar to Star Tours can be found at Hong Kong Disneyland, and in 2019 an *Ant Man and the Wasp* attraction replaced Buzz Lightyear Astro Blasters there. In June of 2021, the first Avengers Campus opened at Disney's California Adventure, and the Hong Kong park is planning a similar expansion. That same June, Disneyland Paris Resort opened its rethemed Hotel New York—Art of Marvel and yet another Avengers Campus opened at the Walt Disney Studios Park there in July of 2022. The *Disney Magic* cruise ship has been hosting Marvel Days at Sea since 2018, and at Walt Disney World's Epcot, a *Guardians of the Galaxy*-themed indoor roller coaster opened in May of 2022.

24. Sharon Kennedy Wynne, "Here's Why Walt Disney World Will Likely Never Get a Marvel Theme Park," *Tampa Bay Times*, June 14, 2019, https://www.tampabay.com/fun/heres-why-walt-disney-world-will-likely-never-get-a-marvel-theme-park-20190614/.

Building attractions on such a massive franchise is of course not new—what's new, however, is the clear intent for transmedial worldbuilding and participatory engagement underlying these lands. Since the opening of the land in Anaheim, it has become clear that the parks are cleverly used to promote the MCU televisual and cinematic properties as they are released: while the first season of television series *Loki* (2021–) aired on Disney+, the Loki theme park character changed appearance in accordance with the newest episode. This is not only a nice gimmick for existing fans, but it also sparks fan engagement with those already invested in such character meets[25] and garners interest in following along with the show weekly (and in subscribing to Disney to do so!). This is a form of "drillable immersion"[26] where layers of immersion only become available at an upcharge. This is even more clearly the case with the "webslinger" devices guests can buy at a particular Avengers Campus retail location to unlock different features on WEB SLINGERS: A Spider-Man Adventure. The system borrows from MMOPGs and online gaming by generating extra revenue through upselling, further cementing connections to other "virtual interiorities" in a consumer-capitalist landscape.

What is more, the stated goal of the Avengers campuses, as presented at D23 Expo in 2019, is to interconnect them internationally. While it is not quite clear how exactly the lands will do so, the connection fosters a mentality to motivate fans to travel to all the international parks. Naturally, it is still possible to enjoy the Avengers campuses separately or the WEB Slingers ride without surcharge, but the way these transmedial story worlds function is to invest fans to a degree that makes them want to complete all the experiences possible. On a narrative level, that also means uncovering all parts of the story—if you are an avid fan of the MCU, you watch every film, TV series, and so on, and it might now also mean visiting all Avengers campuses in the world.

25. Williams, *Theme Park Fandom*, 133–52.
26. Besides the Screen, "Down Into the Vaults."

I argue then that when this participatory culture is actively encouraging such global media tourism, it is rooted in an ideology not unlike what Urry has described for tourism more broadly: a quasi-colonialist agenda. Thus, even while the MCU itself does not perpetuate colonial imagery and stereotypes, the fan engagement with it, at least in the spatial medium of the theme park, follows an ideology of consumption that in and of itself is colonial.

When the drive to explore and uncover the unknown—also found in fan engagements with the films and TV series of the MCU—is paired actively with travel to different places, it takes on new connotations. And when it comes to the multi-location story world of S.E.A. (which also expresses colonial narratives at the textual level), it even more clearly showcases the colonial roots of these practices and spaces, or virtual interiorities. Thus, while Disney has begun to retheme and remove some of the more obviously problematic depictions of racialized bodies in attractions such as the Jungle Cruise in a strive for inclusion and diversity, colonial ideology continues to underpin their theme parks on a much more integral level. Michelle Anjirbag has also noted these practices for Disney's film industry:

> Such diversity, though addressing (in very small ways) postcolonial identity politics that are both salient and fraught in the current geopolitical climate, nevertheless serves Disney's corporate interests: (re)producing coloniality and a colonizing progression decentralized from the nation-state but rooted in the projection of a particular "global" culture, or Disney's overarching, central and dominating view of the world as it should be, through its traditionally White, heteronormative, conservative, Christian, middle-class lens.[27]

27. Michelle Anjirbag, "Reforming Borders of the Imagination: Diversity, Adaptation, Transmediation, and Incorporation in the Global Disney Film Landscape" *Jeunesse* 11, no.2 (2019), 151.

This also directly aligns with Disney's impetus for their theme parks as spaces that cater to a white middle class, or as I have referred to them elsewhere, "middle-class kingdoms."[28] Their more recent forays only cement this further, but thus also highlight how transmedia practices themselves are largely rooted in such US- and Eurocentric ideologies. As Disney expands these further, they are continuing to build on their (cultural) imperialist legacy.

Conclusion

As Disney further expands their theme parks, their goal is to increase immersion through both virtually and physically embodied spaces of fandom and participatory culture. By interconnecting these sites with the narrative connective tissue of story worlds such as S.E.A. or the MCU, they encourage visitors to travel to all their international resorts and thus actively foster transmedia tourism. These practices, however, are rooted in colonial ideologies of exploration, and consequently make them hard to align with Disney's recent efforts in increasing diversity. Furthermore, they also expose transmedial practices at large as being intrinsically connected to colonial thought and practice. What these practices then also showcase for the entertainment and, more specifically, theme park industries is a turn towards a more overt catering to fandom, as well as a clear interest in increasing immersivity through such affective and participatory practices. Thus, studying these practices closely will further expand our understanding of virtual interiorities and their significance, as well as what the future holds for multi-media conglomerates like Disney's ever-growing global reach.

Bibliography

Anjirbag, Michelle. "Reforming Borders of the Imagination: Diversity, Adaptation, Transmediation, and Incorporation in the Global Disney Film Landscape." *Jeunesse* 11, no.2 (2019): 151–176.

Condis, Megan, and Bobby Schweizer. "Enlisting Fans in the Society of Explorers and Adventurers." *Society for Cinema and Media Studies Annual Conference* 2022. Chicago, IL,

28. Mittermeier, *Cultural History*, 12.

2022.

Fjellman, Stephen. *Vinyl Leaves: Walt Disney World and America*. Boulder, CO: Westview Press, 1992.

Garner, Ross. "Transmedia Tourism Editorial." *JOMEC Journal* 14 (2019): 1–10.

Jenkins, Henry. "Transmedia Storytelling 101." *HenryJenkins.org*, March 21, 2007, http://henryjenkins.org/blog/2007/03/transmedia_storytelling_101.html.

Marling, Karal Ann. "Disneyland, 1955." *American Art* 5 (Winter/Spring 1991): 167–207. https://doi.org/10.1086/424113.

Mittermeier, Sabrina. "(Un)Conventional Voyages? *Star Trek: The Cruise* and the Themed Cruise Experience." *The Journal of Popular Culture* 52, no. 6 (2020): 1372–13.

———. "Indiana Jones and the Theme Park Adventure." In *Excavating Indiana Jones: Essays on the Film and Franchise*, edited by Randy Laist, 192–202. Jefferson, NC: McFarland, 2019.

———. "Theme Parks—Where Media and Tourism Converge." In *The Routledge Companion to Media and Tourism*, edited by Maria Mansson et al., 27–35. London: Routledge, 2020.

———. *A Cultural History of the Disneyland Theme Parks. Middle-Class Kingdoms*. Bristol: Intellect, 2021.

Moulton, Carter. "Down Into the Vaults: Drillable Immersion at Franchise Lands (Carter Moulton, Northwestern)" Uploaded on June 4, 2021. YouTube video, 25:01. https://www.youtube.com/watch?v=jNXiel-PjuQ.

Philips, Deborah. *Fairground Attractions: A Genealogy of the Pleasure Ground*. London: Bloomsbury, 2012.

Ramirez, Michael. "Jungle Cruise Adds New Characters, Mischievous Wildlife and Skipper Humor to Classic Attraction." *Disney Parks* (blog), March 19, 2021. https://disneyparks.disney.go.com/blog/2021/03/jungle-cruise-adds-new-characters-mischievous-wildlife-and-skipper-humor-to-classic-attraction/.

"Society of Explorers and Adventurers." *The Disney Wiki*. https://disney.fandom.com/wiki/Society_of_Explorers_and_Adventurers.

Telotte, Jay P. *Disney TV*. Detroit: Wayne State University Press, 2004.

Urry, John, and Jonas Larsen. *The Tourist Gaze 3.0*. London: SAGE, 2011.

Williams, Rebecca. *Theme Park Fandom: Spatial Transmedia, Materiality, and Participatory Cultures*. Amsterdam: Amsterdam University Press, 2020.

Wynne, Sharon Kennedy. "Here's Why Walt Disney World Will Likely Never Get a Marvel Theme Park." *Tampa Bay Times*, June 14, 2019. https://www.tampabay.com/fun/

heres-why-walt-disney-world-will-likely-never-get-a-marvel-theme-park-20190614/.

Agent P vs. the Drunks

Competing Interiorities in the Theme Park Space

Jennifer A. Kokai and Tom Robson

The Italy Situation

The collision occurred in Epcot's "Italy." It was a Saturday during Food and Wine Festival season, which meant that the park was extra crowded with both local guests and by the Food and Wine infrastructure itself, which adds dozens of booths, distributing food and beverages, to the park. While Epcot has recently become characterized as a party environment, Food and Wine season is known as an especially debaucherous time to be in the park, with alcohol literally never more than steps away. This reputation proved true when, about midday, a giddy, childless day drinker enjoying their glass of wine in their quest to "drink around the world" fell off the steps of the manicured landscaping, stepping on the weary child who was resting halfway through his quest to defeat Dr. Doofenshmirtz, the villain of both the television show *Phineas and Ferb* and the "Agent P's World Showcase Adventure" at Epcot. The drunk adult didn't notice; the child began to cry, as much out of fear of the out-of-control adults as the physical contact.[1]

1. Oliver Kokai-Means, "Personal Interview with Oliver Kokai-Means," July 28, 2013.

The EPCOT Center theme park emerged from Walt Disney's original concept for what he called an "Experimental Prototype Community of Tomorrow." Walt's EPCOT would feature some 20,000 residents living and working in this environment, making it the utopian community Disney always desired. Following the company founder's passing, however, plans for his "Progress City" withered. When EPCOT Center opened in 1982, it bore little resemblance to Walt's idea but rather became the Walt Disney Company's second "gate" at the Walt Disney World Resort in Orlando, Florida. Gone were any residential aspects, and instead EPCOT Center existed as something of a permanent World's Fair, split into two halves. At the front half of the park sits Future World, a collection of corporate-sponsored pavilions showcasing the latest in science and technology through rides and shows. At the back sits World Showcase, a ring of pavilions themed to (and partially paid for by) countries from around the world. Conservative columnist Herbert London, writing in the *Orlando Sentinel* a few years after EPCOT Center's opening, called the park "the true embodiment of the American dream," emphasizing the "message of promise" that ran through pavilions such as The Wonders of Life and Spaceship Earth and continued "around the world" through the nations of the World Showcase.[2] This promise, echoing its ancestor the World's Fair, was the notion of progress through benevolent corporations as each attraction was sponsored by and heavily featured a specific corporation's technology.

Gottwald and Turner-Rahman argue that the Disney parks were influenced by what they refer to as the "filmic regime" of spatial planning organized through the storyboarding process. They state, ". . . storyboards provide cohesion. They also work as a diagram—a map of acts, scenes, and transitions between."[3] Adopting this logic, each pavilion at

2. Herbert London, "Epcot Is the True Embodiment of the American Dream," *Orlando Sentinel*, August 21, 1985, 237.
3. Dave Gottwald and Gregory Turner-Rahman, "Toward a Taxonomy of Contemporary Spatial Regimes: From the Architectonic to the Holistic," *The International Journal of Architectonic, Spatial, and Environmental Design*, 15, no. 1 (2021): 115. https://doi.org/10.18848/2325-1662/CGP/v15i01/109-127.

Epcot undeniably has such sequences, but Epcot as a park leaves vast swaths of green space between pavilions. Essentially, it leaves gaps where no overt story is imposed upon the space. There is elaborate landscaping design, but that landscape is largely inert.

In his book *The Global Theme Park Industry,* Clavé argues that a theme park includes "a specific narration which runs transversally throughout the whole project and substantivates all of its components."[4] Clavé describes this overarching narrative organizing the overall tourist experience by "establishing the bases of functioning in the time and space of the universe that is created."[5] This narrative experience exists within each pavilion, to a greater or lesser degree, but especially with the aging of some rides, dismantling of areas like Innoventions that demonstrated new and changing technological experiences, and the heavily-idealized nostalgia of World Showcase, there is no clear story an Epcot guest can immerse themselves in. Epcot has attempted to address this deficit for children through the addition of optional participatory narrative games and, as we will discuss later, has recently explicitly admitted the lack with the current project to construct a pavilion literally called "Play."[6] This does not address the absence for adults who also require their own experiences of play and narrative in leisure activity.

Unlike many studies (including Gottwald and Turner-Rahman's on theme parks and immersive settings) that find their origins in film, we always proceed from their connection to a theatrical legacy. Another way of understanding storyboards is of course to see them as a theatrical script, a visual and literate blueprint for the ultimate product that is a jointly constructed set of meanings made between the producers and the audience. The spatial gaps between attractions in the park can be seen as the construction of a stage, occupied by performers, who have been given no script. The theatrical tradition is one that has found close interaction and influence between audience and performer across cultures and across millennia, often in site-specific locations. From the participatory nature

4. Salvador Anton Clavé, *The Global Theme Park Industry*, (Cambridge: CABI, 2007), 33.
5. Clavé, *The Global Theme Park Industry*, 33.
6. Throughout 2022 it has been rumored that Disney has cancelled the Play Pavilion project.

of the Yoruban Egúngún, with spectators cheering, dancing, and drumming along with masked and costumed processional performers[7] to the well-documented use of pageant wagons in the European medieval theatre, where wheeled structures featuring scenery and costumed actors were processed through towns as part of civic-religious festivals,[8] theatre has historically exploded the boundaries of the playhouse. Shakespeare's famous "All the world's a stage" line is as historically accurate as it has become metaphorically cliché.[9] The avant-garde environmental theatre of the 1960s famously blurred—if not erased—the line between actor and audience, with Richard Schechner's participatory, orgiastic *Dionysus in 69* as the most famous example.[10] Set against this historical backdrop, we recognize the theme park for what it is: just another theatre space. Elsewhere we have argued that Disney tourists are put in the roles of actors when they visit the parks.[11] Physical spaces are not activated as places of meaning making until they are acted upon and against by performers (tourists), and performances cannot ignore the physical space they are located in. Essentially, Epcot's design leaves a lot of room for improvisation.

In this chapter, we explore how these guests choose to create or participate in differing virtual games laid over top of the geographical space and what happens when these alternate uses of the park come into conflict. Each of these performances represents an attempt at collaboration between Imagineer and tourist, or put differently, between designer and tourist-as-actor, and viewed collectively they demonstrate the ways in which interiority collision is an inevitable byproduct of such wide-open

7. Tobin Nellhaus, "From Oral to Literate Performance," *Theatre Histories: An Introduction*, 3rd edition, ed. Bruce McConachie, Tobin Nellhaus, Carol Fisher Sorgenfrei, and Tamara Underiner (New York: Routledge, 2016), 33–37.
8. See, for example, William Tydeman, *The Theatre in the Middle Ages: Western European Stage Conditions, c. 800–1576*, (Cambridge: Cambridge University Press, 1978).
9. William Shakespeare, *As You Like It*, V, vii, 139.
10. Arnold Aronson, *American Avant-Garde Theatre: A History* (New York: Routledge, 2000), 97–100.
11. Jennifer A. Kokai and Tom Robson, "You're in the Parade: Disney as Immersive Theatre and the Tourist as Actor," *Performance and the Disney Theme Park Experience: The Tourist as Actor*, ed. Jennifer A. Kokai and Tom Robson (Cham, Switzerland: Palgrave Macmillan, 2019), 1–20; Jennifer A. Kokai and Tom Robson, "Disney during Covid-19: The Tourist and the Actor's Nightmare," *Journal of Themed Experience and Attractions Studies* 2 (2022): 17–20, https://stars.library.ucf.edu/jteas/vol2/iss1/5.

themed spaces. That is indeed exactly what was happening in the moment described at the outset of this chapter: both sets of guests were invested in completing their own virtual interior games—both encouraged by Epcot's architecture and design—but those games were intended to be entirely separate experiences for entirely different audiences, making this physical collision in real space an unfortunate happenstance. Ultimately, it is our argument that guest behavior at Epcot and the imposition of competing virtual interiorities onto the space offer an example of both the promise and the pitfalls of the notion of individualizing a theme park experience through virtual experiences projected onto a shared space.

Experience and Narrative

"Experience" is generally recognized by tourism scholars as crucial to the success of a theme park for any age. Pikkemaat and Shuckert note, "experiences should offer not only fun and pleasure but also increasingly a clue, a message or sense."[12] In addition to its lack of a coherent message, in comparison to the other parks, the current iteration of Epcot offers relatively few "experience"-based attractions. An analysis of online comments on message boards, Reddit threads, and vacation-planning services often reveals a single word: "Boring." One Reddit user called it "easily the worst park on Disney property" calling it "overall very boring and easily the most skippable."[13] In 2015 a reviewer on TripAdvisor wrote, "The 'rides' are outdated and boring. A child with our group fell asleep on one. Waste of a day."[14] Even prominent Disney tourism sites like *Disney Tourist Blog*, *AllEars*, and *Inside the Magic* often frame their discussion of

12. Birgit Pikkemaat and Markus Schuckert, "Success Factors of Theme Parks—An Exploration Study," *Tourism: An International Interdisciplinary Journal* 55, no. 2 (June 2007): 197–208.
13. Redditismycrack, "Epcot is definitely the worst park.. Ya'll are crazy," *Reddit*, https://www.reddit.com/r/WaltDisneyWorld/comments/85lwlz/epcot_is_definitely_the_worst_park_yall_are_crazy/.
14. James H Terry, "Outdated and Boring," *TripAdvisor*, April 7, 2015, https://www.tripadvisor.co.za/ShowUserReviews-g34515-d126541-r264127514-Epcot-Orlando_Florida.html.

Epcot in the context of complaints that the park is "boring."[15] Perhaps most of all, these complaints have stated that Epcot offers little for younger tourists to experience, with the park having relatively few rides when compared with the more child-friendly Magic Kingdom.

Unlike other Disney parks, EPCOT Center (which was shortened to simply "Epcot" in the early 1990s) has historically sought to interpolate guests through abstract concepts like imagination, communication, and movement, rather than the narrative stories that comprise the attractions at Magic Kingdom (1971), Disney's Hollywood Studios (1989), and even Disney's Animal Kingdom's (1998) guided walking paths. Each concept is housed in its own pavilion, similar to a museum. Epcot modeled "the convergence between education and entertainment," otherwise known as Edutainment, a trend more common to late-20th Century museums than theme parks.[16] While some might argue that it is this focus on Edutainment that is itself dated or irrelevant, especially given the ubiquity of the internet, families still prize embodied experiences with a learning component. Hilbrecht et al. argue that amusement parks (and by extension, theme parks) as family tourist destinations exhibit a "concerted cultivation" attitude towards child rearing.[17]

15. Tom Bricker, "World Showcase: Borefest or Brilliant?," *Disney Tourist Blog*, https://www.disneytouristblog.com/world-showcase-epcot-boring/; Taylor, "The 'Boring' Disney Rides We Absolutely Love," *AllEars*, January 21, 2021, https://allears.net/2021/01/21/the-most-boring-disney-world-rides-we-actually-love/; Becky Burkett, "Op-Ed: Think Epcot is boring? These will change your mind," *Inside the Magic*, January 18, 2020, https://insidethemagic.net/2020/01/epcot-attraction-artwork-not-boring-bb1/.
16. Michela Addis, "New Technologies and Cultural Consumption–Edutainment Is Born!," *European Journal of Marketing* 39, no. 7–8: 730. See also Pierre Balloffet, François H. Courvoisier, and Jöelle Lagier, "From Museum to Amusement Park: The Opportunities and Risks of Edutainment," *International Journal of Arts Management* 16, no. 2 (Winter 2014): 4–5.
17. Margo Hilbrecht, Susan M. Shaw, Fern M. Delamere, and Mark E. Havitz, "Experiences, Perspectives, and Meanings of Family Vacations for Children," *Leisure/Loisir* 32, no. 2 (2008): 541–571, https://doi.org/10.1080/14927713.2008.9651421. The semantic distinction between "amusement park" and "theme park" is well documented across Disney scholarship. See, as just one example, Janet Wasko, *Understanding Disney: The Manufacture of Fantasy* (Cambridge: Polity Press, 2001), 56.

A "concerted cultivation" approach suggests that activities for children in middle-class families are carefully selected by parents for their educational and developmental value with fewer opportunities for spontaneous or unsupervised play.[18] Family activities have also been identified as sites of "purposive leisure," or leisure that is "planned, facilitated, and executed by parents in order to achieve particular short and long-term goals."[19] Goals may vary, but often include developing family cohesion and instilling family values.[20]

A vacation is less about what it actually provides for the family than an opportunity to perform values for their children and ask their children to do the same for others through mimesis. So, it is not its focus that makes Epcot boring, but rather the way edutainment is deployed in design.

Embedded in the idea of "experience" are the qualities of play and narrative, which Epcot is largely without. They are not spaces one can inhabit nor interpret. Interactive areas, splash pads, or playground equipment have come and gone throughout the history of the park, but these spaces are quite small and, in the case of the metal playground equipment, can be rendered unusable by the brutal Florida sun.

Without opportunities for play, narrative, or experience, guests attempt to construct their own purpose or meaning for their visits, which ultimately allows for a wider variety of virtual interiorities that overlay the same physical space. Disney Imagineers, clearly recognizing this lack of guests' clear interpretive lenses, have provided sanctioned ways to create a coherent narrative with a clue, message, or sense, like the aforementioned "Agent P" game, as well as ultimately codifying guest-created games like "Drinking Around the World" through the addition of Food and Wine festival passports. That these are both virtual games (or, we might argue, scripts with characters, objectives, and meanings) is explicitly noted by Disney fans such as Bart Scott, who writes in his guidebook

18. Annette Lareau, *Unequal Childhoods: Class, Race, and Family Life* (Berkely and Los Angeles, CA: University of California Press, 2003).
19. Susan M. Shaw and Don Dawson, "Purposive Leisure: Examining Parental Discourses on Family Activities," *Journal of Leisure Research* 33 (2001): 217–31.
20. Hilbrecht et al., "Experiences, Perspectives, and Meanings."

Ears of Steel, "A few years back, Epcot created an interactive, role-playing experience called the Kim Possible World Showcase Adventure . . . that's great and all, but the reality is there's been an interactive World Showcase game being played for years, at least by the over-21 crowd."[21]

"Listen Up Now Agents": Theme Park as Spy Movie

Agent P's World Showcase game was the second iteration of Disney's attempt to provide structure and intention to the World Showcase for child visitors. The first iteration, opening in 2006, was themed on the television series *Kim Possible* (2002–2007), about a teenage spy working with a team of young people to stop the villain Dr. Drakken. In 2012, the game was retooled to center on the show *Phineas and Ferb* (2007–2015), which also includes a villainous inventor, Dr. Doofenshmirtz, and a superspy—in this case, Perry the Platypus. Putting participants in the role of a superspy was an ingenious choice because it encouraged children (or adults) to view stealth and blending into a crowd as desired behaviors for a good spy, which avoids disrupting guests using the same spaces in the park in other ways.

Both versions originally utilized a flip phone that was loaned to players and allowed them to interact with secret special effects in some of the World Showcase pavilions. This meant that, in the early era, it was quite obvious who was playing the game—just look for those with the flip phones. In 2016, the game was revised to allow players to use their own cell phones or the flip phone, and, in 2018, the flip phones were retired, and guests had to play through the Disney "Play" app. This was much higher quality technology, but it also served to obfuscate players who now just looked like any guest glued to their smartphones, a number which had been growing significantly every year. Additionally, this altered the game to limit accessibility. Guests now had to own a smartphone with a data plan to participate, presenting both economic (cost of an up-to-date device with plan) and practical (skill in downloading and installing apps) barriers.

21. Bart Scott, *Ears of Steel: The Real Man's Guide to Walt Disney World* (Branford, CT: The Intrepid Traveler, 2014), 51.

In every iteration of the game, players started at clearly marked booths where a Disney cast member would ask them if they were interested in participating and explain the activity. Each group of guests would be issued one phone, usually handed to a child in the family, and then decide which World Showcase pavilion to begin in. Being handed a phone, and therefore controlling the movements of your family group, gives children not only some of the autonomy and independence they value in an experience but also authority over their entire familial group: two of the qualities of experiential play Hilbrecht et al. identifies as highly valuable to children. Different country pavilions housed an entire "mission" although it was randomized by altering the order of activities and exactly which activities were required. Players were instructed to move to certain locations (or sometimes even just to move in any direction for thirty feet or so, presumably to avoid creating traffic jams) to provide answers to questions only available by visually assessing the location. After questions were successfully answered, a hidden special effect would be revealed. Special effects were largely kept consistent from game to game and included characters from the shows popping up, objects like beer steins that had appeared to just be decoration singing, and rockets emerging out of a volcano.

In her overview of play theories, Doris Bergen summarizes Eva Neumann's foundational definition of play as "how much internal control the person had over the activity, what level of internal reality was present, and if there was internal motivation to engage in the activity. She stated that most playful actions have children in control, making up their own reality, and doing the activity because they want to do it."[22] Unlike rides, in which visitors are confined to small vehicles and their attention guided, or activities that require payment and thus permission, Agent P's World Showcase players find their own paths—whether as the game intended or not—largely at will. The game is active and not passive: the players make something special happen at Disney World that maybe only their group observes. There is no prize at all, and thus the reward for

22. Doris Bergen, "Foundations of Play Theory," *The SAGE Handbook of Play and Learning in Early Childhood*, ed. Elizabeth Brooker, Mindy Blaise, and Susan Edwards (United Kingdom: SAGE Publications, 2014), 12.

doing it is intrinsic only. Children's motivations could include an affective relationship with the characters of the television shows represented, a desire for completion or "to win," or creating an internal reality and character of oneself as a spy as the game suggests, but all of these are outside of the park's prevailing consumption model.

There are relatively few non-explanatory videos that document groups playing the game, but those that do include participants depict them as being invested and empowered by the experience. One group of four girls huddled around their flip phone shows one exclaiming, "It's vibrating!" and excitedly dashing to the next location.[23] Another shows two very young boys being earnestly spoken to by the cast member who is down on her knees to address the boys directly and give them directions on how to play the game. She gives the two a strategy on how to take turns controlling the phone and the game so both feel included.[24] It is clear from even these limited videos that a major part of the appeal for the children playing is the sense of agency they get from the experience.

Not every park guest is even aware of the attraction or those participating in it, particularly those without children. The game is intentionally designed to blend in with the pavilions both to maintain their theming and to elicit surprise and discovery when a secret element is revealed: the mapping on top of the geographical space is largely virtual. This is especially true given the move to an individual's smartphone and away from the flip phones. While a savvy spectator could identify who was playing the game, there is nothing in the clothing nor much of the behavior of those participating to identify them as "volunteer superspies." Their new identity is an interior one, a mental framework to reshape existing space and attractions as more exciting and purposeful for those playing. What the choice to construct this as an overlay means, however, is that other tourists have no incentive to make room or defer to the children playing the game. They might not even know the children are playing a sanc-

23. Jason McIntyre, "The girl agents play Kim Possible World Showcase Adventure," uploaded on July 3, 2010, YouTube video, https://www.youtube.com/watch?v=P-_Sezpi5jg.
24. WorthMelting4, "Family Disney World Vlog / July 2015 Episode 8," uploaded on January 24, 2016, YouTube video, https://www.youtube.com/watch?v=fU5yN60ckdg.

tioned game with objectives and instead just see them as ill-mannered and pushy in their haste to reach their next target. Because everyone is not in on the game, the objective, or the rules, tourists viewing Epcot through a different framework and pursuing their own agendas might do something like drunkenly step on a weary child spy.

"Listen I'm Tired of Talkin', Let's Start Drinkin'"

The threats of Dr. Doofenshmirtz within the game are pretend, and the game ultimately lacks actual stakes. Perhaps responding to this as rendering the game childish, adult tourists at Epcot have long constructed play-based experiences for themselves that involve risk through the overconsumption of alcohol. Roland S. Moore writes that "most forms of contemporary tourism are inextricably linked to the consumption of alcohol, sometimes in prodigious amounts."[25] Walt Disney famously refused to allow alcohol to be served publicly inside Disneyland, concerned that, just as at boardwalks such as Coney Island which he abhorred, it would lead to a seedy atmosphere and unwelcome antics.[26] When Walt Disney World opened in 1971, the Magic Kingdom was also dry; alcohol was only served at the resort's hotels. However, when Epcot opened in 1982, the company controversially allowed guests to imbibe publicly for the first time within one of their theme parks. Before long, this popped the cork on an "infamous"[27] tourist activity that has come to overwhelm Disney's second gate in recent years: "Drinking Around the World."

In brief, tourists begin on one side of Epcot's World Showcase and over the course of the day drink an alcoholic beverage at each of eleven—twelve if you count the non-pavilion, vaguely "African" "Refreshment Outpost"—stops. While not officially endorsed by Disney, Drinking Around the World has become one of the most popular pastimes for tourists, especially younger adults, in the park. Jason Cochran, writer

25. Roland S. Moore, "Gender and Alcohol Use in a Greek Tourist Town," *Annals of Tourism Research* 22 (1995): 300–313.
26. As has been documented in numerous broad histories of the parks, Disney did permit alcohol to be served in select private locations, including the earliest iteration of the elite Club 33.
27. Carly Terzingi, "The Ultimate Guide to Drinking Around the World at Epcot," *AllEars*, April 18, 2020, https://allears.net/2020/04/18/the-ultimate-guide-drinking-around-the-world-at-disney-epcot/.

for the popular *Frommer's* travel website, refers to Drinking Around the World as "an open secret that visitors have known about for three decades."[28] While the rise of the internet has increased awareness of this practice, park guests have participated in the game since at least the early 90s.[29]

Scores of Disney travel blogs, fan sites, and community forums have documented the practice of Drinking Around the World since the early 00s. Most of these articles present Drinking Around the World uncritically, which is to say that they present it as either an entirely neutral activity or as a celebratory one. Typical content for these articles includes "best drinks" in each pavilion and guides to completing the quest without spending more than $100 per person (on top of Epcot gate admission, which in 2022 could stretch to $179 for a one-day adult ticket). In addition to these written guides to Drinking Around the World, YouTube abounds with videos documenting the pleasure and pain of this adult Disney game.

The act of Drinking Around the World prompts an analysis of various theorized modes of tourism, among them alcotourism,[30] limit tourism,[31] and party tourism.[32] Bell establishes "the 'letting go' that comes with intoxication," and points to the way that alcotourism creates "an ambivalently sanctioned liminal zone" within its location.[33] Carlisle and Ritchie establish a distinction between alcotourism and party tourism, noting that alcotourism—often associated with visiting wineries, pubs, etc.—"does not habitually mean participating in a period of disruptive alcohol consumption and transgressive behaviour which challenges the customs and

28. Jason Cochran, "How to Drink Around the World at Disney's Epcot," *Frommer's*, https://www.frommers.com/slideshows/848005-how-to-drink-around-the-world-at-disney-s-epcot.
29. Personal conversation with former Epcot cast member, recounting their time as an employee in 1992.
30. David Bell, "Destination Drinking: Toward a Research Agenda on Alcotourism," *Drugs: Education, Prevention, and Policy* 15, no. 3 (June 2008): 291–304.
31. Paul Cloke and Harvey C. Perkins, "'Cracking the Canyon with the Awesome Foursome': Representations of Adventure Tourism in New Zealand," *Environment and Planning D: Society and Space* 16, no. 2 (April 1998): 185–218, https://doi.org/10.1068/d160185.
32. Sheena Carlisle and Caroline Ritchie, "Permission to Rebel: A Critical Evaluation of Alcohol Consumption and Party Tourism," *International Journal of the Sociology of Leisure* 4 (2021): 25–44.
33. David Bell, "Destination Drinking."

norms of the environment."[34] The linkage between tourism, alcohol, and transgressive behavior is well established within US culture, perhaps most explicitly with the recent marketing of Las Vegas.[35] The collision of engagements in Epcot align more neatly with their vision of party tourism, but even that term fails to capture the complexity of the situation. In Carlisle and Ritchie's party tourism, participants are guided by tour groups and companies, traveling explicitly to destinations to drink at. Meanwhile, Drinking Around the World is a formally unsanctioned—or perhaps "ambivalently unsanctioned," to return to Bell's analysis—activity contained within a space that is not on its face principally about alcohol consumption.

Tom Bricker, one of the few Disney bloggers to acknowledge the complexity of public drunkenness in a family theme park, describes many of those who participate in Drinking Around the World as "drinking 'teams' replete with matching shirts and obnoxious attitudes."[36] Unlike the children playing a sanctioned game that is designed to be undetectable to other Epcot guests, visibility is often important for guests Drinking Around the World, either in the form of clever, drunk Disney pun shirts or "checklist" shirts where tourists literally write on their clothing with sharpies to celebrate their successful alcoholic conquering of a new "country." At the time of this writing, a cursory search of Etsy reveals over 5,000 results for the search "Epcot Drink Around the World Shirt." One YouTube video featuring a particularly telling chronicle of Drinking Around the World features participants wearing shirts with phrases like "Bibbidi Bobbidy [sic] Booze" and "Can You Feel the Buzz Tonight."

34. Carlisle and Ritchie, "Permission to Rebel."
35. Ironically, at the time of Epcot's opening and the invention of the drinking game, Las Vegas was undergoing a time of financial and tourist decline and shifted to adopt a "family friendly" marketing and attraction approach, as seen in Diana Tracy Cohen, "Family-friendly Las Vegas: An Analysis of Time and Space." *Center for Gaming Research Occasional Paper Series* (2014): 1–12. The slogan "What Happens in Vegas Stays in Vegas" was adopted in 2000 and shifted perceptions of Vegas to be "no longer being defined by its former attractions, but rather by concepts embracing adult freedom." Mike Beirne, "Playing for Keeps," *Brandweek*, October 11, 2004.
36. Tom Bricker, "Drinking Around the World Showcase at Epcot," *Disney Tourist Blog*, https://www.disneytouristblog.com/drinking-around-world-epcot-world-showcase/.

A video, posted by social media "influencer" Showmelovejete, reveals the scale of impact of this particular theme park virtual interior game on the overall park environment. After a brief introduction, Jete says, "Listen, I'm tired of talkin', let's start drinkin'!" The video shows the participants not simply sipping their drinks but chugging them. Over the course of their celebration, they repeatedly violate Disney guidelines for guest behavior. One member of the party disassembles a post in the fencing in front of the water. By the midpoint of the video, the subjects begin slurring their words heavily. At another moment, a young woman climbs onto a table directly in front of the fence separating the walkway from a dropoff into the World Showcase lagoon. Clearly heavily intoxicated in this moment, one wrong step would send this young woman tumbling into the water below. At the end of their travels, the entire group poses for a photo with them all lying on the ground in front of the entrance to the Mexico pavilion, pretending to be unconscious from intoxication and taking up significant space. Through it all, they cheer and scream for the camera and themselves, prompting one to wonder what tourists from outside their party must be experiencing in their presence.[37]

Jete's post is but one video example of guests behaving in this manner in Epcot. Nearly all videos show people slurring their words and most show people feeling sick, with reports of vomiting. YouTuber Kyle Pallo's video shows people jumping around, cheering, screaming, and dancing.[38] Rebecca Dolan of *Thrillist* best sums up guests' rationale for the construction of their virtual cognitive model of Epcot: "When your parents take you to Disney World as a 20-something, you have to justify things. For instance, why would I spend a day in relatively close proximity to the Mad Tea Party spinning cups? Because I'm a grown-ass, responsible adult, the answer was simple: a drinking game."[39] However, this celebration of adult freedoms is not being held in an adult-focused space like Las Vegas. Even beyond the distasteful potential for vomit, research indicates that playing

37. Showmelovejete, "Drinking Around the World at Epcot / Our 21st Birthday (Vlog)," uploaded on March 9, 2021, YouTube video, https://www.youtube.com/watch?v=Or_aDm4b1vM.
38. Kyle Pallo, "The Only Way to do Epcot! – Drink Around," uploaded on April 4, 2018, YouTube video, https://www.youtube.com/watch?v=_KGZ5GDQ5Mw/.
39. Rebecca Dolan, "Epcot Bar Crawl: Your Game Plan for Drinking in 11 Fake Countries," *Thrillist*, February 4, 2015, https://www.thrillist.com/drink/nation/drinking-around-the-world-drink-at-epcot.

this game in this space is not entirely harmless, despite the intentions of the participants. Research shows that even very young children can determine when an adult is intoxicated and when that limit crosses to highly intoxicated. In a *BBC* survey, 30% of children said the presence of inebriated adults was scary, as they became stupid, silly, aggressive, or weird (essentially unreliable as larger powerful figures now with no assurance of security or authority), and research by the Institute of Alcohol Studies indicated that seeing heavily intoxicated adults normalizes such drinking for children and ultimately influences their adult alcohol consumption.[40] Performing adult leisure as based upon excessive alcohol consumption in front of children does negatively influence their long term health outcomes, adding a new underrecognized element of "losing" to this particular game.

More than enjoyment of the alcohol itself, the adults in these videos or accounts demonstrate a focus on "winning" the game of proving adult independence. This is best illustrated by a video posted by Kate Lindinger, of the YouTube channel "Princess Minnie." Her plan originally appeared to be to distract part of their group, including the children with them, with the Agent P game while two of the adults drank around the world. "These are the people involved in the mission," she mutters, panning her phone over three other adults and the one child huddled over the phone. "My mission is margaritas," she says, turning the camera back to herself and wiggling her eyebrows. However, only minutes later she is sucked into the game and declares "I want to do this!" and "That is SO cool" as they trigger the appearance of Doofenshmirtz and his evil invention on top of a roof. As the video goes on, she grows more and more enthusiastic about the Agent P game, which she recommends for adults, while continuing the Drink Around the World game, even to the point of ordering beverages she states she does not like. "It's not bad," she says after sipping her alcoholic iced coffee, "but it's not good." The women repeatedly chose drinking—even drinks they have expressly declared they do not like—over

40. See "Third of Children 'Scared' by Adult Drinking," *BBC News*, July 4, 2010, https://www.bbc.com/news/10491057; Jose Luis Vazquez Martinez, "Like Sugar for Adults: The Effect of Non-Dependent Parental Drinking on Children and Families," published by the Institute of Alcohol Studies (IAS) (2017): 1–82.

the Agent P game, which they confessed they did like. After five drinks, one woman has a sixteen-year-old girl helping her walk, and, after seven, she drunkenly slurs that they're taking a break from alcohol while their family goes on rides.

This example provides insight into why people engage in Drinking Around the World (even while saying they don't like the drinks and harming their own health). Drinking Around the World, by virtue of legal drinking ages and costs, is a game only available to adults. But it is play. Reflecting on Bergen's definition, the motivations are internal but significant to players, even when "winning" seems to involve drinking things you don't like and in quantities that aren't good for you. Players are asserting authority and control over themselves, paradoxically by doing something bad for themselves and potentially destructive to other guests in the shared space. And, as the game is not officially sanctioned by the park, those in a drinking "team" create their own reality—both through their conception of themselves as a team on a quest—and by the mind-altering effects of the alcohol itself.

Epcot's New Horizons: The Pitfalls and the Promise

Both the anecdote at the start of this chapter and the Princess Minnie video demonstrate how one tourist's individual engagement with the themed environment and the construction of their own interior game manifests in a manner that clashes with another tourist's narrative or what happens when performers try to enact two different and conflicting scripts on the same stage. Among the many Disney bloggers who discuss Drinking Around the World, few acknowledge this reality. Among the exceptions are the previously cited Bricker, who reminds readers, "Never forget that Epcot is a family theme park, and while Drinking Around the World Showcase can be a ton of fun, that fun should not occur at the expense of your fellow park guests."[41] Similarly, an article appears on the website *DisneyLists.com* that closes with a note from the site's publishers but not the article author herself: "While drinking around the world can be a lot of fun, please remember you are in a family park with lots of

41. Bricker, "Drinking Around the World."

children around. As you near the end of your journey, please keep your language and behavior appropriate."[42] From the other point of view, the "super spy" children (or adults), indistinguishable to other guests and focused on their own objectives, can also provide conflict by demanding access to unmarked spaces in pursuit of their goals.

As the Disney parks continue to evolve, and as guests have continued to seek alternative modes of engagement with these themed environments, Disney has continued to add reactionary signage making actions explicitly prohibited.[43] They have also begun significant renovations on Epcot to create more sanctioned experiences and transmediated experiences that explicitly privilege Disney character intellectual property over the abstractions of its origins, and begun adding virtual ways to engage in all the parks. The Play Disney Parks app provides guests a means of passing time in the park that does not involve riding rides, seeing shows, or consuming food and drink. The app also has tremendous interface opportunities with the technology in Disney's newest theme park land, *Star Wars*: Galaxy's Edge, and many Disney fans and commentators expect to see further integration between the Play Disney Parks app and theme park spaces in the years to come, especially as COVID-19 restrictions recede. In this way, we see Disney promoting an organized, sanctioned set of virtual interiority possibilities to its guests. These are designed to appeal to a variety of ages and individualize experiences while at the same time promoting consistent usage of geographic space and minimizing the danger of the guest-created experiences. These have proven only moderately successful with guests who complain that the games are rarely updated.[44]

42. Caitlin Corsello, "7 Tips and Tricks for Drinking Around Epcot's World Showcase," *DisneyLists.com*, April 28, 2020," https://www.disneylists.com/2020/04/7-tips-tricks-drinking-around-epcots-world-showcase-2/. When an intoxicated guest climbed the outside of the pyramid of the Mexico pavilion in World Showcase, Disney sought additional means to at least marginally restrain behavior.

43. Matt Mauney, "Video Shows Man Climbing Pyramid at Epcot's Mexico Pavilion," *Orlando Sentinel*, November 11, 2015, https://www.orlandosentinel.com/features/gone-viral/os-man-climbs-disney-epcot-pyramid-post.html.

44. "Controversial Changes Are Quickly Tiring Out Disney's Top Fans. Can They Bring Back the Magic?" *Theme Park Tourist*, December 16, 2021, https://www.themeparktourist.com/features/20211216/32127/controversial-changes-are-quickly-tiring-out-disneys-top-fans-can-they.

While it is evident that theme park designers seek to provide experiences that center individual users, responding to the development of video games and the rise of smart phones and managing traffic patterns with large volumes of guests in contested shared geographical space will ultimately necessitate creating more scripted and controlling experiences. For some guests, this will likely provide a more solid message or through line to their visits and make their visit to Epcot (and other parks) feel more meaningful. This could help introduce some of the experience, play, and stakes that visitors crave and diminish more disruptive activities. At the same time, this will ultimately diminish feelings of agency and exploration for guests. While these virtual overlays may be successful, they will likely also always disappoint a segment of the audience.

At the same time, retrofitting virtual overlays into the park does not ultimately redress the spatial gaps of Epcot: the holes in the storyboards—increasingly filled with food and beverage carts—mean that it will be a challenge for the park to truly eliminate potentially destructive games like Drinking Around the World. This seems reflected in the construction of the Play Pavilion, specifically designed for small children and perhaps to shield them from the out-of-control adults in the World Showcase. However, the literal and metaphorical collisions now seem endemic to the Epcot experience. The more scripts being performed on the same stage space, the more conflicting objectives being pursued, the more potential for conflict between guests. The unstructured space of Epcot holds tremendous appeal to some, a throwback to the pleasure gardens that served as amusement- and theme parks' ancestors. But guests who see that aspect as a feature stand apart from the legion of Epcot guests who alternatively view the park as "boring" or as a stage for their own performances of adventure. Perhaps apt for a Florida theme park in the 21st century, Walt Disney's original optimistic vision of global unity through science and culture has been replaced by one in which personal pleasures are seemingly destined to collide.

Bibliography

Addis, Michela. "New Technologies and Cultural Consumption—Edutainment Is Born!" *European Journal of Marketing* 39, no. 7–8: 729–736.

Aronson, Arnold. *American Avant-Garde Theatre: A History*. New York: Routledge, 2000.

Balloffet, Pierre, François H. Courvoisier, and Jöelle Lagier. "From Museum to Amusement Park: The Opportunities and Risks of Edutainment." *International Journal of Arts Management* 16, no. 2 (Winter 2014): 4–18.

Bell, David. "Destination Drinking: Toward a Research Agenda on Alcotourism." *Drugs: Education, Prevention, and Policy* 15, no. 33 (June 2008): 291–304.

Bergen, Doris. "Foundations of Play Theory." In *The SAGE Handbook of Play and Learning in Early Childhood*, edited by Elizabeth Brooker, Mindy Blaise, and Susan Edwards. United Kingdom: SAGE Publications, 2014: 9–20.

Bricker, Tom. "Drinking Around the World Showcase at Epcot." *Disney Tourist Blog*. https://www.disneytouristblog.com/drinking-around-world-epcot-world-showcase/.

———. "World Showcase: Borefest or Brilliant?" *Disney Tourist Blog*. https://www.disneytouristblog.com/world-showcase-epcot-boring/. Accessed July 2, 2021.

Burkett, Becky, "Op-Ed: Think Epcot is boring? These will change your mind." *Inside the Magic*, January 18, 2020. https://insidethemagic.net/2020/01/epcot-attraction-artwork-not-boring-bb1/.

Carlisle, Sheena, and Caroline Ritchie. "Permission to Rebel: A Critical Evaluation of Alcohol Consumption and Party Tourism." *International Journal of the Sociology of Leisure* 4 (2021): 25–44.

Clavé, Salvador Anton. *The Global Theme Park Industry*. Translated by Andrew Clarke. Cambridge: CABI, 2007.

Cloke, Paul, and Harvey C. Perkins. "'Cracking the Canyon with the Awesome Foursome': Representations of Adventure Tourism in New Zealand." *Environment and Planning D: Society and Space* 16, no. 2 (April 1998): 185–218. https://doi.org/10.1068/d160185.

Cochran, Jason. "How to Drink Around the World at Disney's Epcot." *Frommer's*. https://www.frommers.com/slideshows/848005-how-to-drink-around-the-world-at-disney-s-epcot.

Cohen, Diana Tracy. "Family-Friendly Las Vegas: An Analysis of Time and Space." *Center for Gaming Research Occasional Paper Series* (2014): 1–12.

"Controversial Changes Are Quickly Tiring Out Disney's Top Fans. Can They Bring Back the Magic?" *Theme Park Tourist*, December 16, 2021. https://www.themeparktourist.com/features/20211216/32127/.

controversial-changes-are-quickly-tiring-out-disneys-top-fans-can-they. Accessed February 10, 2022.

Corsello, Caitlin. "7 Tips and Tricks for Drinking Around Epcot's World Showcase." *DisneyLists.com*, April 28, 2020. https://www.disneylists.com/2020/04/7-tips-tricks-drinking-around-epcots-world-showcase-2/.

Dolan, Rebecca. "Epcot Bar Crawl: Your Game Plan for Drinking in 11 Fake Countries." *Thrillist*, February 4, 2015. https://www.thrillist.com/drink/nation/drinking-around-the-world-drink-at-epcot.

Ellis, Lindsay. "The Epcot Challenge: Drinking Around the World 2016." Uploaded on May 4, 2016. YouTube video. https://www.youtube.com/watch?v=gI4T6pvbIAY.

Gottwald, Dave, and Gregory Turner-Rahman. "Toward a Taxonomy of Contemporary Spatial Regimes: From the Architectonic to the Holistic." *International Journal of Architectonic, Spatial, and Environmental Design* 15, no. 1 (2021): 109–127. https://doi.org/10.18848/2325-1662/CGP/v15i01/109-127.

Grillot, Kateri. "What Happened in Vegas? The Use of Destination Branding to Influence Place Attachments." Master's thesis. Wichita State University, 2007.

Hilbrecht, Margo, Susan M. Shaw, Fern M. Delamere, and Mark E. Havitz. "Experiences, Perspectives, and Meanings of Family Vacations for Children." *Leisure/Loisir* 32, no. 2 (2008): 541–571. https://doi.org/10.1080/14927713.2008.9651421.

Kokai-Means, Oliver. "Interview with Oliver Kokai-Means." Interviewed by Jennifer A. Kokai. July 28, 2013.

Kokai, Jennifer A. and Tom Robson. "Disney During Covid-19: The Tourist and the Actor's Nightmare." *Journal of Themed Experience and Attractions Studies*, 2 (2022): 17–20. https://stars.library.ucf.edu/jteas/vol2/iss1/5.

———. "You're in the Parade!: Disney as Immersive Theatre and the Tourist as Actor." In *Performance and the Disney Theme Park Experience: The Tourist as Actor*. Edited by Jennifer A Kokai and Ton Robson. Cham, Switzerland: Palgrave Macmillan, 2019.

Lareau, Annette. *Unequal Childhoods: Class, Race, and Family Life*. Berkeley: University of California Press, 2003.

London, Herbert. "Epcot Is the True Embodiment of the American Dream." *Orlando Sentinel*, August 21, 1985.

Lukas, Scott A. "The Themed Space: Locating Culture, Nation, and Self." *The Themed Space: Locating Culture, Nation, and Self*. New York: Lexington Books, 2007.

Martinez, Jose Luis Vazquez. "Like Sugar for Adults: The Effect of Non-Dependent Parental Drinking on Children and Families." Published by the Institute of Alcohol Studies (IAS) (2017): 1–82.

Mauney, Matt. "Video Shows Man Climbing Pyramid at Epcot's Mexico Pavilion," *Orlando Sentinel*, November 11, 2015. https://www.orlandosentinel.com/features/gone-viral/os-man-climbs-disney-epcot-pyramid-post.html.

McIntyre, Jason. "The girl agents play Kim Possible World Showcase Adventure." Uploaded on July 3, 2010. YouTube video. https://www.youtube.com/watch?v=P-_Sezpi5jg.

Moore, Roland S. "Gender and Alcohol Use in a Greek Tourist Town." *Annals of Tourism Research* 22 (1995): 300–313.

Nellhaus, Tobin. "From Oral to Literate Performance." In *Theatre Histories: An Introduction*, 3rd Edition. Edited by Bruce McConachie, Tobin Nellhaus, Carol Fisher Sorgenfrei, and Tamara Underiner, 25–66. New York: Routledge, 2016.

Pallo, Kyle. "The Only Way to do Epcot! – Drink Around," Uploaded on April 4, 2018. YouTube video. https://www.youtube.com/watch?v=_KGZ5GDQ5Mw.

Pikkemaat, Birgit, and Markus Schuckert. "Success Factors of Theme Parks – An Exploration Study." *Tourism: An International Interdisciplinary Journal* 55, no. 2 (June 10, 2007): 197–208.

Redditismycrack. "Epcot is definitely the worst park.. Ya'll are crazy," *Reddit*. https://www.reddit.com/r/WaltDisneyWorld/comments/85lwlz/epcot_is_definitely_the_worst_park_yall_are_crazy/.

Scott, Bart. *Ears of Steel: The Real Man's Guide to Walt Disney World*. Branford, CT: The Intrepid Traveler, 2014.

Shaw, Susan M., and Don Dawson. "Purposive Leisure: Examining Parental Discourses on Family Activities." *Journal of Leisure Research* 33 (2001): 217–31.

Showmelovejete. "Drinking Around the World at Epcot / Our 21st Birthday (Vlog)," Uploaded on March 9, 2021. YouTube video. https://www.youtube.com/watch?v=Or_aDm4b1vM.

Taylor. "The 'Boring' Disney Rides We Absolutely Love." *AllEars*, January 21, 2021, https://allears.net/2021/01/21/the-most-boring-disney-world-rides-we-actually-love/.

Terry, James H. "Outdated and Boring," *TripAdvisor*, April 7, 2015, https://www.tripadvisor.co.za/ShowUserReviews-g34515-d126541-r264127514-Epcot-Orlando_Florida.html, Accessed July 2, 2021.

Terzingi, Carly. "The Ultimate Guide to Drinking Around the World at Epcot." *AllEars*, April 18, 2020. https://allears.net/2020/04/18/the-ultimate-guide-drinking-around-the-world-at-disney-epcot/.

"Third of Children 'Scared' by Adult Drinking," *BBC News*, July 5, 2010. https://www.bbc.com/news/10491057.

Tydeman, William. *The Theatre in the Middle Ages: Western European Stage Conditions, c. 800–1576*. Cambridge: Cambridge University Press, 1978.

Wasko, Janet. *Understanding Disney: The Manufacture of Fantasy*. Cambridge: Polity Press, 2001.

WorthMelting4, "Family Disney World Vlog / July 2015 Episode 8," Uploaded on January 24, 2016. YouTube video. https://www.youtube.com/watch?v=fU5yN60ckdg.

Rescripting Saudi Arabia
The Curation of a National Metaverse

Anna Klingmann

The Rebranding of Nations Through Virtualized Mega-zones

In recent decades, the management and marketing of brands for nations, regions, and cities have garnered much attention from scholars and practitioners alike as tools to create soft power and help attract foreign investment, tourism, and skilled human capital.[1] As Kotler and Gertner argued nearly two decades ago, global competitiveness among countries revolves around attracting investment, business, residents, and visitors, increasing employment opportunities and exports.[2] Hence, the importance of branding for nations to actively manage their image has been widely acknowledged.[3] In a climate of accelerated globalization and digitalization, nation branding has presented countries with an effective

1. Cheng Lu Wang, Dongjin Li, Bradley R. Barnes, and Jongseok Ahn. "Country Image, Product Image and Consumer Purchase Intention: Evidence from an Emerging Economy," *International Business Review* 21 no. 6 (2012): 1041–1051.
2. Philip Kotler and David Gertner, "Country as a Brand, Product and Beyond: A Place Marketing and Brand Management Perspective," *The Journal of Brand Management* 9, no. 4–5 (2002): 249–261. See also Andy W. Hao, Justin Paul, Sangeeta Trott, Chiquan Guo, and Heng-Hui Wu, "Two Decades of Research on Nation Branding: A Review and Future Research Agenda," *International Marketing Review* 38, no. 1, (2021): 46–69, https://doi.org/10.1108/IMR-01-2019-0028.
3. Jiaxun He, Cheng Lu Wang, and Yi Wu, "Building the Connection between Nation and Commercial Brand: An Integrative Review and Future Research Directions," *International Marketing Review* 38, no.1, (2021): 19–35, https://doi.org/10.1108/IMR-11-2019-0268. See also Keith Dinnie, T.C. Melewar, Kai-Uwe Seidenfuss, and Ghazali Musa, "Nation Branding and Integrated Marketing Communications: An ASEAN Perspective," *International Marketing Review* 27, no. 4 (2010): 388–403.

medium to streamline their image abroad, promote their products and resources, and acquire general notability on the global map.[4] As Nye and Dinnie point out, nation branding has become an essential tool for developing and sustaining a nation's competitiveness.[5] In contrast to place branding, which emphasizes the promotion of specific economic interests (export, tourism, or internal investment), nation branding focuses on the overall image of an entire country, encompassing cultural, economic, and political dimensions and how others perceive these.[6] Consequently, Anholt defines nation branding as a strategic process of aligning a country's behaviors, actions, innovations, investments, and communications to achieve a strengthened competitive identity.[7] Conversely, Fan observes that a nation's brand exists with or without any conscious efforts in nation branding, as each country exudes a specific image to its international audience, be it strong or weak, carrying both factual and affective information.[8] Accordingly, Beerli and Martin define a nation's brand image as the sum of people's beliefs and impressions about a country,

4. Cornelia Zeineddine, "Employing Nation Branding in the Middle East: United Arab Emirates (UAE) and Qatar," *Management & Marketing: Challenges for the Knowledge Society* 12, no. 2 (2017), https://doi.org/10.1515/mmcks-2017-0013.
5. Joseph S. Nye, "Soft Power and American Foreign Policy," *Political Science Quarterly* 119, no. 2, (2004): 255–270; Keith Dinnie, *Nation Branding: Concepts, Issues, Practice* (2nd Edition) (Oxfordshire: Routledge, 2016).
6. Salah Hassan and Abeer Mahrous, "Nation Branding: The Strategic Imperative for Sustainable Market Competitiveness," *Journal of Humanities and Applied Social Sciences* 1, no. 2, (2019): 146–158, https://doi.org/10.1108/JHASS-08-2019-0025. See also John A. Quelch and Katherine E. Jocz, "Positioning the Nation-State," *Place Branding* 1, no.1, (2004): 74–79.
7. Simon Anholt, *Competitive Identity: The New Brand Management for Nations, Cities, and Regions* (New York: Palgrave Macmillan, 2007).
8. Ying Fan, "Branding the Nation: What is Being Branded?," *Journal of Vacation Marketing* 12, no. 1 (2006): 5–14. See also Nicolas Papadopoulos and Louise Heslop, "Country Equity and Country Branding: Problems and Prospects," *Journal of Brand Management* 9 (2002): 294–314, https://doi.org/10.1057/palgrave.bm.2540079.

including all stereotypes.⁹ As stated by Anholt and Fetscherin, a nation brand, therefore, comprises the total sum of all perceptions of a nation in stakeholders' minds covering political, economic, social, environmental, historical, and cultural aspects.[10]

During the last two decades, the strategic management of nation brands has become a critical tool for countries to confront existing negative stereotypes and to improve their economy by rescripting negative brand images that impair tourism, discourage favorable trade conditions and foreign investment, and engender unwillingness from other countries to cooperate in academic and scientific affairs.[11] By engaging in this process, nations seek to identify appropriate measures to bring their countries closer to a positive national image, actively increase their global awareness, and mitigate negative associations.[12] Consequently, nation branding is ultimately a political tool that strives to alter a nation's international perception, allowing it to compete more effectively in global markets.[13]

With the impact of significant environmental pressures and calls for conservation, nations are now increasingly forced to incorporate social responsibility agendas and sustainable development themes as part of their positioning.[14] These paradigms are consistent with the expectations of affluent tourist- and ex-pat segments that demand exclusive desti-

9. Asunciòn Beerli and Josefa D. Martín, "Factors influencing Destination Image," *Annals of Tourism Research*, 31, no. 3 (2004): 657–681.
10. Simon Anholt, "Anholt Nation Brands Index: How does the World see America," *Journal of Advertising Research* 45, no. 3 (2005): 296–304. See also Marc Fetscherin, "The Determinants and Measurement of a Country Brand: The Country Brand Strength Index," *International Marketing Review* 27, no. 4 (2010): 466–479.
11. Mark Donfried, "How Saudi Arabia is building a New National Brand," *Arab News*, January 13, 2018, https://www.arabnews.com/node/1224971. See also Robert Govers and Frank Go, *Place Branding: Glocal, Virtual and Physical Identities, Constructed, Imagined and Experienced* (London: Palgrave Macmillan, 2009).
12. Simon Anholt "Should Place Brands be Simple?," *Place Branding and Public Diplomacy* 5, no. 2, (2009): 91–96. See also Mihalis Kavaratzis, "Place Branding: A Review of Trends and Conceptual Models," *The Marketing Review* 5, (2005): 329–342; and Mihalis Kavaratzis and Mary Jo Hatch, "The Dynamics of Place Brands: An Identity-Based Approach to Place Branding Theory," *Marketing Theory* 13, no. 1, (2013): 1–18.
13. He, Wang, and Wu, "Building the Connection."
14. Yuan Ren and Per Olof Berg, "Developing and Branding a Polycentric Mega-city: The Case of Shanghai," in *Branding Chinese Mega-Cities: Policies, Practices, and Positioning*, eds. Per Olof Berg and Emma Björner (Northampton, MA: Edward Elgar Publishing, 2014).

nations that exude authenticity on multiple levels, preserve the environment, and "help the planet regenerate."[15] Repackaging places' distinctiveness and cities' historical and cultural authenticity for sophisticated consumers demands a scalar understanding of "branding" that stretches from crafted narratives to "places," "regions," and ultimately to "nations."[16] As Dinnie remarks, territories are produced not only materially and geographically but also in the social imagination through changing ideologies and cultural representation. Far from being politically neutral, nation branding from this perspective reflects a highly complex endeavor that forms the social imagination through the rescripting of memories, stories, and places, embracing both elite and parochial cultural dispositions as well as political narratives and representations of belonging and exclusion.[17] The urban imaginary, in this context, not only serves to produce new fictional spaces but is also strategically deployed to effect change in the public perception of urban reality. In this context, the rewriting of history through crafting enticing narratives, spectacular events, and themed destinations recoding the physical realm all play pivotal roles in manipulating a country's image and experience. However, as Castell argues, messages and symbols will not survive without their presence in the media. Accordingly, virtual image-creation and social media have become highly influential tools in restructuring geographies and gaining political and economic leverage by prioritizing visual and experiential appeal over substance, the haves over the have-nots, and the virtual over the real.[18] Rather than serving as mere backdrops, urban spaces and places have become virtualized national territories in which the management of brand perception through tailored, placed-based, and monitored experiences has become ever more prevalent. While we might not

15. Hassan and Mahrous, "Nation Branding."
16. Dinnie, *Nation Branding, Concepts, Issues, Practice*.
17. Ahmad Bonakdar and Ivonne Audirac, "City Branding and the Link to Urban Planning: Theories, Practices, and Challenges," *Journal of Planning Literature* 35, no. 2 (May 2020): 147–160, https://doi.org/10.1177/0885412219878879.
18. Manuel Castells, *Networks of Outrage and Hope: Social Movements in the Internet Age* (New York: John Wiley & Sons, 2013).

typically think of physical spaces as virtual media, the curation of personalized environments has become a powerful tool of nation branding, encouraging certain behaviors, activities, and economies while excluding others—editing many of the circumstantial frictions of "real" urbanity.

Because of their sheer scale and functional complexity, urban mega-projects in the form of large-scale zones are frequently at the core of countries' re-imaging and marketing efforts. As spectacular signifiers, these zones serve a critical role as change agents that strategically reshape territory to mirror specific socio-political agendas, perspectives on history, imagined societies, and assumptions of power. Their design and compositions typically involve sophisticated formulas reproduced by multinational firms (e.g., CRTKL, SOM, AECOM, WATG) and marketed as "exclusive" lifestyle products across different cultural contexts. Governmental agencies, together with private developers, marketing consulting firms, independent advisors, destination management organizations, and public relations involved in branding territory, heavily invest in what place branders call "experience masterplanning,"[19] involving a full complement of residential, resort, educational, commercial, and leisure programs that echo the aspirations of a demanding breed of global cosmopolitans. Driven by the goal of creating "never before seen" destinations, these branded territories typically offer "curated lifestyle experiences" that offer "a wide range of luxury accommodations" while "preserving cultural heritage and enhancing the region's exquisite natural beauty and diverse ecosystem" for the next-generation travelers who prize responsible travel and meaningful connections. Devoid of unwelcomed distractions, these quasi-utopian territories align political, economic, social, environmental, historical, and cultural objectives with new intended behaviors, actions, innovations, investments, and communications. Just like any data-driven virtual environment that is interactive, immersive, and three-dimensional (think *Roblox*), these highly controlled spaces make certain things possible and other things impossible. Consequently, it is not the declared content but rather the content management

19. Malcolm Allan, "Experience Masterplanning," *City Nation Place*, February 9, 2017, https://www.citynationplace.com/experience-masterplanning.

that dictates the game's rules in the designer milieus of choreographed destinations and branded lifestyle districts. As Easterling contends, "While promoted as relaxed, open and free from inefficient state bureaucracy, the politics written into the zone's spaces and activities often diverges from the declared intent. It is usually an isomorphic exurban enclave that, exempt from the law, can easily banish the circumstances and protections common in richer, more complex forms of urbanity."[20] Meta-zones are therefore of particular interest to authoritarian regimes and governmental leaders in emerging economies aiming to align their country's policies to global market demands by creating controlled virtualized worlds, each with its privatized access, membership, monetization rights, and formats of creative expression.[21]

Themed Cities in the GCC

Many Middle Eastern countries, most notably in the Gulf Cooperation Council (GCC), have applied national branding and place marketing strategies to diversify their economies and create positive urban imaginaries.[22] No place embodies this phenomenon more than the city-state of Dubai, whose image and identity has undergone a rapid transformation to become the region's leading commercial and financial hub while building a world-class luxury tourism industry from almost nothing, albeit with the high cost of social disintegration.[23] Dubai was also the first nation in the Middle East to employ spectacular mega-destinations, themed environments, and other iconic design forms that combine media, marketing, and architecture into one interlinked entity, where the boundaries between fictional narrative and "real" urban space have effectively merged.

20. Keller Easterling, *Extrastatecraft: The Power of Infrastructure Space* (New York: Verso, 2014), 16.
21. Ibid.
22. Joao R. Freire, "Place Branding in the Middle East," *Place Branding and Public Diplomacy* 8 (2012): 46–47, https://doi.org/10.1057/pb.2011.35.
23. Yasser Elsheshtawy, *Dubai: Behind an Urban Spectacle* (London: Routledge, 2009), https://doi.org/10.4324/9780203869703.

From the late 1990s onwards, themed destinations have played a key role in repositioning Dubai's image from a backward fishing and trading town to a cosmopolitan, 21st century mass communication, logistics, and tourism hub. In the earlier days of the Dubai boom, malls brazenly seduced visitors with spectacular themes, a strategy initially copied from Las Vegas Casinos but now applied with great success first to lifestyle environments. Gradually the semantic programming of places expanded to encompass an endless collage of resorts, mixed-use destinations, and gated communities, such that its urban fabric has now expanded to an agglomeration of branded "city zones." Through the deployment of narratives, slogans, events, and visual symbols, these zones embrace a variety of themes as festival spaces (Dubai Festival City), leisure spaces (Dubailand), production spaces (Dubai Industrial City, Dubai Textile Village, and Dubai International City), sports activity spaces (Motor World, Dubai Sports City), destinations that evoke cultural and historical aspects (Alserkal Avenue, City of Arabia, Culture Village, Global Village), educational and knowledge spaces (Knowledge Village, Media City, Internet City, Dubai Silicon Oasis), and sustainable communities (Sustainable City). Futuristic designs (Burj al Arab, Museum of the Future) alternate with faux historicity in an uninterrupted flow, visible for example, in the arabesque destinations of Madinat Jumeirah, Wafi City Mall, Ibn Battuta Mall, Wild Wadi Water Park, and later in the reconstruction of Bastakiya, much of which had to be rebuilt from scratch to appease tourists looking for a sense of rootedness and local heritage. In parallel, Dubai has initiated dozens of iconic mega projects that have vied for the status of world-firsts.[24] This race to gigantism can be observed in the Palm Islands and "The World," which make up the largest artificial islands in the world, the largest artificial marina (Dubai Marina), and the tallest residential tower (the Princess Tower). Downtown Dubai, a massive mixed-use district, is anchored by Burj Khalifa, the tallest building globally, and Dubai Mall, the world's largest mall, both of which are facing the world's largest choreographed fountains. Packed together into one gigantic destination, "Downtown Dubai" makes an immediate and dramatic impression that

24. Samer Bagaeen, "Brand Dubai: The Instant City; or the Instantly Recognizable City," *International Planning Studies* 12, no. 2 (2007): 173–197.

confronts the visitor with a condensed image of Dubai. At close range, these emblems dissolve into a richly detailed experience-scape, animated by fictional elements and the meticulous recreation of historical and cultural settings, which offer a synergy of atmospheres connected by well-designed pedestrian spaces where people from all backgrounds can meet, socialize, and—despite Islam's status as an official state religion—also enjoy a glass of wine.[25]

The other Gulf States soon followed suit in adopting the Dubai model. Abu Dhabi, for example, gained much notoriety by constructing the Saadiyat Cultural District, which, among other cultural facilities, comprises five museums, including the Louvre Abu Dhabi, designed by star architect Jean Nouvel; the Guggenheim Abu Dhabi, designed by Frank Gehry; and the Sheikh Zayed National Museum by Norman Foster who also designed Masdar City, a free zone for green energy enterprises. Doha, in contrast, reconstructed its entire center as a polished downtown in a faux historical setting (Souq Waqif) complemented by an array of iconic cultural and leisure destinations, which include the National Museum, designed by Jean Nouvel, an OMA-designed library; the Al Wakrah Stadium, designed by Zaha Hadid; the Pearl, a string of artificial islands; and Qatar Education City.

Rebranding Saudi Arabia

Due to its sheer size (2.15 million km² versus Dubai at 35 km² and Qatar at 11,571 km²) and politically conservative and, until recently, highly restricted social environment, Saudi Arabia has been slow to develop into a significant global player. While other states in the gulf positioned themselves as diversified global business hubs open to tourism and a mix of cultures, Saudi Arabia had remained a closed society, which first and foremost emphasized the preservation of Islamic traditions. While importing many Western brands and products, the Kingdom did not permit leisure tourism for a very long time. Because of severe religious

25. Anna Klingmann, "The Rise of Shopping Malls within the Framework of Gulf Capitalism," in *World of Malls: Architectures of Consumption*, eds. Andres Lepik and Vera Simone Bader (Berlin: Hatje Cantz, 2016), 175–183.

restrictions, Saudi culture still lacks any diversity of religious expression, buildings, annual festivals, and public events. Until recently, cinema was banned, and single people were kept strictly segregated, while bars, music venues, theaters, and nightclubs did not exist. Hence, the nation's image—revered in many countries with a majority Muslim population as the birthplace of Islam—is to this day still tainted by a series of perceived negative stereotypes in the West, summarized by a trilogy of excessive wealth, abuse of women, and political and religious extremism. Further complicating the situation are the country's problems, such as freedom of the press, the war in Yemen, and human rights in general, which adversely affect the country's reputation in Western countries.

In the last five years, however, a young population of well-educated, technology-savvy Saudis has forced the government to re-evaluate its policies and make serious efforts to diversify its economy while loosening existing socio-cultural and religious restrictions.[26] To this effect, Saudi Arabia announced an economic blueprint titled "Saudi Vision 2030" in 2016, outlining how the country envisions transforming itself as a more open, tolerant, and progressive nation. Designed with the management consulting firms McKinsey and Boston Consulting Group, Vision 2030 is a developmental program that aims to clear the country of negative perceptions and reposition it as an economically, culturally, and socially reformist nation within the global community. Vision 2030's socio-economic reform program prominently affiliates with King Salman's son Mohammed bin Salman (or MBS), promoted to crown prince in 2017, and has branded him as a powerful forward-thinking ruler in Saudi Arabia and internationally. The plan essentially revolves around three core elements: developing a diversified and sustainable economy that moves away from dependency on the energy sector; shifting economic growth and prosperity from the public to the private sector; and creating the jobs needed for Saudi Arabia's booming population, where nearly 45 percent is under the age of twenty-five with nearly one-third without employ-

26. Turki Shoaib, "Place Branding in a Globalizing Middle East: New Cities in Saudi Arabia," (PhD. diss, Oxford Brookes University, 2017), https://radar.brookes.ac.uk/radar/file/88098f91-21f6-46a7-9b7a-a271a34f8cd5/1/TurkiShoaib_PhD_Thesis_2017_RADAR.pdf.

ment.[27] Targeting a predominantly young population, the strategy, aside from economic objectives, also implies a degree of social liberalization with its embedded "Quality of Life Program." The envisioned improvements include the enhancement of urban lifestyles and livability, most notably by creating an "ecosystem, which enables citizens' active participation in cultural, leisure, and sports activities," which had been conspicuously absent in the public realm.[28]

Within this framework, themed meta-projects represent crucial change agents to attract a national and international tourist industry, domestic and international investment, and keep more of the money spent on entertainment within the country's borders. From a nation branding perspective, the creation of spectacular destinations becomes a critical milestone in furthering Saudi Arabia's international status and influence, promoting the country economically, culturally, and politically: economically by diversifying and extending its influence; culturally by transforming the nation from being a remote player of world culture into a creator of symbols of global consumer culture; and politically by helping the country to move from the world's periphery to the world's core. As part of the country's rebranding process, the government's socio-economic reforms strategically interlace with the construction of at least fifteen meta-zones which span the global themes of leisure, sustainability, technology, entertainment, culture, heritage, health, and wellbeing. Spread throughout the country's different regions at strategic locations, these include themed, high-end resort areas, economic-free zones, environmental parks, heritage destinations, and technology-driven megacities. Like other significant initiatives of Vision 2030, all destinations are funded by the Public Investment Fund, which is among the most significant sovereign wealth funds globally founded to invest funds on behalf of the Government of Saudi Arabia.

27. Varun Godinho, "Two-thirds of Saudi Arabia's Population is under the Age of 35," *Gulf Business*, August 10, 2020, https://gulfbusiness.com/two-thirds-of-saudi-arabias-population-is-under-the-age-of-35/.
28. Jane Kinninmont, "Vision 2030 and Saudi Arabia's Social Contract: Austerity and Transformation," *Chatham House: The Royal Institute of International Affairs* (July 2017): 1–44, https://www.chathamhouse.org/sites/default/files/publications/research/2017-07-20-vision-2030-saudi-kinninmont.pdf.

Through their sheer scale, complex infrastructure, and sophisticated technology, these projects usher in a new era of territorial branding where customized lifestyle universes present immersive, three-dimensional, high-tech utopias within groomed ecological settings. In this respect, Saudi Arabia's metaverses portray the next iteration of "politically correct" subjective worlds and acknowledge that we are entering into a more substantive, virtualized geography than ever before, rendering Dubai a hedonic playground. The design of immersive worlds—guided by the notion that spaces and their multiple architectural, material, performative, and virtual agencies effectively condition "guests" and their behavior—has, of course, become a well-established practice.[29] Editing any form of freedom, unpredictability, and "real world" messiness in the name of our personal safety, theming, in this matter, has long transcended the notion of escapism, embracing globally engrained sententious ideologies that conjure notions of wellbeing and health, the greater good, and optimization of self, all under the umbrella of a perversely contorted commoditized version of sustainability.

Exclusive Ecological Enclaves

Aside from seeking to reform the lifestyle of its citizens to comply with neoliberalist values, Saudi Arabia is also fervently working on multiple top-down tourism strategies aspiring to turn the country into the next global destination. While Saudi Arabia has been a host for religious tourism for centuries in the form of pilgrimages to the holy cities of Mecca and Medina, it has recently opened the country for leisure and cultural tourism through the construction of large-scale, enclavic resort-zones, each with its own airport, infrastructure, and exclusive access. As part of this mission, the crown prince declared vast territories, including coastlines, entire islands, and other attractive sites, as Special Economic Zones (SEZ), seeking to leverage the country's natural assets for high-end

29. See also Scott Lukas, "The Meanings of Themed and Immersive Spaces," in *A Reader in Themed and Immersive Spaces*, ed. Scott A. Lukas (Pittsburg: Carnegie Mellon Press, 2016), 3.

tourism while consolidating his power over large tracts of land. Created to attract affluent (primarily non-Muslim) tourists from the GCC, Europe, North America, China, Japan, and Russia, these territories will be regulated by an independent set of laws "in line with international standards."

According to Healy and Jamal, enclave tourism refers to a type of tourism development that comprises concentrated geographic areas of tourist-oriented facilities and attractions removed from the surrounding environment by spatially or psychologically created boundaries.[30] From a geopolitical perspective, separating enclaves from their surrounding socio-cultural environments and regional economies can be understood as a form of human territoriality. While tourism portrays itself as a peaceful and benevolent sector "that brings people from different cultural backgrounds together and contributes to employment, poverty alleviation, and global sustainable development,"[31] it also involves practices of dispossession and erasure, along with an incessant manipulation of territory. Established modification practices include eviction (removing communities and individuals from territories that they have previously occupied), enclosure (dispossessing people from access to material means of subsistence and resources), extraction (exploiting the natural environment by extracting resources), and erasure (rewriting pre-existing definitions of place, livelihood, identity, and history).[32] By employing one or more of these practices, tourism enclaves become potent tools of border-making between "us and them," affecting exclusive spaces and spaces of exclusion at the same time. As elaborated by Edensor, these "purified" spaces are carefully scripted, themed, and managed, ensuring that tourists enact prescribed protocols as "actors" in a scripted setting.[33] In the case of Saudi Arabia, a variety of scripting methods include the era-

30. Noel Healy and Tazim Jamal, "Enclave Tourism," in *The Sage International Encyclopedia of Travel and Tourism*, ed. Linda L. Lowry (Thousand Oaks: SAGE Publications, Inc., 2017), 418–419, http://dx.doi.org/10.4135/9781483368924.n160.
31. Jarkko Saarinen and Sandra Wall-Reinius, "Enclaves in Tourism: Producing and Governing Exclusive Spaces for Tourism," *Tourism Geographies* 21, no. 5 (2019): 739–748, https://doi.org/10.1080/14616688.2019.1668051.
32. Andreas Neef, "Tourism, Land Grabs and Displacement: A Study with Particular Focus on the Global South," *Tourism Watch* (February 2019), https://www.tourismwatch.de/system/files/document/Neef_Tourism_Land_Grab_Study.pdf.
33. Tim Edensor, "Staging Tourism," *Annals of Tourism Research* 27, no. 2 (2000), 322–344.

sure of cultural heritage in the form of "purged" futuristic settings (Mecca and Medina), themed recreations of cultural heritage as historicist destinations (Diriyah Gate and Al Ula), enclosed cognitive utopias (Neom and Qiddiya), and scenographic worlds of ecology (Amaala and the Red Sea Resort), created through the appropriation and enclosure of virgin land.

Luxury Islam: The Holy Cities of Mecca and Medina

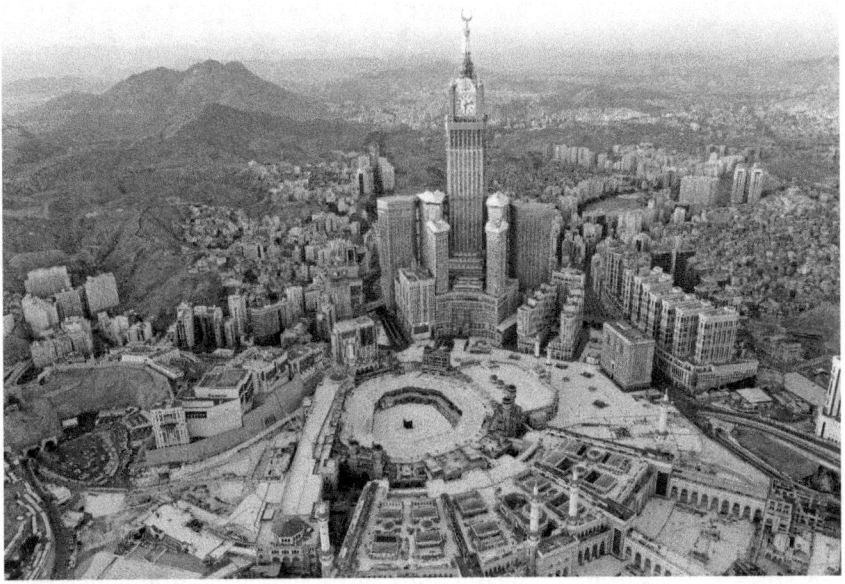

Image 8.1. View of the Makkah Clock Royal Tower (A Fairmont Hotel), the Great Mosque, and the Kaaba. Photo: Faredah Al-Murahhem.

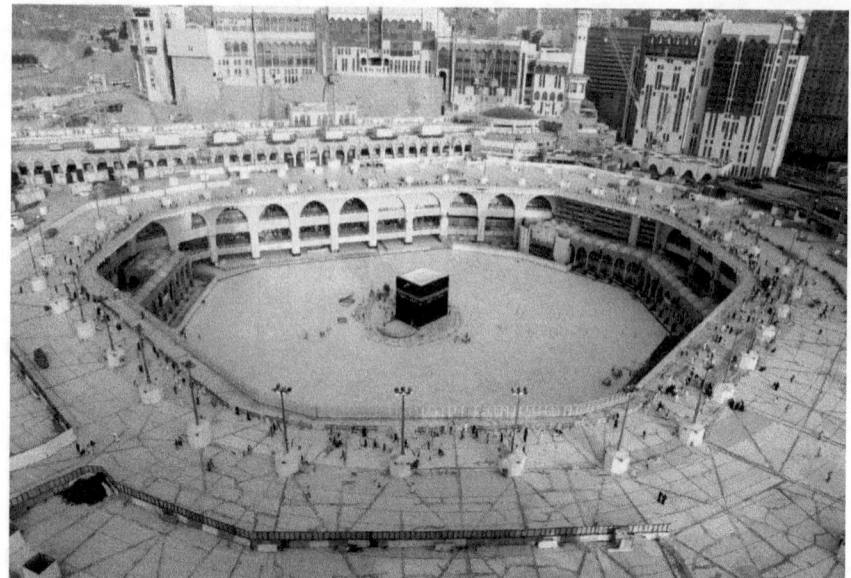

Image 8.2. Three-level pedestrian infrastructure encircling the Kaaba. Photo: Faredah Al-Murahhem.

Due to the centrality of Mecca and Medina in the Muslim world and the millions of pilgrims they attract, the two holy cities form a significant component of Saudi Arabia's national identity and tourism industry. Following the notion that these kinds of tourism spaces are separated from their surrounding environment by well-defined perimeters that isolate the enclave space from the surrounding socio-spatial environment,[34] both Mecca and Medina constitute large-scale territorial enclaves that are exclusively accessible to Muslim pilgrims. The control of these territories happens far beyond the city's actual territory via a series of patrolled checkpoints that prevent non-Muslims from entering Mecca. In addition, large-scale road signs on a highway to Mecca, for example, emphasize that one direction is for "Muslims only" while another is "obligatory for non-Muslims."

34. Jarkko Saarinen, "Enclavic Tourism Spaces: Territorialization and Bordering in Tourism Destination Development and Planning," *Tourism Planning and Development* 19, no. 3 (2017): 425–437.

In order to accommodate the growing number of people making the pilgrimage to Mecca and Medina that is required at least once of all Muslims who can afford it, Saudi Arabia is in the midst of enormous expansion projects in the holy cities. Over the past two decades, as the number of pilgrims traveling to Mecca and Medina for the annual hajj ballooned from 1.2 million in 1997 to 2.9 million in 2018, the Saudi government launched a multibillion-dollar expansion and destruction project in both cities.[35] While Saudi officials argue that the expansions are necessary measures to accommodate the increasing number of pilgrims, activists argue that the government's relentless demolitions are part of a campaign to purposely erase historical and religious sites in keeping with the Wahhabi doctrine. Wahhabism, the ultra-conservative branch of Islam that emerged in Saudi Arabia 250 years ago, has long regarded the veneration of historical monuments, especially those predating the Prophet Muhammad's life in the seventh century, as tantamount to idolatry advocating their neglect or outright destruction.[36] In the wake of this massive demolition drive, 98% of the old quarters of the holy cities, including historical mosques, tombs, mausoleums, monuments, and houses, have been bulldozed[37] to make way for a monolithic landscape of large-scale infrastructures, luxury hotels, shopping malls, and apartment blocks (see image 8.1). Demolition involves the ongoing expansion of the Prophet's Mosque in Medina, whose successive expansion has taken over entire city areas with a capacity for 1.6 million people. Meanwhile, at Mecca's Al-Haram Mosque, where pilgrims gather to pray around the Kaaba, entire porticos that encircled the sacred cube of the Kaaba have been torn down for being in the path of construction. The Ajyad Fortress, a sprawling castle built by the Ottomans that once overlooked the Grand Mosque

35. Carla Power, "Saudi Arabia Bulldozes Over Its Heritage," *Time*, November 14, 2014, https://time.com/3584585/saudi-arabia-bulldozes-over-its-heritage/.
36. Edek Osser," Why is Saudi Arabia Destroying the Cultural Heritage of Mecca and Medina?," *The Art Newspaper*, November 19, 2015, https://www.theartnewspaper.com/2015/11/19/why-is-saudi-arabia-destroying-the-cultural-heritage-of-mecca-and-medina. See also Mohammed Khaku, "Never-ending Destruction of Historical Sites in Mecca and Medina, Cradle of Islam," *Arab American News*, May 15, 2021, https://www.arabamericannews.com/2021/05/15/never-ending-destruction-of-historical-sites-in-mecca-and-medina-cradle-of-islam/.
37. Lorena Muñoz-Alonso, "Saudi Arabia Destroyed 98 Percent of Its Cultural Heritage," *ArtNet*, November 19, 2014, https://news.artnet.com/art-world/saudi-arabia-destroyed-98-percent-of-its-cultural-heritage-174029.

from the crags of Mt. Bulbul south of the shrine, was demolished in its entirety to clear the area for the 15 billion-dollar construction project of the Makkah Clock Royal Tower, a postmodern mega-version of Big Ben, now the third-tallest building in the world.[38] Simultaneously, numerous historical sites affiliated with the life of Prophet Muhammad have been taken down and built over by mundane structures which include parking lots, a Hilton Hotel, and a Burger King. The house of the Prophet's wife, Khadija, is now the site of public lavatories, while a large McDonald's greets pilgrims just outside the gates of the Grand Mosque.[39] In their effort to create a streamlined infrastructure, planners have also leveled the city's varied topography that once was dotted with the homes of the Prophet Muhammad's acquaintances and friends. Hovering over one of Mecca's hills—once sprinkled with modest houses—thirty-nine towers of hotels and apartments are now reaching for the sky as part of the Jabal Omar megaproject.[40] As the skyscrapers perched above generic malls cast their eerie shadow over a city that once was, all that remains is the Kaaba, encircled by a multi-level steel structure for perambulating pilgrims, dwarfed by monolithic commercial complexes (see image 8.2). As Sami Angawi, a Saudi Arabian architect and social activist, commented a decade ago, "They are turning the holy sanctuary into a machine, a city with no identity, no heritage, no culture, and no natural environment."[41] By relentlessly reshaping urban spaces according to Wahhabi doctrine and restricting regional specificities by erasing heterodox places of worship, the Saudi rulers demonstrate their exclusive control over these religious territories, turning Mecca and Medina into purged enclaves of a Saudi–Wahhabi luxury Islam.[42] As the cultural critic Ziauddin Sadar comments: "The spiritual heart of Islam has become an ultramodern, mono-

38. AbdulRahman Al-Mana, "The Destruction of Mecca & Medina's Historic Landscapes," *Cities from Salt* (blog), October 3, 2019, https://www.citiesfromsalt.com/blog/the-destruction-of-mecca-and-medinas-historic-landscapes.
39. Mustafa Hameed, "The Destruction of Mecca: How Saudi Arabia's Construction Rampage is Threatening Islam's Holiest City," *Foreign Policy*, September 22, 2015, https://foreignpolicy.com/2015/09/22/the-destruction-of-mecca-saudi-arabia-construction/.
40. Jabal Omar, https://jabalomar.com.sa/.
41. Raya Jalabi, "After the Hajj: Mecca Residents Grow Hostile to Changes in the Holy City," *The Guardian*, September 14, 2016, https://www.theguardian.com/cities/2016/sep/14/mecca-hajj-pilgrims-tourism.
42. Stefan Maneval, "Mass Accommodation for the 'Guests of God': Changing Experiences of Hajj-Pilgrims in Jeddah," *Arab Urbanism*, www.araburbanism.com/magazine/hajj-pilgrims-jeddah.

lithic enclave, where difference is not tolerated, history has no meaning, and consumerism is paramount."[43] The erasure of Meccan history has also had a tremendous impact on the experience of the pilgrimage (hajj) itself. The word "hajj" means effort, which implies traveling to Mecca often under challenging conditions, walking from one ritual site to another in strenuous weather conditions, and meeting people from different cultures and sects, soaking in the diverse history of Islam. Today, the hajj presents a highly monitored end-to-end experience where pilgrims follow a highly prescriptive trajectory, rarely encountering people of different cultures and ethnicities on their journey. Disciplined collective performances follow a rigid script around which rituals are organized, allowing little room for reflexivity or improvisation. Monitored through surveillance technology, participants generally remain typecast, occupying specified roles in a self-contained environment. While the hajj still allows millions of Muslims every year to experience the notion of equality before God, Sadar argues that the pilgrimage, drained of history and religious and cultural plurality, has been reduced to a mundane exercise in rituals and shopping, where pilgrims are encouraged to spend as much money as possible.[44] In the meantime, the architecture constructed to accommodate "God's guests" in Mecca suggests that, on earth, inequality persists—and those in power, who own and lodge in five-star hotels, have no desire to change the status quo.

43. Ziauddin Sardar, "The Destruction of Mecca," *New York Times*, September 30, 2014, https://www.nytimes.com/2014/10/01/opinion/the-destruction-of-mecca.html
44. Ibid.

Diriyah Gate: History Rescripted

Image 8.3. Rendering showing the extent of the Diriyah Gate masterplan. Courtesy of DGDA (Diriyah Gate Development Authority).

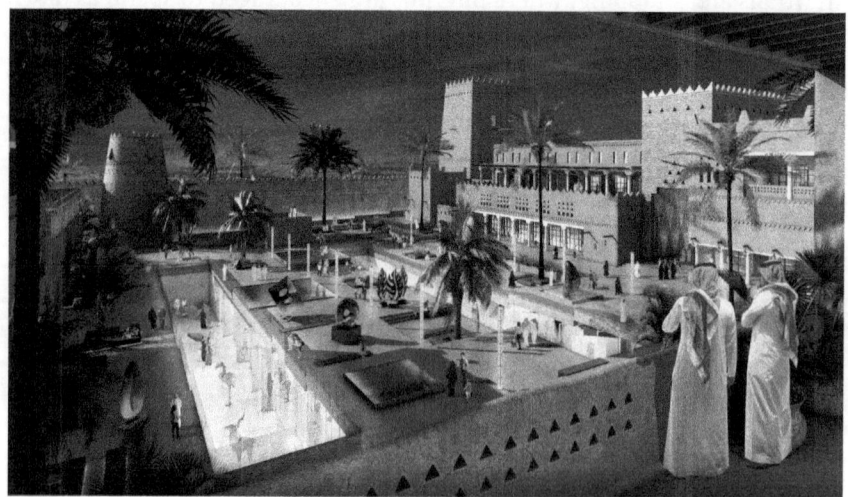

Image 8.4. Impression of Najdi-style architecture at Diriyah Gate. Courtesy of DGDA (Diriyah Gate Development Authority).

In the meantime, Diriyah—Saudi Arabia's ancient capital which comprises the landmark districts of Al Bujairi and At-Turaif, both significant landmarks of the first Saudi state—is aggressively expanding into a seven square kilometers "Cultural and Lifestyle Tourism Destination" that seeks to leverage the historical site's national and international relevance (see image 8.3). At-Turaif was designated as a UNESCO World Heritage Site in 2010 and is recognized as one of the world's largest mud-brick cities, bearing witness to the Najdi architectural style, specific to the center of the Arabian Peninsula. For many decades this historical city was sealed off to the general public and lay in ruins, until 2010 when the government decided to renovate the area and preserve it according to UNESCO standards. Spearheaded by Jerry Inzerillo, a seasoned veteran in hospitality and tourism, the Diriyah Gate Authority (DGA) has since been escalating the historic site into a scripted historicist model city that seeks to amplify the site's national and international relevance (see image 8.4).[45] As an exclusive destination, the project involves a predictable mix of luxury residences, lifestyle retail, and entertainment in a curated setting "that abides by the latest international and local sustainable standards, designed for 21st-century living," targeting a cash-rich cosmopolitan clientele.

Launched by the crown prince four years ago "as the jewel of the Kingdom," the project has gone from "mega" to "giga" both in budget and project area and will have the capacity to host seven million tourists upon the arrival of its completion.[46] Modeled on New Urbanist principles and historical architecture,[47] the project's masterplan encapsulates a contemporized mega-medina, which references the high-density, low-rise medina quarters of older Arab cities, albeit without the buzzing, tight-knit, messy layering of religious and secular histories. At once nostalgic and futuristic, this vision positions the kingdom "at the heart of the Arab and Islamic worlds, while also offering world-class entertainment

45. "Diriyah Gate Development Authority Starts Work on a Major Heritage Project," *Arab News,* July 1, 2020, https://arab.news/8g8e7.
46. Frank Kane, "Frankly Speaking: Saudi Arabia Doubling Down on Diriyah Gate Project, says DGDA CEO," *Arab News,* June 13, 2021, https://arab.news/46naz.
47. SNC LAVALIN, "Transforming Cultural Destinations in Saudi Arabia," *SNC-Lavalin,* 2020, https://www.snclavalin.com/en/projects/diriyah-transforming-cultural-destinations-in-saudi-arabia.

options, sustainable living, at the cutting edge of a global, urbanized future."[48] Recalling faux historicist environments such as Souq Waqif in Qatar or Celebration in the US, along with much larger iterations in China such as "Orange County," "Vancouver Forest," "Thames Town," and "Venice Aquatic City," many of Diriyah Gate's buildings are predictively conceived as built metaphors. However, contrary to the above examples which rely on the copy-paste of postmodern pastiche guided by cultural displacement, a regionalist twist guides this project in which indigenous craft, labor, and materials seamlessly blend with imported western technology. Concepts like "authenticity" and "heritage" are emulated unselfconsciously as architects ponder the expression of regionally specific designs and ecological paradigms, imbuing the project with a holistic approach that emulates the human scale of the traditional city in the form of connected pedestrian-oriented architectural designs that are responsive to the local climate. For the myriad global practices commissioned to design and craft the symbols of this new destination, these various narratives are potent—indeed more inspiring than the everyday realities of the crumbling old towns, the banal malls, and the impoverished housing in the neighborhoods surrounding it.[49] Numerous international consultants work together to develop this mega-medina, weaving together contemporary abstraction with the region's vernacular settlement patterns. Guided by a contemporary interpretation of regionalist urban principles, an array of public services—which include a curated mix of cultural institutions, entertainment venues, shops, sports facilities, and gardens—seamlessly connect to courtyards and arcades, creating an integrated walkable community in what tourists perceive as a harsh climate. Enlisting cultural heritage while envisioning a hypermodern infrastructure have proven effective tools for Saudi Arabia's national rebranding. Together, these strategies have created an entirely new context in Diriyah in which an imaginary golden age of Arabia fuses with the promise of a technologically advanced ecological utopia. All infrastructures, including three kilometers of tunnels for roads and parking spaces,

48. Diriyah Gate Development Authority, "Development Overview," 2021, https://www.dgda.gov.sa/our-destinations/diriyah.aspx.
49. See also Amale Andraos, "The Arab City," *Places Journal* (May 2016), https://doi.org/10.22269/160531.

are constructed fifteen meters below ground to facilitate a picture-perfect staging.[50] Above ground, bike tracks, horse bridle paths, and pedestrian walkways will lead visitors from the medina, along "traditional" date farms, to the vast canyon-like Wadi Hanifa valley, which will be preserved as a large-scale ecological park.[51] With its emphasis on regionalist architecture coupled with an ecological approach to landscaping, Diriyah Gate continues the legacy of urban signature projects in Riyadh, including the Diplomatic Quarter, Qasr Al Murabba, and Qasr Al Hukm, which have all successfully blended the historical with the contemporary. The conjoining of tradition and modernity demonstrates the government's keen commitment to reconciling ancient values with technologically-driven innovations while crafting a region-specific cultural experience that reinforces local identity in an era of global spectaculars. The calculated revival of cultural practices and the imaging of a hypermodern future suggests the marriage of regional authenticity with enlightened statehood as Saudi Arabia is now the driver of futuristic visions purveyed by urbanists, developers, and starchitects.

Unsurprisingly, the Saudi rulers are seeking not just to blend the historical and contemporary; the identity they seek to construct is also exclusive and exclusionary. From the various billboards that surround the construction, which advertise "branded residences," "exclusive boutique hotels," "iconic lifestyle retail brands," and "fine dining experiences," it is evident that the DGA positions the Diriyah Gate district as a "premier destination" for luxury tourism and "select residential communities." As part of this massive endeavor, the government expropriated many of the owners of historic palm groves and farms in the area to assemble large development parcels. Through the use of eminent domain, vast stretches of the surrounding heterogeneous fabric inhabited mostly by modest communities and guest workers were demolished in their entirety

50. Ranju Warrier, "Saudi's DGDA inks Deal with NWC for Water Projects at Diriyah Gate," *Construction Week*, November 29, 2020, https://www.constructionweekonline.com/projects-and-tenders/269207-saudis-dgda-inks-deal-with-nwc-for-water-projects-at-diriyah-gate.
51. See also Anna Klingmann, "Re-scripting Riyadh's Historical Downtown as a Global Destination: A Sustainable Model?," *Journal of Place Management and Development* 15, no. 2 (2022): 93–111, https://doi.org/10.1108/JPMD-07-2020-0071.

to choreograph a seamless world that evokes the longstanding dichotomy between an Arab progressive nationalism on the one side, and a conservative Islamic nationalism on the other, which demands nothing less than a political rescripting of history.

Neom: The Cognitive Creative Zone

Image 8.5. Diagram showing the envisioned cut of "The Line" from the Red Sea land inwards. Courtesy of Neom.com.

Image 8.6. Diagram showing connected high-density community pods surrounded by nature. Courtesy of Neom.com.

In 2017, the Saudi government announced the controversial meta-zone of "Neom," which is arguably the most publicized project in Saudi Arabia covering 10,000 square miles, an area thirty-three times the size of New York. The name "Neom" is merged from the Greek prefix "Neo" (new) and the first letter of *Mustaqbal* (Arabic for future). Driven by the concept to create "the first fully cognitive city of the future," complete with hyper-automation, creative entrepreneurship, and environmental initiatives, Neom is envisioned as a fully integrated conurbation comprising research and development campuses, tourist attractions, leisure and sports destinations, and housing for a population of more than one million inhabitants. Its target group comprises talented entrepreneurs, business leaders, and companies who gather here to develop and commercialize future technology systems and related enterprises.[52] Stretching 460 kilometers along the Red Sea coastline, major sub-zone components so far include "Oxagon," a floating, eight-sided city, set to be the largest fully automated floating industrial complex in the world and "The Line," a hybridized future city/start-up zone, powered by "advanced human-machine fusion," predictive intelligence, and robotics. Designed as a "start-up the size of a country," the project aims at attracting only the "best talents," offering them "technology with unmatched livability at its core." As the website shows, the project aims to lead the country's future in energy and livability, rebrand national identity, and, perhaps most importantly, reaffirm the Crown Prince's power position, as he has aggressively pushed the country's social liberalization policies. These include the abolition of the religious police, the promotion of public entertainment and entrepreneurship, the creation of public social spaces, and the inclusion of women in the workplace. Cinemas have opened, and women can now attend concerts and drive but are still imprisoned if they demand greater freedoms. More importantly, the Crown Prince has affirmed his position by rearranging the power balance through sweeping arrests among the elite. Neom is another chapter in this process, presented as the pioneering vision of exceptional leadership, which signifies

52. NEOM Company, "HRH Prince Mohammed bin Salman announces The Line at Neom," *PR Newswire*, January 1, 2021, https://en.prnasia.com/releases/apac/hrh-prince-mohammed-bin-salman-announces-the-line-at-neom-305130.shtml.

rerouting the Kingdom toward a knowledge economy, technology, tolerance, diversity, and liberalization. The creative class, or, as the Crown Prince calls them, the "dreamers," are to constitute the core of—if not the whole society of—Neom. As the MBS stated during the launch event: "We try to work only with dreamers. This place is not the place for conventional people and companies. . . . Those who cannot dream should not negotiate with us and should not come to Neom. We only welcome dreamers who want to reach a new world."[53]

More recently, in 2021, the Crown Prince announced "The Line," conceptualized as a 170-kilometer linear city of hyper-connected AI-enabled communities powered by 100% clean energy, reaching from the tip of Ras Gasabah on the Red Sea inward across the mountains towards the Altubaiq Natural Reserve (see image 8.5). Within this massive corridor, clusters of high-density communities, surrounded by nature, will replicate as needed, joined by a single ultra-high-speed transit line (see image 8.6). Pedestrian walkways will replace streets as AI-enabled micro-mobility services powered by a 100% renewable energy grid will render cars obsolete, while 95% of the land will be "natural." The population of Neom will grow organically in sync with its automation and robotics developments, set to reduce labor-intensive manual tasks, which will, in turn, ensure the growth of a highly skilled labor force that will fill creative and strategic positions.[54] Following a simplistic vertical layering model that recalls Corbusier's modernist utopias, the Line's systems separate into three distinct infrastructure levels. A "pedestrian layer" defines the ground level and comprises radially organized community modules, each of which will accommodate 80,000 people. Compact mixed-use planning ensures that all services and access to nature are within a five-minute walking distance of the residences. The "service layer" below accommodates all necessary technologies, including last-mile logistics, to run the digital aspects of the city. Finally, the "spine layer" contains all transportation that will connect the urban communities at high speed. A vast tunnel accommodates driverless vehicles, ultra-high-speed transit,

53. Hend Aly, "Royal Dream: City Branding and Saudi Arabia's NEOM," *Middle East - Topics & Arguments* 12, no. 1 (2019): 99–109, https://doi.org/10.17192/meta.2019.12.7937.
54. "What is the Line?," *NEOM,* https://www.neom.com/en-us/regions/whatistheline.

and next-generation freight operations, ensuring that people can get from one end of the city to the other in an unbelievably short time of only twenty minutes. Meanwhile, an "advanced technology platform" coordinates smart services throughout the community and delivers a "hyper-energy-efficient urban environment." The city will run on its own operating system, called "Neos," which will connect various data points and IoT devices to optimize services and energy use, ensuring that no power is wasted. Meanwhile, extensive data analytics will optimize traffic patterns, power demands, temperature, and air quality while buildings and services throughout the communities will be outfitted with "health indicators" that continually evaluate maintenance requirements. Whereas most smart cities today typically use 1% of available data, Neos seeks to extract 90% of the communities' information, which, aside from objective metrics, also includes residents' data. The ultimate idea is that the Line eventually will know its users better than they know themselves, learning unceasingly in a continuous feedback loop between technology and residents.[55] A combination of consumption-oriented data extraction and objectified metrics will enable the system to be reactive and proactive, customize services according to personal needs, and establish a highly cognitive environment. Neos will be an omnipresent surveillance system that knows where residents are at all times; it will monitor their health and respond if someone has an accident, sending in drones to take video footage and routing appropriate services to deliver medical help. Communication between the systems will be built on blockchain technology and protected by next-generation quantum cryptographic systems. Each user will receive a digital identifier which will process personal preferences, inform service providers, and modify real-time actions in the real world.[56] Furthermore, residents "are encouraged" to share behavioral data, such as leisure or shopping habits, and "will receive highly responsive ultra-customized urban experiences" in exchange. This well-known

55. "Neom's Head of Tech on what Daily Life will be like for Neomians," *The National Business*, January 21, 2021, https://www.thenationalnews.com/business/technology/neom-s-head-of-tech-on-what-daily-life-will-be-like-for-neomians-1.1151293.

56. Daphne Leprince-Ringuet, "A City that knows your Every Move: Saudi Arabia's New Smart City might be a Glimpse of the Future," *ZD Net*, February 18, 2021, https://www.zdnet.com/article/a-city-that-knows-your-every-move-saudi-arabias-new-smart-city-might-be-a-glimpse-of-the-future/.

formula of "value exchange" allows, of course, for a far deeper profiling, as real-time analytics—and the continuous accumulation of more and more predictive forms of behavioral surplus—translate into real-time action. In the meantime, Saudi Arabia has already signed a contract for Huawei's 5G network to run part of its system, supporting IoT devices, VR, AR, autonomous vehicles, and many other applications.

Even though most of the project is still in various stages of construction, an international team of engineers, architects, and designers working on the Line are already providing an unsettling snapshot of what the cognitive city is aiming for in terms of delivering a highly controlled "protected" environment that delivers "ultimate safety, comfort, and convenience" to its prospective users. Because the system is designed to produce prediction, continuously improving the system means eventually closing the gap between prediction and certainty. While to some Neom may signify the dystopic vision of Margaret Atwood's *The Handmaid's Tale*, the cognitive rescripting of territories is only the logical next phase of neoliberalist capitalism in which governments and corporations have allied in the deployment of digital technology consolidating and extending their power over all domains of society.[57]

57. See also Shoshana Zuboff, *The Age of Surveillance Capitalism: The Fight for a Human Future at the New Frontier of Power* (London: Profile Books Ltd., 2019).

Anna Klingmann

Qiddiyah: The City of Tomorrow

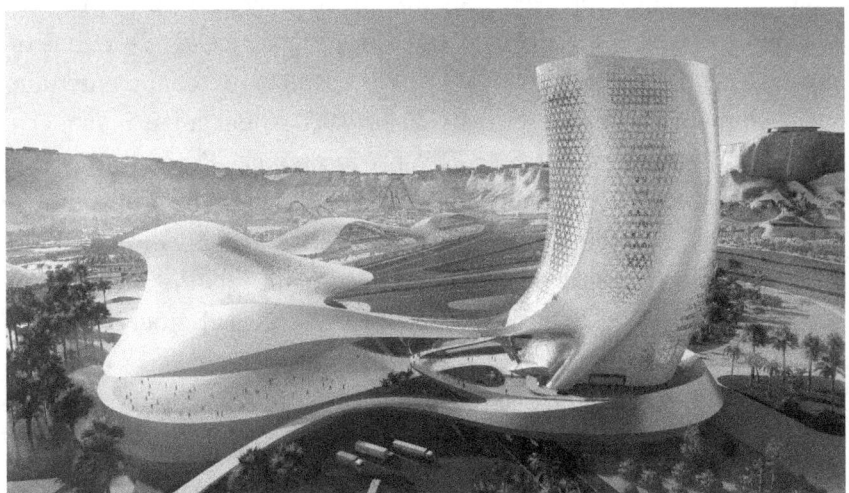

Image 8.7. Qiddiya Speed Park Stadium & Hotel designed by Coop Himmelb(l)au. Courtesy of Wolf D. Prix / Coop Himmelb(l)au.

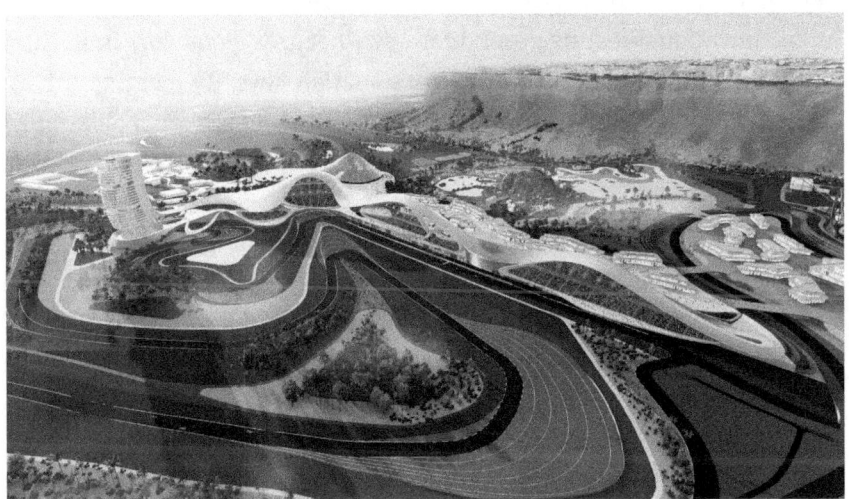

Image 8.8. Qiddiya Racetrack designed by Coop Himmelb(l)au. Courtesy of Wolf D. Prix / Coop Himmelb(l)au.

Positioned as the "capital of entertainment, sports, and the arts in Saudi Arabia,"[58] Qiddiya presents another technology-driven meta-zone planned to boost the Kingdom's offering in large-scale entertainment, repatriating the billions of dollars Saudis spend on outbound entertainment annually. As a core tenet of Vision 2030, Qiddiya has a dual economic and social purpose: to advance economic diversification and unlock new professional pathways while enriching the lives of youths in the Kingdom. According to the project's website, "Qiddiya will be a disruptive destination recognized on the world stage as the home of the most innovative and immersive experiences"[59] themed around five cornerstones: Sports & Wellness; Nature & Environment; Parks & Attractions; Motion & Mobility; and Arts & Culture. The project offers multiple entertainment parks, wellness facilities, sports, leisure, residential communities, high-brow cultural facilities, shopping, and "creative villages" to redefine urban living.[60] Masterplanned by Danish *starchitect* Bjarke Ingels, the 24/7 city covers 366 square kilometers—roughly the size of Las Vegas—and wants to play a similar role for Saudi Arabia and adjacent neighbors, albeit not only as a place for pleasure and indulgence but also as an educational testing ground for new "healthy" behaviors in a "safe" social space that reflects the country's shariah laws. By merging urbanism, iconic architecture, technology, and nature into a layered palimpsest of multiple narratives in order to reform citizen's lifestyles, Qiddiya, therefore, more accurately represents a kind of utopian territory, "an escape from the crime, the traffic, the chaos and the pollution from the metropolis" reminiscent of Disney's original EPCOT concept. Designed to be an experimental prototype community, EPCOT would be Disney's utopian city, a meticulously planned city where every resident would have access to nature, a wealth of leisure experiences, and the latest technology. Citizens would be guaranteed employment and plenty of leisure time to explore the shopping malls, pristinely groomed green spaces, and Disney's theme parks. EPCOT would also be a pedestrian-friendly city with many public transit options where residents would quietly travel

58. Refer to https://qiddiya.com/
59. Ibid.
60. "Diriyah Gate Development Authority."

via monorail and electric people movers, while cargo and supplies would be delivered via a system of tunnels beneath the city. Residences would be located on the city's fringes, bordering a generous greenbelt dotted with parks, golf courses, and other recreational amenities, while a climate-controlled city center would house the satellites of international corporations.[61] The idea was that the companies could use the residents as testers for new products so people living at EPCOT would have access to the cutting edge of technology. While Disney never had a chance to realize his EPCOT vision, its concept was eventually developed as a theme park of futurism, combining several themed areas referred to as "neighborhoods": World Celebration (focusing on creativity, imagination, and storytelling), World Nature (focusing on ecology and conservation), and World Discovery (focusing on science, technology, and adventure).[62]

Bringing Disney's EPCOT concept to fruition in a hybridized city/theme park, Qiddiya similarly encompasses several themed "cores" that merge concepts of environmentalism with the celebration of digitally advanced technologies. The spectacular site of the project is located at the Tuwaiq escarpment, which stretches over more than 600 kilometers through central Saudi Arabia and once overlooked an ancient trade route that used to cross the Arabian Peninsula from Yemen into the Levant and Persia. The cliffs drop down 200 meters into an ancient ocean bed and give visitors an uninterrupted view of the horizon. While an array of themed destinations will be built in the valley as a vast, connected entertainment zone, a proper city is situated on the site's cliffs. The "Resort Core" represents the amusement area of Qiddiya, where four theme parks, skating and skiing facilities, and a large outdoor entertainment venue surround specialty retail, dining, and entertainment centers. Adjacent is the "Motion Core," which, reminiscent of Epcot's World of Motion, comprises an array of "action-oriented," technology-enhanced experiences (see images 8.7 and 8.8). The "Eco Core," in contrast, offers passive experiences inspired

61. Matt Patches, "Inside Walt Disney's Ambitious, Failed Plan to Build the City of Tomorrow," *Esquire*, May 20, 2015, https://www.esquire.com/entertainment/news/a35104/walt-disney-epcot-history-city-of-tomorrow/.

62. Austin Lang, "The History of Disney's Epcot: From City of Tomorrow to the Eternal World's Fair," *All Ears* (blog), April 19, 2020, https://allears.net/2020/04/19/the-history-of-disneys-epcot-from-city-of-tomorrow-to-the-eternal-worlds-fair/.

by nature and outdoor sporting adventures. Overlooking the valley from the Tuwaiq escarpment edge, the "City Center" comprises a pedestrian-friendly, mixed-use district, which merges residential, retail, and workplace environments that connect via a system of funiculars and other advanced infrastructure to the Resort Core below. Arts and entertainment create an integrated town center with galleries, a performing arts theatre, and a multiplex cinema dotting the central walkways as primary anchors. In parallel, creative villages offer art- and media spaces and educational facilities. Large-scale sports venues, equestrian facilities, and a golf community surround the town center, expanding to the escarpment edges where a network of biking trails along the cliff's edge complete the master plan.[63]

The reincarnation of Disney's "City of Tomorrow" comes as no surprise as Qiddiya's CEO Phillipe Gas is a seasoned Disney veteran who has worked for the company for thirty years designing resorts in Europe and China. According to Gas, "Qiddiya will be a place that enables the youth of Saudi Arabia to fulfill their ambitions. It will be a place where they [will not only] enjoy, [but] appreciate, aspire, advance and nurture their potential; a place that unlocks opportunities and new professional pathways to help build a more prosperous and progressive society."[64] Like Epcot, Qiddiya will therefore not only be a playground for hedonistic pleasures but moreover serve as a themed testing ground for a new national lifestyle infrastructure that grooms citizens' social behaviors through choice architecture and gamification structuring will predetermine situations to shape appropriate actions, aligning with the country's national vision. Through engineering seamlessly linked virtual and physical contexts that prompt particular behaviors, users are encouraged to "co-create their involvement." The twist here (as in all virtual worlds) is that "nudging" and "herding" intend to "encourage" choices that accrue to the "Imagineers," not to the individual. According to Gas, this is where technology comes into the picture. "Augmented reality, virtual reality, and many of the effects we can play with and use will draw people into the experience.

63. Charles Read, "Qiddiya: Inside the Multi-Billion Dollar Saudi Giga-Project," *Blooloop*, December 17, 2020, https://blooloop.com/brands-ip/in-depth/qiddiya-philippe-gas/.
64. Ibid.

[First] they will become actors in the experience, and then [they will] want to live the experience." By fusing digital means of modification with real-time actions, this process involves a mix of operant conditioning in the form of curated contexts and subliminal cues that eliminate interpretations that might interfere with the targeted outcome. For this to happen, all deviant forces and behaviors must be actively curtailed to maintain the consistency of the narrative. As Gas states, "I think [the project's] beauty will be this kind of harmony. The story of Qiddiya has to be consistent throughout. So, even though we work with our partners to define their creative concepts, they will all go into this one story."[65]

Territories Reformed: Eco-luxe on the Red Sea

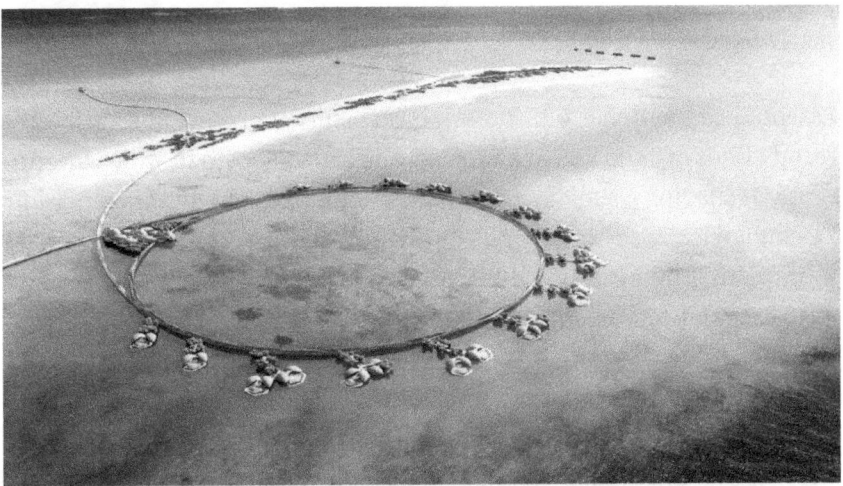

Image 8.9. Rendering showing the Red Sea Resort's "coral villas," providing 360-degree-views of the surrounding sea. Courtesy of TRSC (The Red Sea Company).

65. Ibid.

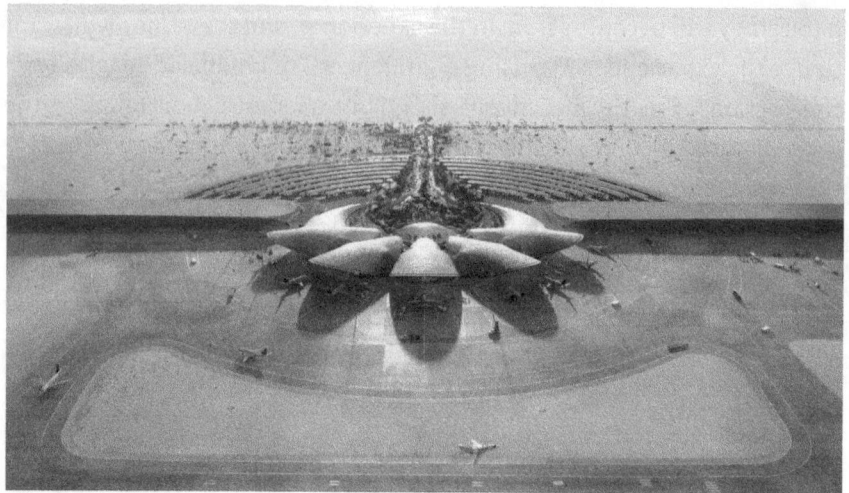

Image 8.10. Rendering showing Red Sea International Airport, designed by Foster Partners. Courtesy of TRSC / Foster Partners.

Essential cornerstones of Saudi Arabia's luxury tourism ambition are the resort zones of "The Red Sea Project" and Amaala, both of which are currently reshaping Saudi Arabia's natural and marine environments into "technologically advanced and eco-friendly tourism destinations" aimed at attracting high-net-worth eco-conscious luxury travelers. Both projects respond to current trends in the ecological luxury tourism market, "where travelers are increasingly seeking exclusive, healthy and safe experiences while (you guessed it) safeguarding the environment."[66] Competing with neighboring Dubai and other Middle East countries, these and similar developments aspire to position Saudi Arabia as the "next world-class destination for regenerative luxury tourism." Like other large-scale tourism enclaves in the Global South, the projects aspire to attract domestic and international investment through relaxed legislation, the promise of freehold ownership, and partnerships with top-tier global brands and companies.

66. Jerry Clausing, "Red Sea Development Co.'s John Pagano on Saudi Arabia Tourism," *Travel Weekly*, April 5, 2019, https://www.travelweekly.com/On-The-Record/Red-Sea-Development-Co-John-Pagano.

The Red Sea Project, situated on the Western coast of Saudi Arabia between the small towns of Umluj and Al Wajh, comprises a site of 28,000 square kilometers along a stretch of a 200 kilometers-long virgin coastline. Lined by ninety uninhabited islands on the seaside and a varied landscape of desert and mountainous areas in the coast's hinterland, this meta-resort zone encompasses a vast territory, which was, until recently, only visited by occasional diving groups and ordinary Saudi families in search of the perfect camping site. This peaceful idyll will soon give way to a staggering number of fifty resorts surrounded by exclusive residential communities (see image 8.9), spread across twenty-two of the islands and six inland sites, imagined by WTAG from Singapore in collaboration with British engineering company Buro Happold. Designed to wean the Saudi economy off a dependence on falling oil revenues and to create jobs for the Saudi population, the planners' mission is to transform islands, coast, and part of the backcountry into an "exquisite, barefoot luxury, regenerative tourism destination, built around a natural environment, coupled with a rich cultural heritage." To ensure the resort zone's exclusivity while mitigating potential environmental impacts of over-tourism, "annual visitors will be capped at one million."[67]

Further north, Amaala is planned as another complementary destination, albeit positioned with a more cultural twist to provide guests with a transformative offering in three distinct thematic zones, "which will awaken the imagination with a focus on wellness and sports, art and culture, sun, sea, and lifestyle."[68] While "Triple Bay" will be a holistic wellness retreat with state-of-the-art medical and sports facilities that include "globally respected healing arts inspired by local traditions," the "Coastal Development" will include a cultural center, a museum of contemporary art, a center for film festivals, a performing arts venue, and a biennale park. Finally, the "Island," the third development, will present an exclusive enclave where residents and visitors can "relax in intimate

67. The Red Sea Development Company, "2020 Sustainability Report: Laying the Foundation for a Sustainable Destination," https://issuu.com/theredsea/docs/trsdc_sustainability_report_english.
68. "A Hidden Jewel," *AMAALA*, retrieved February 12, 2021, https://www.amaala.com/en/master-plans.

resorts."[69] Tourists will fly directly into the zones via greenfield airports (see image 8.10), from which they will be chaperoned by private boats, effectively shielding them from the varied socio-spatial context of the zones' surroundings. Swiftly whisked to their hotels, they will avoid any "risky" cultural encounters with the conservative population in the vicinity. As the security and safety of the guests are of the utmost importance, digital devices will be ubiquitously present in the resort zones. "Smart services" will monitor anything from environmental conditions and guest experiences to logistics and performance of security, mobility, utilities, buildings, administration, public realm, retail, logistics, health care, and education in a panoptic form of seamless surveillance. To achieve the status as the world's first while meeting (and ideally exceeding) the expectations of eco-conscious luxury travelers, the Red Sea Project will be powered by the world's largest off-grid renewable energy grid comprised of interconnected solar and wind energy storage systems. An on-site seawater reverse osmosis desalination plant powered by renewable energy will provide potable water, while wastewater will be treated and used for irrigation. Organic-rich waste and food waste, in turn, will be converted to compost used in the project's nursery, growing turf grass and other indigenous plants needed to green golf courses, hotels, and residential properties. Non-recyclable waste will be incinerated appropriately to generate ash that can produce bricks when mixed with cement. Meanwhile, the project will also include obligatory programs for the local population via paid work in the sustainability sector, such as cleaning marine debris, while providing them educational guidance that highlights the importance of sustainable waste disposal. A green mobility plan linked to a networked digital monitoring system of "context-aware" sensors will ensure a "sustainably optimized" transport network that supports "community connectivity" and a "personalized end-to-end guest experience" through a seamless arrival and departure process, optimized management of environs and facilities, and fully integrated security and site operations. Biometric technology installed across the resort's borders and conveniently connected to law enforcement systems will identify visa

69. Frank Kane, "INTERVIEW: Amaala — the 'audacious' Red Sea Riviera Project," *Arab News*, September 27, 2020, https://www.arabnews.com/node/1740556/business-economy.

verifications, watch lists, entry/exit registration, and enable cashless payments along with "touch-free experiences," thus constantly monitoring guests' locations, their medical statuses, and their activities. Through augmented and virtual reality, "relevant promotions" inform potential travelers before and during their visit to the destination, while an automated check-in and check-out provides "an unobstructed" walk-through of the project's borders with zero waiting queues.[70]

Both resorts reiterate the now all-too-familiar saga of creating a decontextualized tourist fantasy of pristine, isolated, and unpeopled landscapes through the restaging of natural resources. In the effort to rescript pre-existing definitions of place into showcases of consolidated state power, vast territories are converted into enclosed enclaves driven by powerful local elites and patrolled by security forces. Conveniently, the uncanny paradox of ecological luxury resorts offers the pretense that everyone, irrespective of social class, employment, and income, is "in it together," united in striving to hand over a sustainable planet to future generations, strategically masking exclusionary interests. These include the marginalization and disempowerment of specific segments of society and other disturbing elements often referred to as "eco-threats." Scripted around the well-known narratives of health, wellness, and sustainability, these destinations constitute highly controlled, depoliticized, three-dimensional testing sites that enact the neoliberal ideology of consumerism through aphoristic narratives about sustainable progress and equality, invoked not to question the steep power inequalities of neoliberal capitalism but rather to prevent the critique of unequal power structures rampant in contemporary societies.[71]

As Goffmann has demonstrated in the 1960s, gated enclaves depend on minutely staged settings enhanced by emblematic role-play, choreographies, group formations, and instructions, constantly observed and programmed by a panoptic gaze that strips visitors of their identity kit.

70. The Red Sea Development Company, "2020 Sustainability Report."
71. Christian Fuchs, "Critical Social Theory and Sustainable Development: The Class, Capitalism and Domination in a Dialectical Analysis of Un/Sustainability," *Sustainable Development* 25, no. 5 (2017): 443–458.

Guided by specific cues, performative rituals reinforce the enclaves' symbolic values, reproducing them as dramaturgical spaces where visitors are "cleanly stripped of many of [their] accustomed affirmations, satisfactions, and defenses, . . . subjected to a rather full set of mortifying experiences: restriction of free movement, communal living, [and a] diffuse authority of a whole echelon of people."[72] Once the subjects begin to settle down, the main outlines of their fate tend to follow those of a whole class of segregated establishments in which they "spend the whole round of life on the grounds, and march through their regimented day in the immediate company of a group of persons of their own institutional status."[73] As such, these purified territories resemble "total institutions"[74] that, abstracted from their socio-cultural surroundings and securitized from the surrounding population, depend upon continual policing and monitoring to assure their thematic coherence. Accordingly, one of their most important features is the consistent maintenance of a clear boundary, which demarcates which activities may occur and who may be admitted. While these criteria, to various degrees, hold for all enclavic spaces, at least earlier resort versions evoked the rhetoric of freedom as spaces of individual autonomy where "you could just let go," where no one would make you conform to expectations about yourself. In contrast, eco-luxury's technology-powered panoptic worlds constitute stringent, self-optimizing regimes in which sobriety and other behavioral modifications are recast as wellness practices demanding the exertion of self-imposed pressures. Subtly nudged to comply in a specific manner by prescribed algorithmic protocols, guests learn to orient themselves in terms of the "system," in which situations are pre-structured and appropriate behavior is rewarded through the granting of certain "privileges."

While "behavioral surplus" was not known in the 1970s, Foucault's panoptical surveillance anticipated the continuous intensification of behavioral modifications and the gathering might of instrumental power. In this respect, Foucault highlighted modern technologies' effectiveness

72. Erving Goffmann, *Asylums: Essays on the Social Situation of Mental Patients and other Inmates* (New York: Anchor Books, 1961), 148.
73. Goffmann, *Asylums,* 147
74. Ibid.

in the self-imposed modification of people's behaviors while introducing the notion that observation by an invisible force induces "voluntary" techniques of self-optimization, whereby people effectively recondition their belief systems and activities.[75] In the panoptic space, the actions of invisible observers entail the continuous recording of behaviors. The more behavioral data they accumulate, the more powerful they become. As their power increases by accumulating knowledge through consistent observations, modes of interaction become increasingly more targeted, resulting in a constant feedback loop. The formation of knowledge and accumulated power regularly reinforce one another, ultimately resulting in the subject's complete docility and compliance. First, effecting normalization, the process eventually leaves the subject "singing in its chains."[76] In a more advanced and sophisticated manner, today's virtualized "worlds" rely on the instrumentalization of behaviors for the purpose of modification, prediction, monetization, and control, enabled by a ubiquitously connected material architecture of sensate computation that renders, interprets, and actualizes human experience in real time, exploiting contemporary anxieties.[77] In this respect, Saudi Arabia's meta-resort zones—controlled by the computational architecture of networked devices and consistently reinforced by choreographed imagery and rescripted spaces—might foreshadow the next reiteration of surveillance capitalism in which automated machine processes seamlessly blend with virtualized territories, aiming to impose a new collective order based on total certainty.

The Arrival of the Metaverse

Meta-zones, socio-economic reforms, and nation branding create a synergistic triangle which will position Saudi Arabia as a powerful player in the years to come. The virtualized rescripting of Saudi Arabia's territories as meta-worlds closely intertwines with the rebranding of Saudi

75. Michel Foucault, "The Subject and Power," in *Beyond Structuralism and Hermeneutics*, eds. Hubert Dreyfus and Paul Rabinow, (Brighton: Harvester, 1988). See also Michel Foucault, *Discipline and Punish: The Birth of the Prison* (New York: Vintage Books, 1977).
76. Zuboff, *The Age of Surveillance Capitalism*, 11.
77. Ibid., 353.

Arabia as a nation and with its expressed desire to be an influencer in the global economy. Within the context of global competition, all meta-zones are positioned to exceed established standards, seeking to benchmark against upcoming cognitive ecological cities. However, looking at the leaps and strides of real estate examined here, one can also detect the driving forces of neoliberal economic policies coupled with nationalist ideology and power, evident in the ruling class's role in setting the overall agenda for each development. In negotiating nationalist aims with the contradictions of global free-market capitalism, specific ideologies and narratives for each destination are strategically deployed which target behavioral modification of both internal and external audiences. Predictably, these high-end enclaves follow the tried-and-true track of other global cities that have been value-engineered through a lucrative brew of neoliberal principles. Poised to transform Saudi Arabia into a bifurcated topography of the technology-savvy super-elite versus the rest, this enclavic model of urbanism entails an intensified securitization of large-scale, surveilled, and privatized zones as a result of the secession of transnational elites from the "commons" and the entrenchment of inequality, as has been the case in many other "globalizing and global nations."

While Saudi Arabia's meta-zones proclaim to offer a future-oriented and progressive vision to a global audience—resting on established platitudes of saving the environment—the examples above clearly demonstrate that these destinations posing as lifestyle infrastructures are narrowly confined, programmed, and policed, nullifying the fundamental rights associated with individual autonomy. Their instrumentarian power comprised of behavioral surplus, data science computational power, algorithmic systems, and automated platforms rests in the hands of a political and economic super-elite who are crafting total social environments, aiming to profit from their monetization, prediction, and control. If realized as planned, these virtualized worlds will finally dispel lingering fictions of freedom and dignity in the name of "harmony and wellbeing," forever rendering the dreams of urban heterogeneity and personal liberty mere aphorisms of a bygone era. From the viewpoint of surveillance capitalism, Saudi Arabia will undoubtedly set an uncanny precedent for the cogni-

tive, controlled, sustainable cities of a not-too-distant future where the global ideology of environmental protection, nationalist discourses, and data-driven surveillance technologies are eagerly interlacing in the comprehensive curation of highly customized, commoditized, and monitored metaverses populated with compliant cosmopolitans.

Bibliography

"A Hidden Jewel." *AMAALA*. https://www.amaala.com/en/master-plans.

Al-Mana, AbdulRahman. "The Destruction of Mecca & Medina's Historic Landscapes." *Cities from Salt* (blog), October 3, 2019. https://www.citiesfromsalt.com/blog/the-destruction-of-mecca-and-medinas-historic-landscapes.

Allan, Malcolm. "Experience Masterplanning." *City Nation Place*, February 9, 2017. https://www.citynationplace.com/experience-masterplanning.

Aly, Hend. "Royal Dream: City Branding and Saudi Arabia's NEOM." *Middle East—Topics & Arguments* 12, no. 1 (2019): 99–109. https://doi.org/10.17192/meta.2019.12.7937.

Andraos, Amale. "The Arab City." *Places Journal* (May 2016). https://doi.org/10.22269/160531.

Anholt, Simon. "Anholt Nation Brands Index: How does the World see America." *Journal of Advertising Research* 45, no. 3 (2005): 296–304.

———. *Competitive Identity: The New Brand Management for Nations, Cities, and Regions*. New York: Palgrave Macmillan, 2007.

———. "Should Place Brands be Simple?" *Place Branding and Public Diplomacy* 5, no. 2, (2009): 91–96.

Bagaeen, Samer. "Brand Dubai: The Instant City; or the Instantly Recognizable City." *International Planning Studies* 12, no. 2, (2007): 173–197.

Beerli, Asunciòn, and Josefa D. Martín. "Factors influencing Destination Image." *Annals of Tourism Research* 31, no. 3, (2004): 657–81.

Bonakdar, Ahmad, and Ivonne Audirac. "City Branding and the Link to Urban Planning: Theories, Practices, and Challenges." *Journal of Planning Literature* 35, no. 2 (May 2020): 147–60. https://doi.org/10.1177/0885412219878879.

Castells, Manuel. *Networks of Outrage and Hope: Social Movements in the Internet Age*. New York: John Wiley & Sons, 2013.

Clausing, Jerry. "Red Sea Development Co.'s John Pagano on Saudi Arabia Tourism." *Travel Weekly*, April 5, 2019. https://www.travelweekly.com/On-The-Record/

Red-Sea-Development-Co-John-Pagano.

Dinnie, Keith, T.C. Melewar, Kai-Uwe Seidenfuss, and Ghazali Musa. "Nation Branding and Integrated Marketing Communications: An ASEAN Perspective." *International Marketing Review* 27, no. 4 (2010): 388–403.

Dinnie, Keith. *Nation Branding: Concepts, Issues, Practice* (2nd Edition). Oxfordshire: Routledge, 2016.

Diriyah Gate Development Authority. "Development Overview." 2021. https://www.dgda.gov.sa/our-destinations/diriyah.aspx.

"Diriyah Gate Development Authority Starts Work on a Major Heritage Project." *Arab News*, July 1, 2020. https://arab.news/8g8e7.

Donfried, Mark. "How Saudi Arabia is Building a New National Brand." *Arab News*, January 13, 2018. https://www.arabnews.com/node/1224971.

Easterling, Keller. *Extrastatecraft: The Power of Infrastructure Space*. New York: Verso, 2014.

Edensor, Tim. "Staging Tourism." *Annals of Tourism Research* 27, no. 2 (2000), 322–344.

Elsheshtawy, Yasser. *Dubai: Behind an Urban Spectacle*. London: Routledge, 2009. https://doi.org/10.4324/9780203869703.

Fan, Ying. "Branding the Nation: What is Being Branded?" *Journal of Vacation Marketing* 12, no. 1 (2006): 5–14.

Fetscherin, Marc. "The Determinants and Measurement of a Country Brand: The Country Brand Strength Index." *International Marketing Review* 27, no. 4, (2010): 466–479.

Foucault, Michel. *Discipline and Punish: The Birth of the Prison*. New York: Vintage Books, 1977.

———. "The Subject and Power." In *Beyond Structuralism and Hermeneutics*, edited by Hubert Dreyfus and Paul Rabinow. Brighton: Harvester, 1988.

Freire, Joao R. "Place Branding in the Middle East." *Place Branding and Public Diplomacy* 8 (2012): 46–47. https://doi.org/doi: 10.1057/pb.2011.35.

Fuchs, Christian. "Critical Social Theory and Sustainable Development: The Class, Capitalism and Domination in a Dialectical Analysis of Un/Sustainability." *Sustainable Development* 25, no. 5 (2017): 443–458.

Godinho, Varun. "Two-thirds of Saudi Arabia's Population is under the Age of 35." *Gulf Business*, August 10, 2020. https://gulfbusiness.com/two-thirds-of-saudi-arabias-population-is-under-the-age-of-35/.

Goffmann, Erving. *Asylums: Essays on the Social Situation of Mental Patients and Other Inmates*. New York: Anchor Books, 1961.

Govers, Robert, and Frank Go. *Place Branding: Glocal, Virtual and Physical Identities, Constructed, Imagined and Experienced.* London: Palgrave Macmillan, 2009.

Hameed, Mustafa. "The Destruction of Mecca: How Saudi Arabia's Construction Rampage is Threatening Islam's Holiest City." *Foreign Policy*, September 22, 2015. https://foreignpolicy.com/2015/09/22/the-destruction-of-mecca-saudi-arabia-construction/.

Hao, Andy W., Justin Paul, Sangeeta Trott, Chiquan Guo, and Heng-Hui Wu. "Two Decades of Research on Nation Branding: A Review and Future Research Agenda." *International Marketing Review* 38, no. 1 (2021): 46–69. https://doi.org/10.1108/IMR-01-2019-0028.

Hassan, Salah, and Abeer Mahrous. "Nation Branding: The Strategic Imperative for Sustainable Market Competitiveness." *Journal of Humanities and Applied Social Sciences* 1, no. 2 (2019):146–158. https://doi.org/10.1108/JHASS-08-2019-0025.

He, Jiaxun, Cheng Lu Wang, and Yi Wu. "Building the Connection between Nation and Commercial Brand: An Integrative Review and Future Research Directions." *International Marketing Review* 38, no.1 (2021): 19–35. https://doi.org/10.1108/IMR-11-2019-0268.

Healy, Noel, and Tazim Jamal. "Enclave Tourism." In *The Sage International Encyclopedia of Travel and Tourism,* edited by Linda L. Lowry, 418–419. Thousand Oaks: SAGE Publications, Inc., 2017. http://dx.doi.org/10.4135/9781483368924.n160.

Jalabi, Raya. "After the Hajj: Mecca Residents Grow Hostile to Changes in the Holy City." *The Guardian*, September 14, 2016. https://www.theguardian.com/cities/2016/sep/14/mecca-hajj-pilgrims-tourism.

Kane, Frank. "Frankly Speaking: Saudi Arabia Doubling Down on Diriyah Gate Project, says DGDA CEO." *Arab News*, June 13, 2021. https://arab.news/46naz.

———. "INTERVIEW: Amaala — the 'audacious' Red Sea Riviera Project." *Arab News*, September 27, 2020. https://www.arabnews.com/node/1740556/business-economy.

Kavaratzis, Mihalis. "Place Branding: A Review of Trends and Conceptual Models." *The Marketing Review* 5 (2005): 329–342.

Kavaratzis, Mihalis, and Mary Jo Hatch. "The Dynamics of Place Brands: An Identity-Based Approach to Place Branding Theory." *Marketing Theory* 13, no. 1 (2013): 1–18.

Khaku, Mohammed. "Never-ending Destruction of Historical Sites in Mecca and Medina, Cradle of Islam." *Arab American News*, May 15, 2021. https://www.arabamericannews.com/2021/05/15/never-ending-destruction-of-historical-sites-in-mecca-and-medina-cradle-of-islam/.

Kinninmont, Jane. "Vision 2030 and Saudi Arabia's Social Contract: Austerity and Transformation." *Chatham House: The Royal Institute of International Affairs* (July 2017): 1–44. https://www.chathamhouse.org/sites/default/files/publications/research/2017-07-20-vision-2030-saudi-kinninmont.pdf.

Klingmann, Anna. "Re-scripting Riyadh's Historical Downtown as a Global Destination: A Sustainable Model?" *Journal of Place Management and Development* 15, no. 2 (2022): 93–111. https://doi.org/10.1108/JPMD-07-2020-0071.

———. "The Rise of Shopping Malls within the Framework of Gulf Capitalism." In *World of Malls: Architectures of Consumption*, edited by Andres Lepik and Vera Simone Bader, 175–183. Berlin: Hatje Cantz, 2016.

Kotler, Philip, and David Gertner. "Country as a Brand, Product and Beyond: A Place Marketing and Brand Management Perspective." *The Journal of Brand Management* 9, no. 4-5 (2002): 249–261.

Lang, Austin. "The History of Disney's Epcot: From City of Tomorrow to the Eternal World's Fair." *All Ears* (blog), April 19, 2020. https://allears.net/2020/04/19/the-history-of-disneys-epcot-from-city-of-tomorrow-to-the-eternal-worlds-fair/.

Leprince-Ringuet, Daphne. "A City that knows your Every Move: Saudi Arabia's New Smart City might be a Glimpse of the Future." *ZD Net*, February 18, 2021. https://www.zdnet.com/article/a-city-that-knows-your-every-move-saudi-arabias-new-smart-city-might-be-a-glimpse-of-the-future/.

Lukas, Scott. "The Meanings of Themed and Immersive Spaces." In *A Reader in Themed and Immersive Spaces*, edited by Scott A. Lukas. Pittsburg: Carnegie Mellon Press, 2016.

Maneval, Stefan. "Mass Accommodation for the 'Guests of God': Changing Experiences of Hajj-Pilgrims in Jeddah." *Arab Urbanism*. www.araburbanism.com/magazine/hajj-pilgrims-jeddah.

Muñoz-Alonso, Lorena. "Saudi Arabia Destroyed 98 Percent of Its Cultural Heritage." *ArtNet*, November 19, 2014. https://news.artnet.com/art-world/saudi-arabia-destroyed-98-percent-of-its-cultural-heritage-174029.

Neef, Andreas. "Tourism, Land Grabs and Displacement: A Study with Particular Focus on the Global South." *Tourism Watch*, February 2019. https://www.tourism-watch.de/system/files/document/Neef_Tourism_Land_Grab_Study.pdf.

NEOM Company. "HRH Prince Mohammed bin Salman Announces 'The Line' at NEOM." *PR Newswire*, January 1, 2021. https://en.prnasia.com/releases/apac/hrh-prince-mohammed-bin-salman-announces-the-line-at-neom-305130.shtml. Related link: http://www.NEOM.com.

"Neom's Head of Tech on what Daily Life will be like for Neomians." *The National Business*, January 21, 2021. https://www.thenationalnews.com/business/technology/neom-s-head-of-tech-on-what-daily-life-will-be-like-for-neomians-1.1151293.

Nye, Joseph S. "Soft Power and American Foreign Policy." *Political Science Quarterly* 119, no. 2 (2004): 255–270.

Osser, Edek. "Why is Saudi Arabia Destroying the Cultural Heritage of Mecca and Medina?" *The Art Newspaper*, November 19, 2015. https://.ww.theartnewspaper.com/2015/11/19/why-is-saudi-arabia-destroying-the-cultural-heritage-of-mecca-and-medina.

Papadopoulos, Nicolas, and Louise Heslop. "Country Equity and Country Branding: Problems and Prospects." *Journal of Brand Management* 9 (2002): 294–314. https://doi.org/10.1057/palgrave.bm.2540079.

Patches, Matt. "Inside Walt Disney's Ambitious, Failed Plan to Build the City of Tomorrow." *Esquire*, May 20, 2015. https://www.esquire.com/entertainment/news/a35104/walt-disney-epcot-history-city-of-tomorrow/.

Power, Carla. "Saudi Arabia Bulldozes Over Its Heritage." *Time*, November 14, 2014. https://time.com/3584585/saudi-arabia-bulldozes-over-its-heritage/.

Quelch, John A., and Katherine E. Jocz. "Positioning the Nation-State," *Place Branding* 1, no.1 (2004): 74–79.

Read, Charles. "Qiddiya: Inside the Multi-Billion Dollar Saudi Giga-Project." *Blooloop*, 17 December 2020, https://blooloop.com/brands-ip/in-depth/qiddiya-philippe-gas/.

The Red Sea Development Company. "2020 Sustainability Report: Laying the Foundation for a Sustainable Destination." https://issuu.com/theredsea/docs/trsdc_sustainability_report_english.

Ren, Yuan and Per Olof Berg. "Developing and Branding a Polycentric Mega-City: The Case of Shanghai." In *Branding Chinese Mega-Cities: Policies, Practices and Positioning*, edited by Per Olof Berg and Emma Björner. Northampton, MA: Edward Elgar Publishing, 2014.

Saarinen, Jarkko and Sandra Wall-Reinius. "Enclaves in Tourism: Producing and Governing Exclusive Spaces for Tourism." *Tourism Geographies* 21, no. 5 (2019): 739–748. https://doi.org/10.1080/14616688.2019.1668051.

Saarinen, Jarkko. "Enclavic Tourism Spaces: Territorialization and Bordering in Tourism Destination Development and Planning." *Tourism Planning and Development* 19, no. 3 (2017): 425–437.

Sardar, Ziauddin. "The Destruction of Mecca." *New York Times*, September 30, 2014. https://www.nytimes.com/2014/10/01/opinion/the-destruction-of-mecca.html.

Shoaib, Turki. "Place Branding in a Globalizing Middle East: New Cities in Saudi Arabia." PhD. diss, Oxford Brookes University, 2017. https://radar.brookes.ac.uk/radar/file/88098f91-21f6-46a7-9b7a-a271a34f8cd5/1/TurkiShoaib_PhD_Thesis_2017_RADAR.pdf.

SNC LAVALIN. "Transforming Cultural Destinations in Saudi Arabia." *SNC-Lavalin*, 2020. https://www.snclavalin.com/en/projects/diriyah-transforming-cultural-destinations-in-saudi-arabia.

Wang, Cheng Lu, Dongjin Li, Bradley R. Barnes, and Jongseok Ahn. "Country Image,

Product Image and Consumer Purchase Intention: Evidence from an Emerging Economy." *International Business Review* 21, no. 6 (2012): 1041–1051.

Warrier, Ranju. "Saudi's DGDA inks deal with NWC for water projects at Diriyah Gate." *Construction Week*, November 29, 2020. https://www.constructionweekonline.com/projects-and-tenders/269207-saudis-dgda-inks-deal-with-nwc-for-water-projects-at-diriyah-gate.

"What is the Line?" *NEOM*. https://www.neom.com/en-us/regions/whatistheline.

Zeineddine, Cornelia. "Employing nation branding in the Middle East United Arab Emirates (UAE) and Qatar." *Management & Marketing: Challenges for the Knowledge Society* 12, no. 2 (2017). https://doi.org/10.1515/mmcks-2017-0013.

Zuboff, Shoshana. *The Age of Surveillance Capitalism: The Fight for a Human Future at the New Frontier of Power*. London: Profile Books Ltd., 2019.

about the editors

Dave Gottwald is a designer and design historian. His research explores the theming of consumer spaces and interplay between the built and the virtual. Along with Gregory Turner-Rahman, he was recipient of the 2019 Design Incubation Writing Fellowship for their current collaboration, *Theme Parks, Video Games, and Evolving Notions of Space: The End of Architecture* (forthcoming, Intellect Books). He is also co-author of *Disney and the Theming of the Contemporary Zoo: Kingdoms of Artifice* (forthcoming, Lexington Books). He is currently an Assistant Professor at the University of Idaho in the College of Art & Architecture where he teaches interaction design, experiential design for the built environment, and exhibit design.

Gregory Turner-Rahman is a designer and writer-illustrator. His current research and creative activity explores both the intersections of physical and virtual spaces and visual and experiential storytelling. In 2019, he and Dave Gottwald were recipients of the Design Incubation Writing Fellowship for their collaboration, *Theme Parks, Video Games, and Evolving Notions of Space: The End of Architecture* (forthcoming, Intellect Books). He has also contributed to *The Journal of Design History, Post-Identity, Fibreculture and Media Authorship*, an edited American Film Institute Reader published by Routledge. As a member of a creative team, he garnered Apex and Clarion awards for writing and design work. He is currently an Associate Professor at the University of Idaho in the College of Art & Architecture where he teaches motion graphics and design history.

Vahid Vahdat is an architect, interior designer, and historian of architecture and urban form. His primary field of research is the global circulation of modern architecture, with an emphasis on medial agency. He is the author of *Occidentalist Perceptions of European Architecture in Nineteenth Century Persian Travel Diaries—Travels in Farangi Space*. Dr. Vahdat has held academic positions in the US and abroad, including at the University of Houston and Texas A&M University. He is currently an Assistant Professor at the School of Design and Construction at Washington State University. His teaching primarily involves explorations in architectural media, including virtual interiorities and filmic expressions of space.

about the contributors

Ágnes Karolina Bakk is a researcher at Moholy-Nagy University of Art and Design. She is the founder of the immersive storytelling conference and magazine *Zip-Scene* (zip-scene.com and zip-scene.mome.hu); the cofounder of Random Error Studio, a lab that supports various VR productions; curator of Vektor VR. She was previously a research fellow at Sapientia – Hungarian University of Transylvania. She is teaching escape room design, immersive & VR storytelling and speculative design, and she is also a board member of the COST Action INDCOR. Bakk presented her research on immersive theatre, science of magic and VR at various conferences and platforms from Moscow (CILECT, 2019) to Montreal (SQUET, 2019).

Florian Freitag has been professor of American Studies at the U of Duisburg-Essen (Germany) since 2019. Freitag received his PhD from the U of Konstanz (Germany) in 2011 and his post-doctoral degree (Habilitation) from JGU Mainz (Germany) in 2019. He is the cofounder of three research groups on theme parks, two of which have been funded by the German Research Foundation (DFG). Freitag is the author of *Popular New Orleans: The Crescent City in Periodicals, Theme Parks, and Opera, 1875-2015* (Routledge 2021) and the co-editor of *Key Concepts in Theme Park Studies: Understanding Tourism and Leisure Spaces* (Springer Nature 2022); his other work on theme parks has appeared in *The Journal of Popular Culture, Continuum*, and *Journal of Themed Experience and Attractions Studies*.

Andri Gerber is an architecture and urban design theoretician and urban metaphorologist. He earned his MSc in Architecture as well as his PhD (awarded with an ETH medal) and his habilitation from the ETH Zurich. He is a professor for Urban History at the ZHAW and a private lecturer at the ETH. His current research and publications focus on matters relating to spatial perception from a cognitive perspective, and on the potential of board and video games in architecture and urban design. Among his recent publications are *Architectonics of Game Spaces* (with Ulrich Götz, transcript 2019, *Training Spatial Abilities* (Birkhäuser 2019) and a Covid-19 themed videogame, *Dichtestress* (https://www.zhaw.ch/de/archbau/institute/iul/dichtestress/).

Graham Harman is Distinguished Professor of Philosophy at the Southern California Institute of Architecture (SCI-Arc) in Los Angeles. Previously he was Distinguished University Professor at the American University in Cairo, where he spent sixteen years on the faculty. He is a founding member of the Speculative Realism and Object-Oriented Ontology movements, Editor-in-Chief of the journal Open Philosophy, Series Editor of the Speculative

Realism series at Edinburgh University Press, and Series Co-Editor (with Bruno Latour) of the New Metaphysics Series at Open Humanities Press.

Anna Klingmann is an architect, urbanist, and researcher. She is an Associate Professor in the Department of Architecture at the New York Institute of Technology. Anna is driven by a relentless desire to shape places and communities. Guided by an ongoing passion for discovering what is next, her work investigates proactive methods and cross-disciplinary techniques that can meet today's challenges of urbanization and the progressive interlacing of global and local economic and cultural environments. By integrating multiple scales and disciplines into a holistic approach, her work aims to develop nuanced expressions of urbanity tailored to the needs and means of specific regions and cultural contexts. Resilience is understood here as a multidimensional and heterogeneous process that integrates the fields of ecology, economics, sociology, and culture in a dynamic cross-disciplinary palimpsest, depending on each context. Anna lectures internationally and serves on academic and professional juries and symposia. In the past, she was Chair of Architecture at Dar Al Hekma University in Jeddah and has held guest professorships at Prince Sultan University in Riyadh, Cornell University, Columbia University, the University of Pennsylvania, the Architectural Association in London, the ETH in Zurich, the University of Arts in Berlin and the University of Texas at Austin. Her book *Brandscapes: Architecture in the Experience Economy* (MIT Press 2010 [2007]) investigates the concept of branding in architecture and its effects on the global urban landscape. Anna is currently working on new research exploring the inverse effects of global consumer culture. While her earlier research focused on the iconicity of global cities as "branded phenomena" this project undertakes a strategic reversal of emphasis to examine the deeper and more perplexing issue of the local in a climate in which the particularities of regional cultures are under immense pressure.

Sabrina Mittermeier is an assistant professor of American history at the University of Kassel, Germany. She is the author of *A Cultural History of Disneyland Theme Parks – Middle-Class Kingdoms* (Intellect Books 2020), the co-editor, among other volumes, of *Fan Phenomena: Disney* (Intellect Books 2022), *The Routledge Handbook to Star Trek* (2021), and *Fighting for the Future: Essays on Star Trek: Discovery* (Liverpool University Press 2020). Her work has also appeared in the *Journal of Popular Culture*, *Queer Studies in Media and Popular Culture*, and many other edited collections and journals.

Deniz Tortum works in film and new media. His work has screened internationally, including at the Venice Film Festival, IFFR, SxSW, Sheffield, True/False and Dokufest. He has worked as a research assistant at the MIT Open Documentary Lab, where his research focused on virtual reality. In 2017–2018, he was a fellow at Harvard Film Study Center, working on "Phases of Matter", which premiered at International Film Festival Rotterdam in 2020 and received the Best Documentary awards at Istanbul and Antalya Film Festivals. His film "If Only There Were Peace" (co-dir Carmine Grimaldi) received the best short documentary award at Dokufest and his latest VR film "Floodplain" premiered in Venice Film Festival. He was recently featured in Filmmaker Magazine's 25 New Faces of Independent Film.

about the etc press

The ETC Press was founded in 2005 under the direction of Dr. Drew Davidson, the Director of Carnegie Mellon University's Entertainment Technology Center (ETC), as an open access, digital-first publishing house.

What does all that mean?

The ETC Press publishes three types of work: peer-reviewed work (research-based books, textbooks, academic journals, conference proceedings), general audience work (trade non-fiction, singles, Well Played singles), and research and white papers

The common tie for all of these is a focus on issues related to entertainment technologies as they are applied across a variety of fields. Our authors come from a range of backgrounds. Some are traditional academics. Some are practitioners. And some work in between. What ties them all together is their ability to write about the impact of emerging technologies and its significance in society.

To distinguish our books, the ETC Press has five imprints:

- **ETC Press:** our traditional academic and peer-reviewed publications;
- **ETC Press: Single:** our short "why it matters" books that are roughly 8,000-25,000 words;
- **ETC Press: Signature:** our special projects, trade books, and other curated works that exemplify the best work being done;
- **ETC Press: Report:** our white papers and reports produced by practitioners or academic researchers working in conjunction with partners; and
- **ETC Press: Student:** our work with undergraduate and graduate students

In keeping with that mission, the ETC Press uses emerging technologies to design all of our books and Lulu, an on-demand publisher, to distribute our e-books and print books through all the major retail chains, such as Amazon, Barnes & Noble, Kobo, and Apple, and we work with The Game Crafter to produce tabletop games.

Since the ETC Press is an open-access publisher, every book, journal, and proceeding is

available as a free download. We're most interested in the sharing and spreading of ideas. We also have an agreement with the Association for Computing Machinery (ACM) to list ETC Press publications in the ACM Digital Library.

We don't carry an inventory ourselves. Instead, each print book is created when somebody buys a copy.

Authors retain ownership of their intellectual property. We release all of our books, journals, and proceedings under one of two Creative Commons licenses:

- **Attribution-NoDerivativeWorks-NonCommercial:** This license allows for published works to remain intact, but versions can be created; or
- **Attribution-NonCommercial-ShareAlike:** This license allows for authors to retain editorial control of their creations while also encouraging readers to collaboratively rewrite content.

This is definitely an experiment in the notion of publishing, and we invite people to participate. We are exploring what it means to "publish" across multiple media and multiple versions. We believe this is the future of publication, bridging virtual and physical media with fluid versions of publications as well as enabling the creative blurring of what constitutes reading and writing.

www.ingramcontent.com/pod-product-compliance
Lightning Source LLC
Chambersburg PA
CBHW071422170526
45165CB00001B/360